SAVING AMERICA'S TREASURES

2000

\mathcal{S}AVE AMERICA'S TREASURES
NATIONAL TRUST FOR HISTORIC PRESERVATION

Save America's Treasures is a public-private
partnership between the White House
Millennium Council and the National Trust
for Historic Preservation dedicated to the
celebration and preservation of our nation's
irreplaceable historic and cultural legacy.

COMPILATION COPYRIGHT © 2001 NATIONAL GEOGRAPHIC SOCIETY

Additional copyright information on page 192.

LIBRARY OF CONGRESS CATALOGING-IN-PUBLICATION DATA

Saving America's treasures / National Trust for Historic Preservation.

 p. cm.

 Includes index.

 ISBN 0-7922-7942-5 (r) -- ISBN 0-7922-7966-2 (d)

 1. Historic sites--United States. 2. Historic sites--United States--
Pictorial works. 3. Historic sites--Conservation and restoration--
United States. 4. Architecture--Conservation and
restoration--United States. 5. Archival materials--Conservation
and restoration--United States. 6. Cultural property--Protection--
United States. 7. Historic preservation--United States. 8. United
States--History, Local. I. National Trust for Historic Preservation
in the United States. II. National Geographic Society (U.S.)

 E159 .S26 2000

 973--dc21

 00-056261

SAVING AMERICA'S TREASURES

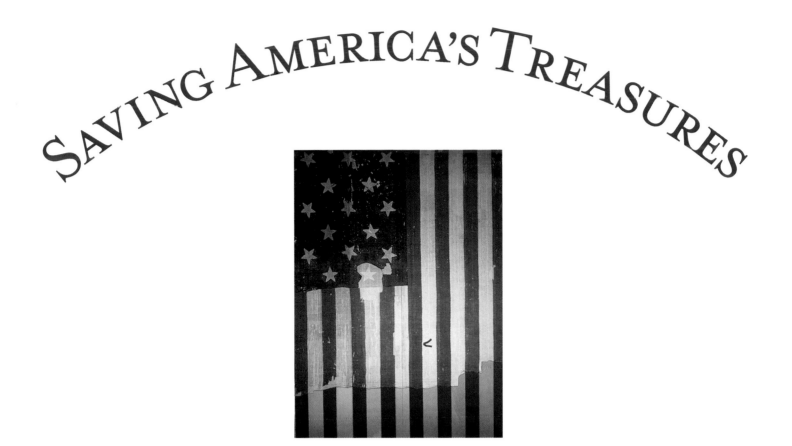

NATIONAL TRUST FOR HISTORIC PRESERVATION

PHOTOGRAPHS BY *Ira Block* TEXT BY *Dwight Young*

ESSAYS BY

Ian Frazier, Thomas Mallon, Henry Petroski,
Francine Prose, Ray Suarez, Phyllis Theroux

□ NATIONAL GEOGRAPHIC

WASHINGTON, D. C.

CONTENTS

POLITICAL LEANINGS

AMERICAN DIVERSIONS

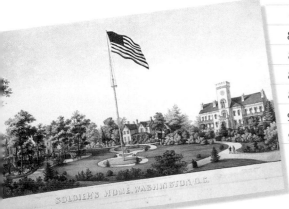

Above: *Page from Babe Ruth's scrapbook*

Below: *The Soldiers' Home—Lincoln's retreat*

Communities of Faith

Nation at Work

Land of the Free

Top to Bottom: *African Meeting House in 1895; Teeple Barn cupola; Tobacco Girl cigar-box label*

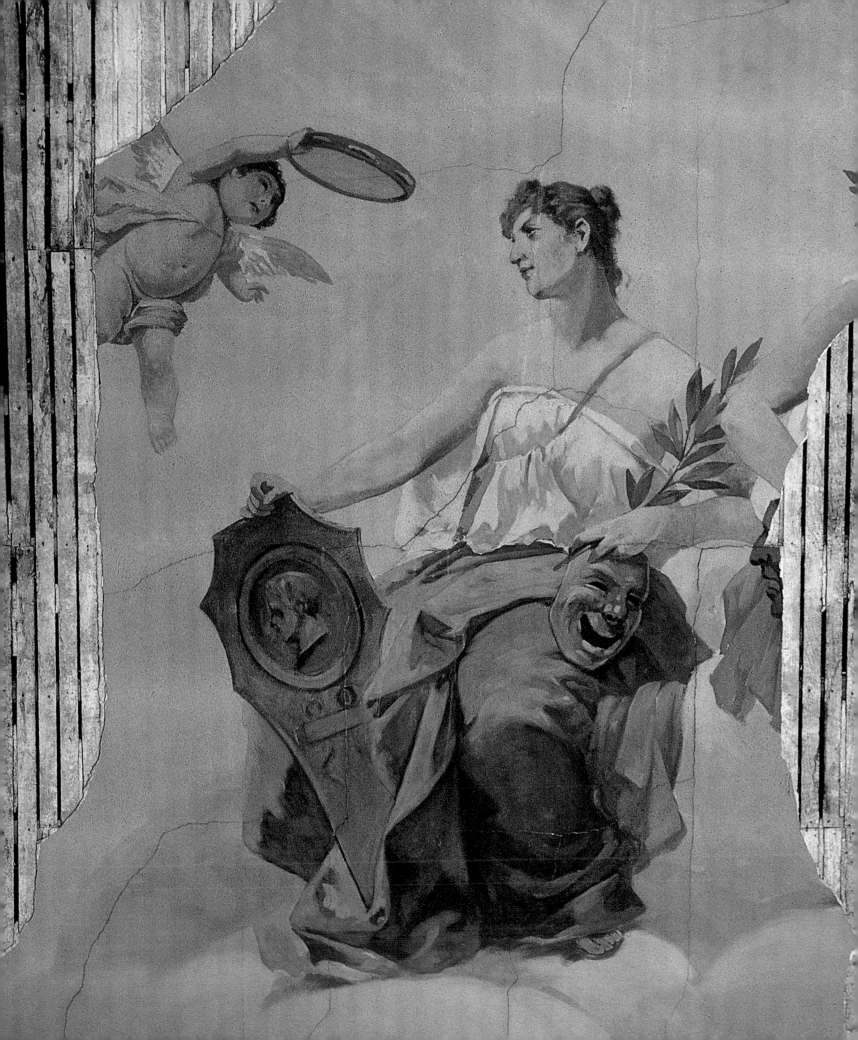

Preserving America's Story

Hillary Rodham Clinton

HAVE YOU EVER THOUGHT ABOUT WHAT YOU WOULD GRAB first if your house were on fire? Most of us, after making sure that our loved ones and pets were safe, would probably reach for the irreplaceable symbols of our family's history, including photographs, baby books, home movies, yearbooks, and Grandmother's love letters.

Hanging in the East Room of the White House is just such an irreplaceable symbol—a symbol of America's family history. Every time I walk past it, I think back to the summer of 1814, when Dolley Madison was First Lady. As British soldiers entered Washington, intent on burning the White House and the rest of the capital's public buildings to the ground, Mrs. Madison refused to leave until Gilbert Stuart's portrait of George Washington was safely removed. Today, that portrait—one of only two objects in the house that survived the soldiers' looting and the fire—hangs in the East Room, a proud reminder of the triumph of America's young democracy.

As British troops advanced on Washington that torrid August day, Stephen Pleasonton, a clerk at the State Department, was ordered to safeguard the papers in his office. Gathering together the official documents of the revolutionary government—including the Declaration of Independence, the Constitution, and George Washington's letters—he commandeered wagons to transport the documents to a secure location in the northern Virginia countryside. The next day, he learned that every public building in Washington had been burned to the ground. But thanks to his foresight and courage, important documentation of the early years of our nation's struggle for freedom was saved for future generations.

Unlike then, the greatest danger facing our historic legacy today comes

On a perch made precarious by falling plaster, a painted muse graces the ceiling of the Colonial Theatre in Pittsfield, Massachusetts.

not from military siege, but from indifference, neglect, the lack of much-needed resources, and the ravages of time. As a nation, we have allowed too much of our heritage—the places and objects that comprise the collective memory of America—to deteriorate. These remnants of our past could, if protected, illuminate and inspire future generations. Their preservation is our sacred trust.

When the President began his second term in 1997, we talked about the exciting prospect of leading our country's official commemoration of the new millennium. Beyond parties, fireworks, and champagne, this historic milestone offered a rare opportunity for the nation to come together to reflect on the best of our past and contemplate a future we could proudly bequeath our children.

Yet, as the year 2000 approached, important symbols of our past, such as the Gettysburg Battlefield, Little Rock's Central High School, and *Brown v. Board of Education*'s Monroe School, where the battle for human rights still raged a century after the Civil War, were deteriorating from lack of proper care. If we could protect and restore important sites like these, we realized that we could preserve more than the physical fabric of our nation's history. We could, in fact, preserve the rich diversity that is truly America's story.

So, rather than build new monuments to mark our passage into the next millennium, the President and I made preservation of historic sites the cornerstone of our millennium activities, charging the White House Millennium Council with designing and overseeing a wide array of celebrations and programs guided by the national theme, "Honor the Past—Imagine the Future." At the center of this initiative was Save America's Treasures, a public-private partnership between the White House Millennium Council and the National Trust for Historic Preservation. Save America's Treasures, for which I serve as honorary chair alongside co-chairs Richard Moe, president of the National Trust, and Susan Eisenhower, author and granddaughter of the late President, was created to raise public awareness and generate new resources to give a brighter future to our past. Since its creation, I have watched as Americans all across the country have risen to the challenge of seeking out and saving the history in their own backyards—

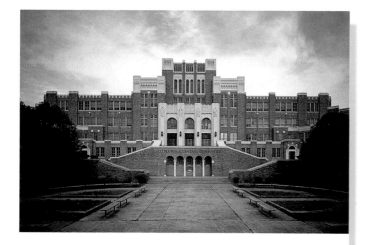

Central High School National Historic Landmark

LOCATION • Little Rock, Arkansas

ORIGIN • 1927

CONDITION • Severely deteriorated roofs; failure of ceiling and wall plaster; water damage to foundation and basement

PROJECT SCOPE • Preserve structure and interpret its role in the integration of public schools and development of the Civil Rights movement in the United States

graffiti-covered monuments, overgrown cemeteries, historic buildings threatened by development, and photographs and documents yellowing in local historical societies.

In just over two years, we have designated more than 600 official Save America's Treasures projects and generated more than $50 million in contributions ranging from a few dollars to $13 million. With an additional $60 million in federal Save America's Treasures matching grants, and the strong backs and the determination of countless individuals and community organizations from around the nation, we are helping to save landmarks and artifacts such as Thomas Edison's Invention Factory, George Washington's winter encampment at Valley Forge and his military tents in Yorktown, collections of deteriorating films from the early years of American cinema, the Rev. Martin Luther King, Jr.'s Ebenezer Baptist Church in Atlanta, the Golden Gate Park's magnificent Conservatory of Flowers, the Ferry Building at Ellis Island, the Immigration Station at Angel Island, and New Mexico's mission of San Esteban del Rey at the Pueblo of Acoma, the oldest continuously inhabited community in America. In the last two years, I have had the great pleasure of visiting more than 40 of these sites, where I have seen firsthand not only the harsh effects of time and the elements, but the heroic efforts under way to reverse the damage.

My first "Treasures Tour" began at the Smithsonian Institution's National Museum of American History on July 13, 1998, when the President and I stood before the timeworn and threadbare Star-Spangled Banner and announced two extraordinary gifts: $10 million from Polo Ralph Lauren and an early grant of $5 million from the Pew Charitable Trusts for the flag's preservation, conservation, and future display. Thanks to these generous and patriotic donors, and a $3 million federal Save America's Treasures matching grant, generations to come will gaze at the flag and sing the National Anthem with a fresh

understanding of the price our ancestors paid for their freedom—and ours.

On that same trip, I stopped in Auburn, New York, to tour the home of Harriet Tubman, one of the great leaders of the Underground Railroad. Since that day, visits to the Tubman home have increased a hundred percent, and tens of thousands of dollars in preservation funds have poured in. The children of one elementary school in Philadelphia adopted Tubman's home with a project they called "Pennies for Preservation." Penny by penny, the students collected $1,100 to help preserve the place where one of the true heroes of America's struggle for equality once lived. In the process, their minds opened to a whole new understanding of Tubman's place in our country's history.

Third graders at a Boulder, Colorado, elementary school devised a similar plan to preserve a piece of history close to their home. They raised nearly $3,000 by doing odd jobs and extra chores, and by selling "Adopt-a-Ruin" calendars they designed. Their contributions went to the Ute Mountain Tribe and Mesa Verde National Park to help protect the remains of a thousand-year-old pueblo culture. One of the students explained why she worked so hard to raise money for Mesa Verde: Looking ahead 40 years, to the day when she would have children who would clamor to see the ruins, she said, "I think the best part is that, when I grow up, it will be great to see the expressions on my kids' faces when I tell them I helped save the ruins." I can't think of a more eloquent expression of the way Save America's Treasures has struck a chord with so many Americans—the thousands who joined us at public events around the Treasures Tours, and countless others who became involved after reading accounts in their newspapers or watching stories on television.

With the help of partners including the White House Millennium Council, the National Trust, the Federal Emergency Management Agency, the National Park Service, the National Park Foundation, Heritage Preservation, the U.S. Mint, and the National Geographic Society, our vision for Save America's Treasures has become a reality. Many other exceptional donors, including the General Electric Company, AT&T, the J. Paul Getty Trust, the Richard and Rhoda Goldman Fund, Fran Goldstein and

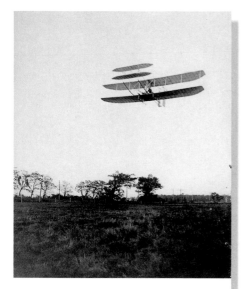

1905 Wright Flyer III

LOCATION • Dayton, Ohio

ORIGIN • 1905

CONDITION • Surface rust; fabric tears and rust stains, broken struts

PROJECT SCOPE • Conservation treatment of metal, fabric, and wood elements; design and implementation of environmental controls for exhibition in Wright Hall

Sandra Wagenfeld, Goldman Sachs, Norman and Lyn Lear, the Pritzker Foundation, the Madeleine H. Russell Fund and the Columbia Foundation, and Warner Bros. Records were eager participants. Along with countless community groups and volunteers, they helped to bring these once-vibrant sites and collections alive again, introducing us along the way to some remarkable examples of American ingenuity and spirit.

I wish every American could visit East Los Angeles's Boyle Heights neighborhood. There, Latino residents, in what was once a thriving Jewish community, are working with the Jewish Historical Society of Southern California to restore the historic Breed Street Shul (Congregation Talmud Torah) as a museum and cultural center. On the other coast, dedicated preservationists and community leaders are working to save South Carolina's Old Charleston City Jail, which between 1802 and 1938 housed prisoners, witnesses awaiting trial, newly arrived slaves, and Union prisoners of war. The School of the Building Arts, located in the jail, will, in the truest spirit of our millennium celebration, strive to "preserve the past to educate the master craftsmen of the future." Once the building is structurally sound, the school will train young people in preservation crafts such as masonry, carpentry, plaster, and ironwork.

A hundred years from now, children will visit the Breed Street Shul and the Old Charleston City Jail. They will tour the National Archives and read aloud the words of our Founding Fathers. In the shadow of the Capitol, they will see the Sewall-Belmont House, with its vast collection of documents, photographs, and banners chronicling the early years of the struggle for women's suffrage. As they travel around the country, visiting other historic sites, they will be intrigued by the Wright Brothers' Flyer, fascinated by Babe Ruth's scrapbooks, and inspired by the echoes of our immigrant heritage at Ellis Island and Angel Island. They will take in what they see and hear, and leave with America's legacy of rights and responsibilities, creativity, energy, and generosity firmly embedded in their hearts and minds.

to affect the sentiments of sincere friendship & respect, consecrated to you
by so long a course of time, and of which I now repeat sincere assurances.

Th: Jefferson

Prest Jefferson
Esme 27. 1813
[published]
See Memoirs of Jefferson
Vol. 4. p. 201.

to Price
almost
indisputable
nment
ed and
Restoration
ch Revolu
th, the Fate
f Cromwell
s on Govern
rely a Man
d. David
Court and
he Republicans
he had nearly
and even
al in almost
or Writers upon

Words
and
Randolph
of
Burbons
that

Lock. ...
all Europe to Speak of Constitutions, or Writers upon
35326 the Principles or the Fabricks of them.

was about to r...
of the Americ... desire that
my name may be blotted out forever, from its Re-
cords.

You and I, ought not to die, before We have
explained ourselves to each other.

I shall come to the Subject of Religion, by and
by.
Your Friend

John Adams,

I have been looking ... for a space in
my good Husband ... of an old
... through all
... Place since
... as long
reside ...

XL 116
[1813]
[To JA] Monticello June 27.13.

Ἴδαν ἐς πολύδενδρον ἀνὴρ ὑλατόμος ἐλθὼν.
Παπταίνει, παρεόντος ἅδην, ποθεν ἄρξεται ἔργυ.
Τί πρᾶτον καταλέξω; ἐπεὶ πάρα μυρία εἰπῖν.

and I too, my dear Sir, like the wood-cutter of Ida, should doubt where to begin,
... to enter the forest of opinions, discussions, & contentions which have occur-
... I should exclaim with Theocritus Τί πρᾶτον καταλέξω; ἐπεὶ πάρα
... it, the summum bonum with me is now truly
... and to these I wish to consign
... divided into

FOUNDING FATHERS' PAPERS

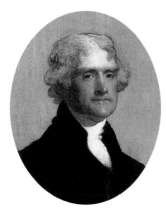
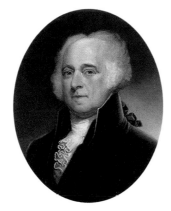

Opposite: *Two aging revolutionaries—Thomas Jefferson (above left) and John Adams (above right)—exchange views on the state of the nation in 1813.*

In a hushed atmosphere generally found only in churches and banks, visitors shuffle through the great rotunda of the National Archives to gaze at two of the best-known pieces of paper in the world: the Declaration of Independence and the Constitution. These documents encapsulate the American dream of liberty and democratic government, but the process by which that dream was realized and the character of those who presided over it are illuminated in thousands of other documents—such as an 1813 correspondence between Thomas Jefferson and John Adams.

What is perhaps most remarkable about the letters is their difference in tone.

Jefferson's is serene. He reminisces fondly about the fires of rebellion and nation-building: the heat of youth, recollected in the tranquility of old age. While deploring the bitter partisan wrangling that dominates the political scene, he notes that it's nothing new: "The same political parties which now agitate the U.S.," he says, "have existed thro' all time."

Adams, by contrast, recalls the high ideals for which the Revolution was fought and the new republic founded, and questions whether the struggle actually accomplished anything. "Where are now in 1813, the Perfection and perfectability of human Nature...the Augmentations of human Comforts...the diminutions of human Pains and Miseries?" he asks. "When? Where? and how? is the present Chaos to be arranged into Order?"

If the dialogue has a familiar ring, it's because it's still going on. Tune in to any radio talk show, and you'll hear no end of adamant assertions that the country is going to hell in a handbasket. You'll also hear plenty of people saying that everything is just fine.

In short, you'll hear the lively sound of America being itself: evidence that our *unum* still allows for plenty of *pluribus,* testimony to the strength of the foundation laid more than 200 years ago by men such as Jefferson and Adams.

13

ORIGIN
● 1706-1836

CONDITION
● Deterioration over time to fragile documents

PROJECT SCOPE
● Make accessible significant papers of George Washington, Benjamin Franklin, John Adams, Thomas Jefferson, and James Madison

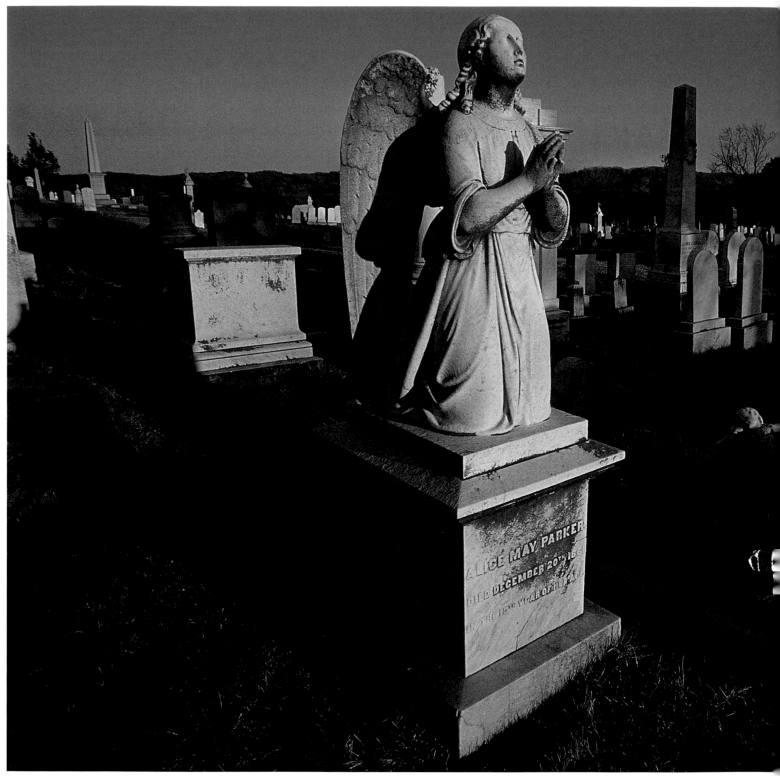

14

Bathed in late afternoon sunlight, one of Congressional Cemetery's many marble angels gazes heavenward.

CONGRESSIONAL CEMETERY

WASHINGTON, D.C.

Established by a group of Capitol Hill residents in 1807, this burial ground became known as Congressional Cemetery after a portion of it was set aside for the interment of members of Congress who died in office. Architect Benjamin Henry Latrobe designed an ominous monument to memorialize these departed public servants, and several hundred were erected—until a senator declared that being buried beneath one of them would add a new terror to death.

The graves of more than 60,000 people, both famous and unknown, are scattered across these gently rolling acres overlooking the Anacostia River. The political world is represented by monuments honoring Vice President Elbridge Gerry, whose name is immortalized in the term "gerrymander," and Belva Lockwood, the first woman to run for President and actually receive votes. Civil War photographer Mathew Brady is here, along with "March King" John Philip Sousa. The bodies of 21 women who died in an explosion at the Washington Arsenal in 1864 are buried under a tall shaft topped with a mournful neoclassical figure. Not far away is the grave of ten-year-old Marion Kahlert, who in 1904 became Washington's first victim of a traffic accident. FBI Director J. Edgar Hoover lies near his longtime companion Clyde Tolson, and former soldier and gay-rights activist Leonard Matlovich rests under an epitaph he composed himself: "When I was in the military, they gave me a medal for killing two men and a discharge for loving one."

The Public Vault here has housed the bodies of three U.S. Presidents. Today, however, Congressional's role as America's Valhalla has been usurped by the much better-known Arlington National Cemetery. In a city of monuments, this out-of-the-way place is largely forgotten, its marble angels and obelisks standing silent in the grass.

15

Top: *View of Congressional Burial Ground in an 1872 guidebook*
Above: *Damaged monument to Marion Kahlert, killed by a car in 1904*

ORIGIN
• 1807

CONDITION
• Reclaimed from overgrown, vandalized state by community volunteers

PROJECT SCOPE
• Restoration of selected monuments; ongoing maintenance of site

STAR-SPANGLED BANNER

Since we sing about it at the opening of every ball game—*dawn's early light...rockets' red glare...land of* (hang on, here comes that high note) *the freeee*—the story of this flag's role in the bombardment of Fort McHenry is familiar enough to have made it the most revered assemblage of wool bunting in the U.S.

It was made by professional flag-maker Mary Pickersgill, with help from her daughter and nieces, under a commission from Maj. George Armistead, Fort McHenry's commander. She was paid $405.90 for her work. When the 30-by-42-foot flag got too big for her tiny house, Mrs. Pickersgill had to finish it on the floor of a nearby brewery; ironically, its praises are still sung to the tune of an English drinking song.

The flag's moment in the spotlight came on September 13-14, 1814. For most of the following century it was a cherished keepsake in the Armistead family, a reminder of their illustrious ancestor's bravery under fire. Family members lent the banner for display on patriotic occasions such as Lafayette's visit in 1824 and the nation's first Flag Day celebration in 1877. They also snipped off fragments—including one of the 15 original stars—and gave them away as mementos.

Over the years, particularly in the decade after the Civil War, a growing public appreciation for America's heritage transformed the flag from little-known family relic into treasured national icon. Recognition of this fact and concern over the banner's deteriorating condition eventually led Maj. Armistead's grandson to donate it to the Smithsonian Institution in 1912.

The flag is currently undergoing thorough conservation and preservation. It's an enormous, technically challenging, and expensive undertaking—but well worth it, of course, since the nation's idea of itself is sewn into every stitch. The flag may be faded and a bit frayed, but—just as it was on that morning in 1814—it's still there, with "America" written all over it.

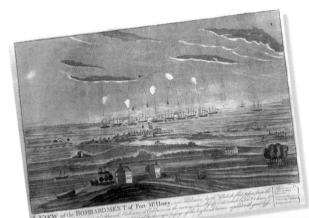

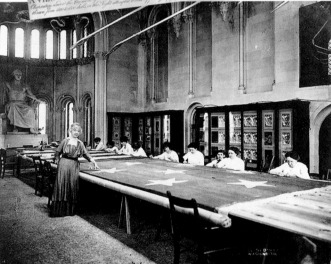

Top: *1816 view of the bombardment of Fort McHenry*

Above: *In the Smithsonian Castle's West Wing, seamstresses repair the flag in 1914.*

Opposite: *This first known photograph of the tattered Star-Spangled Banner was taken at the Boston Navy Yard in 1873.*

CRIGIN	CONDITION	PROJECT SCOPE
• 1813	• Natural deterioration and damage to woolen fibers from artificial light and air pollutants	• Conservation treatment on view to public, creation of an environmentally controlled display, and educational programs

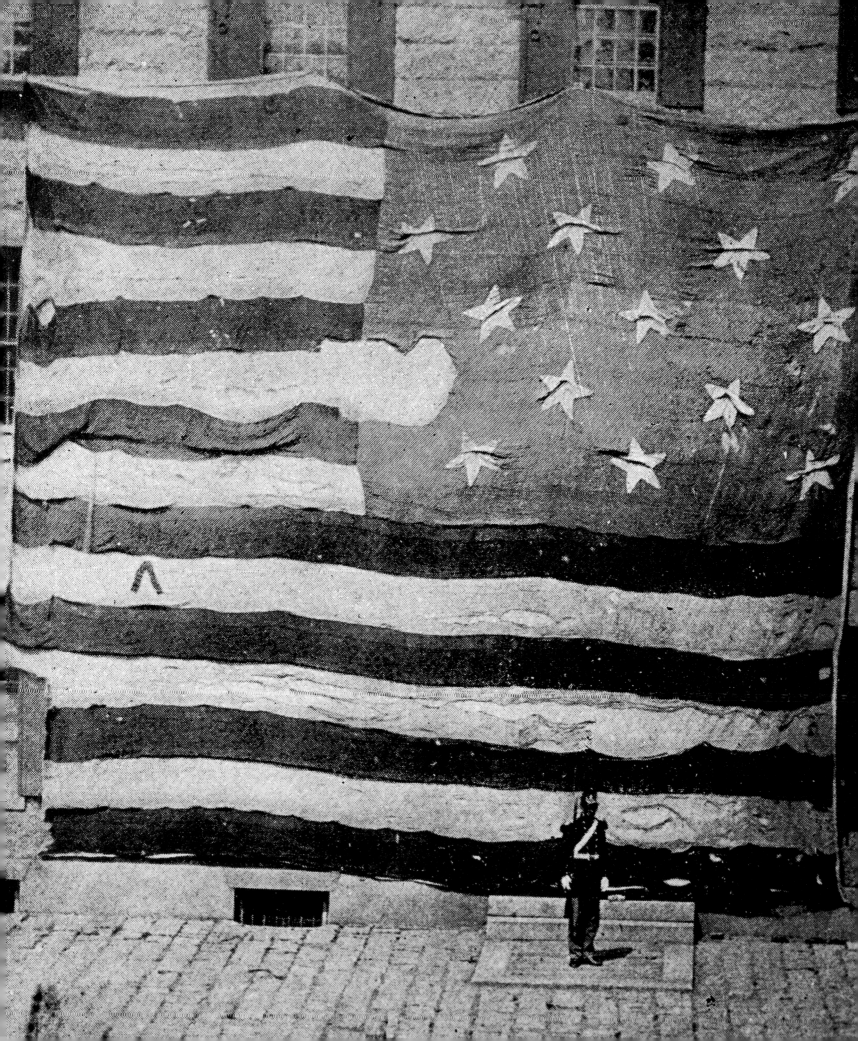

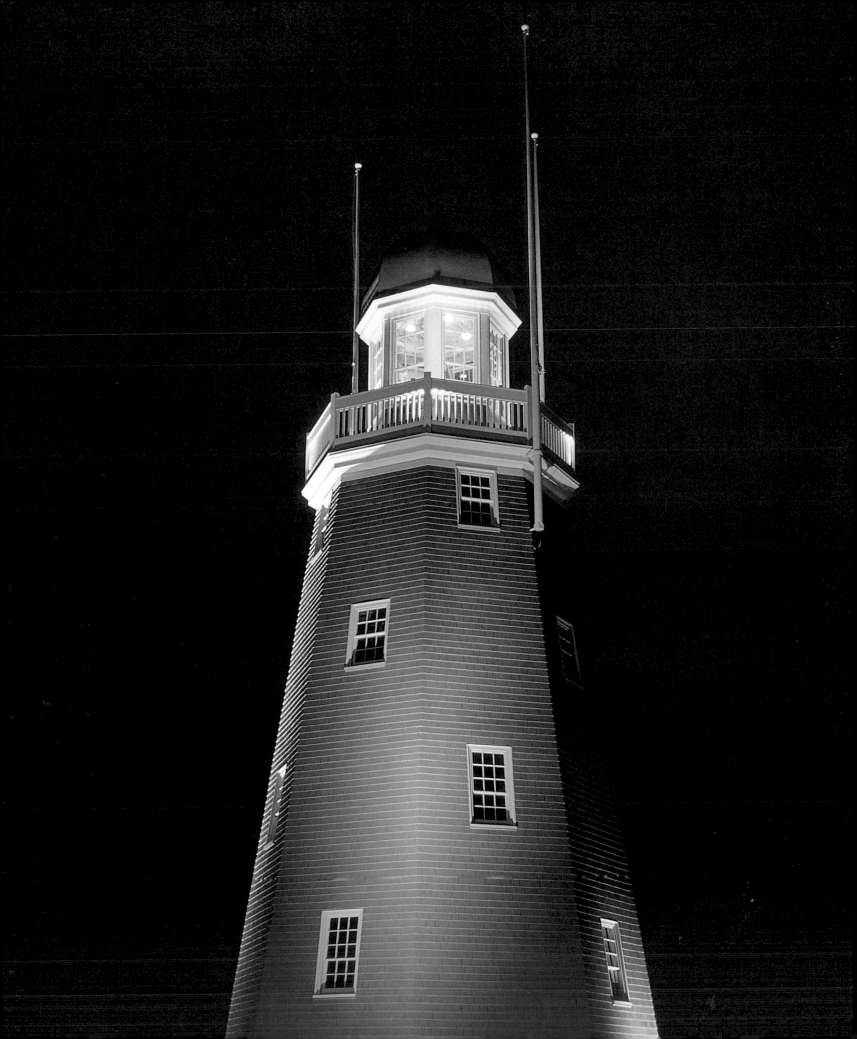

Saving Our Treasures and Ourselves

Ray Suarez

The last of its kind in America, the 193-year-old Portland Observatory glows against the New England nighttime sky.

IS THERE A PLACE YOU CAN GO THAT IMMEDIATELY REMINDS YOU of who you are? Whether you walk by it or watch it pass in your windshield, is there a place that connects you to a jolt of current— of family, ethnic group, shared history, personal past? Imagine that place for a moment. Could you stand the sight of it crumbling in neglect, paved over for a strip mall, or simply abandoned? Would you miss it? Would you raise your voice or write a letter or a check to save it? With our breakneck push across a continent and our ease in discarding our past, it's impossible to calculate how many of us have already felt that loss. A vast array of American treasures—precious buildings, wild lands, and historic neighborhoods—didn't make it to the beginning of this new century.

When an irreplaceable structure —an old house of worship, a farmhouse in the midst of what is now a city, a 200-year-old battleship—is gone, what have we really lost? In a country as big as ours, it seems safe to guess that most Americans will never make it to Frank Lloyd Wright's home, Taliesin, in central Wisconsin. In a country of 275 million people, busy and mobile as we are, would we notice the loss of an old railroad roundhouse in West Virginia or Russian Orthodox churches in a remote part of Alaska? Any of these places can be "visited" in old photos in the pages of a book or by pointing and clicking on the Web. Perhaps it is an abstract proposition to ask people to mourn the loss of a place they'll never see, like the loss of a tiny species of moth in a part of the world they'll never visit. Some of us see our common inheritance as Americans reduced when a place like the Mapes Hotel and Casino in Reno, Nevada, is demolished after a long fight to save her— even if we never go anywhere near Reno.

Americans just back from a trip to Europe or Asia might speak with praise of nations and peoples that have direct physical and cultural links to their pasts, links preserved to be savored today. Yet we are gripped by paradoxical feelings about our own relationship with the past. We are thrilled by newness, ready to cast away places, ideas, or fashions simply because they are old. We invent new identities. We invent

new religions. We give ourselves new names. We shed our personal pasts as easily as we don a new set of clothes. America's economic dynamism has untethered ideas of status and achievement from the anchors of birthplace, social class, religion, and national origin. That is an achievement countries beset by sectional conflict might envy, but this selective amnesia, however, is not cost free.

Even with all that forgetting, our history can give us fits. What is history for? Is it a set of stories meant to create a shared national myth and give us an identity we can be proud of? Or is our history a cautionary tale, meant to warn us away from mistakes of the past and remind us of shared ideals in their breach as well as their fulfillment? I ask because what you decide to save may look very different depending on whether you're bent on uplift and inspiration or a warts-and-all accounting.

When we rummage through our closet, how do we decide what to keep? Shotgun shacks built by the families of freed slaves may seem to us to be a dime a dozen. When we're down to the last few will we suddenly rush in, ready to stuff the last dodoes for exhibition? One man's undistinguished is another man's authentic.

City administrations in places like Baltimore and Detroit are busily overseeing the demolition of row houses, homes that ferried the precious cargo of American dreams up the first hesitant steps into the mainstream. Many of the people who pass by these houses may think, "Why are these landmarks?" Even the people who once lived in them might wonder at the fuss. But workers' housing is part of the American puzzle, along with aging mansions, factories, forts, archaeological sites, works of arts, and documents. This is not some exercise in politicized or revisionist history. It is a struggle for texture, for detail. The shacks without the mansions would create an incomplete portrait, as would the mansions without the shacks.

Depending on the road you choose, you might bulldoze World War II Japanese interment camps rather than preserve them. If you cherry-pick our history for happy inspiration rather than knotty challenge, you might allow the Civil War and slavery to recede into an intangible past and channel our energies into sites associated with celebrities and Presidents.

For all this country's tense arguments with its own past, it isn't hard to find evidence of centuries of a deep American sense of place. It sings in the writing of Faulkner and Thoreau, Isaac Bashevis Singer, and Laura Ingalls Wilder. You can hear it in the urban manifestos of Dr. Dre and Snoop Dogg, Gershwin's soaring woodwinds, and Charles Ives's musical love letters to the land. You see that love of place in bountiful landscapes of the Western painters and in the taverns and tenements of the Ashcan School of artists.

Today the Hispanos of northern New Mexico periodically get together to resurface their adobe churches. Black families travel from the four corners of the country for family reunions in the "home places" that saw their transitions to liberation. In the face of precarious balance sheets and the lure of the cities, farm families across the Great Plains hang on where so many others have given up the struggle.

Anyone looking for proof of an abiding sense of place will find clues scattered across the landscape. Roadside shrines and family plots, Bronx casitas transplanted from rural Puerto Rico, clapboard churches lovingly maintained by dwindling congregations in the upper Midwest, all speak to affection for place. Tourists don't come and snap their pictures. Museum curators don't offer to truck these artifacts back to big-city museums. The places are to our selves what GMT is to time, what magnetic north is to a compass, what absolute zero is to a physicist. For millions of us even now, in an America made a nation of strangers by unlimited mobility and wanderlust, these places whisper to us a steady litany of reminders of who we are and what we were.

You might take a moment right here to remember my fellow Brooklynite Walt Whitman's humanist embrace, "I contain multitudes." On the subject of caring for our inheritance, we are of many more than two minds. Note that lack of unanimity because it's also dead easy to find ample evidence that we're missing that gene, that predisposition, to remember and protect the family jewels. We Americans are always proving how good we are at forgetting to remember. Maybe it's the downside of flinging ourselves across a continent, across oceans, and over land bridges. The Iowans and Oklahomans who poured into California in the 20th century were once Germans, and Scots-Irish Southerners, and New Englanders restlessly looking for something new.

As the sun rises on the 21st century, central Europeans-turned Iowans-turned Californians and English-turned-Yankees-turned Chicagoans-turned Californians are once again on the move to beckoning new frontiers in Oregon and Washington and to two of the fastest-growing cities in America, Las Vegas and Phoenix. They may shed a few tears for schools, churches, and neighborhoods left behind, but their children and grandchildren won't feel the tug. The utilitarian Americans want places that work for them today and roads to take them there with a minimum of fuss.

Skeptics can, not without justification, question the need for the hard work and expense of rehabilitating a bridge when a modern, brand-spanking new one could be built with the latest materials. They wonder whether age, on its own, confers worthiness. It should be recognized that Save America's Treasures and its

partners are not on some starry-eyed pilgrimage across the landscape, trying to save everything old. On the contrary, it is the breathtaking loss already past that energizes those who want to save the dwindling number of structures representing a particular time, place, and people.

These remnants, these survivors, span centuries of American history, from the petroglyphs and homes hewn from the rocks of the Southwest to, remarkably, NASA space suits, less than 40 years old and already starting to disintegrate. In intense crimsons and golds, in Chicago, Tiffany windows tell the viewer of the ornamental glories of the late 19th-century Arts and Crafts movement, just arrived from England. Just a few hundred miles to the east of that South Side church, a different kind of artistry speaks across the decades: fading sketches from the hand of Thomas Alva Edison in the lab complex where the inventor imagined and built the future.

The Cahokia burial mounds, built by Indians not far from the sprawling St. Louis metropolitan area, are no less a part of the American story than the Star-Spangled Banner itself, the flag Francis Scott Key saw flying over Fort McHenry that moved him to write our national anthem. In the flag's case, high-technology fabric-preservation techniques, down to microanalysis of the almost 200-year old fibers, were a necessary part of saving it. Saving the Cahokia burial mounds is only a little bit more complicated than deciding to shield the site from spreading residential and highway development. Before corporate philanthropists and ordinary Americans by the tens of thousands joined the crusade, the Ellis Island immigration center stood crumbling in the shadow of the New York skyline and the Statue of Liberty. On a frigid winter day, I managed to get a national park ranger to take me to the complex in a small launch. I wasn't ready for the scene that greeted me.

Like so many New Yorkers, I had grown up listening to stories of Ellis Island from many immigrants and their children. On this day in 1982, a launch sat submerged to its smokestack in shallow water at a collapsed and rotting pier. This was a boat that picked up immigrants from passenger ships or brought them, after processing, across the bay to New York. It was too late to save her. Inside the reception rooms and corridors, the only sound was the echo of my own footsteps as I walked around the puddles of standing water that had turned to ice.

Paint peeled in giant sheets from the walls and ceilings. Enameled signs in the mess area instructed new arrivals in Yiddish, Italian, Russian, Serbo-Croatian, Polish, and English. Under cover of night, scavengers had crossed the small inlet from New Jersey to strip out copper plumbing, ornamental stonework, and brass. But under the muck and sag of neglect, a jewel waited.

Mukai Farm and Garden

LOCATION • Vashon Island, Washington

ORIGIN • 1926

CONDITION • House and Fruit Barrelling Plant intact; only garden of its size known to be designed by first-generation Japanese woman; garden stones and ponds intact; plant material extant, but overgrown

PROJECT SCOPE • Complete restoration as a historic site commemorating Japanese immigration to Puget Sound, the ancient art of Japanese gardening, and the international strawberry industry

Millions of us have since visited the rehabbed portions of the Ellis Island complex, looked through computer databases for relatives (and ourselves!), and explained to children the historic migration represented by the place. However, two-thirds of the immigration station remains in a condition little different from the one I observed in the early 1980s. With every year, the job gets harder to do and more expensive. After making that down payment on preserving the place where about 40 percent of all U.S. families can trace the beginning of their American journey, it still remains to us to ensure the survival of the rest of Ellis Island for centuries to come.

If over the past 50 years we've absorbed the lesson that blight and decline are contagious, we should also be able to believe that rescue, recapture, and rehabilitation can send out tendrils of new growth, and economic activity can be contagious, too. Sometimes, it's just a matter of remembering not to forget a place that is waiting to be transformed. Saving a treasure may be no more complicated than proclaiming that a place *is* one. That simple act creates a psychic space where a community can show that it does cherish a place. The act of designation and the work of restoration can suddenly unlock wider improvements that have been possible all along but only seem visible when a specific site, a locus for development, is identified.

We've got to walk a fine line. We must make these places safe for the future and make them matter to our countrymen and women. These places and archives are not Fabergé eggs, elaborate little baubles to be enjoyed by a few. They carry in their bricks and mortar, drawings and photographs, the DNA of our democracy. They knock us out with the dazzling variety of who we are and who we were. What else can you say about a collection that includes a home-run hitter's scrapbooks and a church built by Acoma Indians on a butte in New Mexico?

The tiny creeks and runoff of a thousand hills across a hundred centuries have created a vast river of humanity, America in 2000. Cigar rollers in Ybor City and lighthouse keepers in Maine, millers in Minnesota and Eleanor Roosevelt's cultured salon all crowd into the family portrait. We've let too much of the old furniture go already. It's time to make sure we don't lose any more.

A delicate Gothic Revival bargeboard decorates Abraham Lincoln's summer cottage in Washington, D.C.

There and Then

Thomas Mallon

THE LIGHTS ARE BLAZING AT COLUMBUS'S HOUSE. IT'S 2:30 A.M. in the Piazza de Ferrari in Genoa, but you would think someone was up late getting ready for a long trip. Outside Gettysburg, the "copse of trees" is even now hopelessly waiting for Pickett's charge to reach it, but on the Panama Canal, I can see that everything is business and bustle: The lock closest to me has just filled back up. At the Washington Monument it's already too dark to see the different shades of stone on the obelisk—the lower, brighter part dating from before the Civil War; the higher, darker rise from after Reconstruction. But there's enough light to make out some scudding clouds above the column's tip.

I've been to all these places in the last ten minutes, and may wander back to one or two of them before I've finished drafting this essay. I have "live cams" for all four sites bookmarked on my computer, and I can click on almost-real-time images of whichever spot I'm inclined to visit, whenever I'm inclined to go. One more distraction for the deskbound procrastinator, I suppose. But another frontier of virtual reality? I don't think so. These venues depend upon a fundamental authenticity for even their cyber-tourist trade. The live-cam viewer wants the same strong feeling experienced by the in-person visitor—namely, that this particular piece of history still breathes with its ghosts and memories in the present—an assurance we can never quite get from a regular photograph or piece of film, whose frozen image becomes itself a part of the past as soon as the negative has been developed.

As the 21st century gets under way, our conquest of geography is nearly complete. If I want, I can move the live Washington Monument to the right half of my screen and use the left to "chat," via Instant Messaging, with a friend in Tokyo. But the past is no more reachable than it ever was; our links to it are just as tentative, and tantalizing, as they were in A.D. 1900 or 2000 B.C. We can get everywhere else, but we cannot get there—which is to say—then.

That doesn't stop us from seeking visual and tactile transport to an earlier time. Those different-colored portions of the Washington Monument are American

Heavy stonework and a barred gate provide an appropriately somber entrance to the Old Charleston City Jail.

history's own geological layers—a startling imperfection that preserves the country's great before-and-after moment. Tourists at Theodore Roosevelt's boyhood home in Manhattan can see the second-floor window from which the six-year-old "Teedie" watched Lincoln's funeral procession—and feel themselves shuttled among three centuries: their own; Lincoln's 19th; and TR's 20th—still to come, but also finished. To stand behind the window itself, to look through it to a transformed but still-the-same East 20th Street, is to insinuate oneself as successfully into the past as the laws of physics will allow.

Our temporal imaginations are blunt, fitful instruments: We need the objects of reality, preserved and well-tended, to take us where we want to go. The standing structure and available relic create not so much an impression as a sense of momentary, perhaps disorienting, participation. Everyone who stands upon the *Arizona* memorial at Pearl Harbor remembers one sight above all: the drops of oil that bubble up, even now, every day, as if at last escaping.

IN HIS 1959 POEM, "For the Union Dead," Robert Lowell absorbs the vibrations, real and otherwise, caused by construction of a parking garage in downtown Boston:

> *A girdle of orange, Puritan-pumpkin colored girders*
> *braces the tingling Statehouse,*
>
> *shaking over the excavations, as it faces Colonel Shaw*
> *and his bell-cheeked Negro infantry*
> *on St. Gaudens' shaking Civil War relief,*
> *propped by a plank splint against the garage's earthquake.*

Lowell's poem is less immediately concerned with history than with what might be called the history of history—its civic representations in bas-relief and statuary. The monument designed to preserve an historical event—the assault of the African-American 54th Regiment upon Fort Wagner in South Carolina, and the death of its white commander—has itself become a frail piece of the past.

After the Civil War, Washington, D.C., planted a great grove of commemorative sculpture meant to draw the minds of passersby back to the heroic feats of then-recent decades. Today, these pedestals with their forgotten bronze figures are all that remains of the 19th century in certain thoroughfares of the capital. Walk north up 14th Street from L (or look at the photos in Peter R. Penczer's *Washington, D.C.: Past and Present*) and you'll still see Gen. George H. Thomas ("the Rock of Chickamauga") and the Luther Place Memorial Church (1870), but every other building on either side of the road long since postdates both statue and steeple. Not far from

the White House, Admiral Farragut stepped onto a pedestal in 1881, but he is all that's left of that time in the square that still bears his name.

There's an ironic vigor to these monuments: Their job now seems to be not the commemoration of Chickamauga and Mobile Bay, but to make a stalwart last stand for the moment when they themselves were set in the ground. That tends to be what we think of when we pass them—how long they've been there. As such, they are poor evocations of what they were designed to keep alive. For that, we require the battlefield itself, with its actual rusted artillery.

The Lincoln Memorial's 36 pillars (one for each state) can vitally embody the Union's survival, but even Daniel Chester French's statue cannot give us Lincoln himself. To find him we must go where Lincoln ventured himself. One such remaining place is Anderson Cottage at the Soldiers' Home on Rock Creek Church Road. One 1884 guide to Washington, much impressed with the facility's comforts, declared that the visitor "as he strolls through these grounds almost envies the superannuated warriors their privilege of residing here." The contemporary caller will notice an 1874 statue of Gen. Winfield Scott ("Old Fuss and Feathers"), but his mind will be occupied by Abraham Lincoln, who after replacing Scott as head of the Army often rode out to the Soldiers' Home to get some relief from the capital's climate, both political and meteorological—especially its malarial influences, always strongest near the Potomac River and the much-to-be-avoided location of the future Lincoln Memorial.

Our imaginations require fact more than symbol. At the Kennedy Space Center, a silver monument to the country's first space flights—a metal sculpture intertwining the number seven with the symbol of Mercury, at what used to be Pad 14—is a cryptic rune compared to the Liberty Bell capsule of Gus Grissom, recently retrieved from the floor of the Atlantic Ocean. There it had spent 38 years after sinking, during the astronaut's recovery, on July 21, 1961. Now being restored at the Kansas Cosmosphere, the little spacecraft has the strange knowingness of an exile. Designed to fly above the atmosphere, it stayed there only several minutes before beginning its long life below sea level and, now, its eternal rest on a landlocked prairie. The impulse to retrieve the capsule—both to connect with the past and to repeal one hapless moment of it—was willing to wait, for years, upon money, technological progress, and bureaucratic approval in order to fulfill itself.

MY COMPUTER, bookmarked with those live cams, sits on a desk in the second-floor study of my house in Connecticut—a snug place whose clapboard sides and wooden porch give it a traditional New England look. But the house is only 12 years old,

and after a handful of renters, my partner and I are the first occupants to own it. I find it odd living in a home without history, since the novels I write always involve the past and its connections to the present. In one of them, *Dewey Defeats Truman,* an old man named Horace Sinclair, supposedly speaking for himself in 1948, is really speaking for me:

> *"You can't get rid of the past, Mr. Cox. The past is not a matter of time. It's a place. Somewhere just out of reach.... It's right here, rearranged, hiding like the face drawn into a tree in one of those children's puzzles.... The world is divided into two kinds of people, Mr. Cox. Those who, when they pass a house, wonder who lives there, and those who, when they pass it, wonder who used to live there. I belong to the second group...."*

Years ago, when I had my first apartment in New York, a very old walk-up near Grand Central Terminal, I was always aware of the generations of footsteps—copy-boys and salesgirls, all of them in hats, holding cigarettes—who had gone up the same stairs, night after night, on Black Tuesday and V-J Day, and on the 20,000 more ordinary days before and after and in between. My stretch of East 43rd Street had even seen service as a location in the film *The Lost Weekend.*

Not much of what surrounded me 15 years ago still survives on that block: The old Provident Loan Society building has made way for an aqua-glassed skyscraper; a new St. Agnes's Church has replaced the one that burned down; the Kent building has been sheathed in a new facade. But somehow number 151 survives, and when I walk down the block, which I often still do, I look up at my old apartment and have a sense of being there, looking out the window. Light still comes through that same pane of glass, and a part of me is still behind it, just as the young Theodore Roosevelt, 23 blocks south, is still at his window.

We never fully relinquish our feelings of ownership toward the places we've lived. About six months ago I was back in the suburban town where I'd grown up, and I went out to my old house. I soon found myself standing in my old backyard. I was, in a legal sense, trespassing; but in any other sense the word was absurd. The pear tree might be gone, and a modern skylight might cut into the old roof, but I knew exactly where I was—home. The phrase "If these walls could talk" may be in the conditional, but use of it reflects the ordinary person's basic animism, his more-than-childlike feeling that houses are alive, that walls can talk, and in our own voices, which the plaster has absorbed and retained. When I pass my father's old office on Fifth Avenue and 37th Street, I touch the tubular door handle, because I know it's the same one he was touching 40 years ago. Our continuity, our reassurance, resides in what's tangible and longstanding: In moments of anxiety, we knock wood.

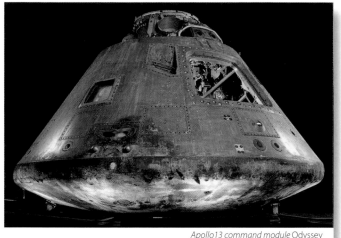

Apollo13 command module Odyssey

Kansas Cosmosphere and Space Center Collections

LOCATION • Hutchinson, Kansas

ORIGIN • Flown on April 11-17, 1970

PROJECT SCOPE • Restore to post-flight condition; 12-year project to collect
and reassemble more than 80,000 parts removed for post-
flight inspection

The power of small, incidental survivals shouldn't be underestimated. When work on a novel took me to the Old U.S. Naval Observatory in Washington's Foggy Bottom—a building that over 150 years has been much drywalled and subdivided to serve a function much different from its original one—my host directed my attention to a pane of glass in the window behind a computer workstation. The glass bore markings only recently discovered: the scratched names of Miss Nannie Maury and her young friends. Nannie was the daughter of Matthew F. Maury, the Observatory's last antebellum superintendent who, in April 1861, resigned his post and returned to his native Virginia. The pane of glass is still keeping out winter winds, still bringing in the District's hot summer sun.

The functional relic has a special appeal to the visitor. A place still being used gives off a stronger scent of its famous, past associations than one that's been encased in the amber of landmarking. When I first came upon Thomas E. Dewey's boyhood home in Owosso, Michigan, I could hear children—current inhabitants—playing in the backyard: An idea of the ordinary midwestern life that Dewey had led came to me more strongly than it would have from docents during visiting hours.

Out in Eldon, Iowa, the "American Gothic" house made famous by Grant Wood's painting is tenanted by a family of six struggling to get by on welfare. The town is waiting for the owner to die, so that it can renovate the place into a tourist attraction, but as the writer Michael Martone points out, people come, even in the meantime

> to see the house in Eldon. It is something to see. Staking a whole economy around seeing it is another matter. The rewards of seeing this house are subtle and complex. Here public and private spaces meet; art meets life. The fact that someone still lives in the house makes the experience of seeing it richer.

How many patrons of Go-Lo's Restaurant at 604 H Street N.W., in Washington, D. C., know that they're dining on the ground floor of Mrs. Surratt's old boarding house, where John Wilkes Booth and his band met to plot Lincoln's assassination? In New York, do the customers at Sal Anthony's restaurant near Gramercy Park realize that they're eating in short-story writer O. Henry's old parlor?

In his essay on Eldon, Martone discusses the unexpected power of returning to a place you've never been:

I remember coming upon the Sanitary Bakery on Bleecker Street in New York, amazed it survived pretty much unchanged from the Berenice Abbott photograph from the thirties. I knew the picture before the place. Now I was in the picture. It was almost as if taking the picture a half-century before had frozen the place itself, an image now of the image.

Every day at least a few first-time business travelers to Dallas are startled to look out the window of their rental cars and discover that, while following the map to the airport, they are passing through Dealey Plaza. If they feel suddenly to be in a waking dream, trapped inside the news-channel footage and historic home movies they have seen broadcast hundreds of times, it is because the plaza is so unchanged. It is both functioning and landmarked. Several years ago, when it won listing as a National Historic Landmark, Mrs. John Connolly, the sole surviving passenger from the presidential limousine that came through on November 22, 1963, was asked to cut the ceremonial ribbon. Nellie Connolly broke into a big, gracious Southern grin as she obliged, celebrating the efforts of those who had fought to preserve a location where her husband had once been shot and nearly killed. It was a peculiar moment, a collision of horror and pride for which history offered no clear protocol or exact timetable. Her smile seemed grotesque and appropriate all at once.

It seems particularly American that the streets of Dealey Plaza still carry ordinary traffic. We are, after all, a utilitarian people, given more to getting on with the job than to contemplation. The English writer Rose Macaulay's 1953 book, *Pleasure of Ruins*, which pays tribute to a quiet, melancholic "delight in decayed or wrecked buildings," may be the most non-American travel book I can think of. When confronted with decay, our own impulse is either to sweep it away or to fix it up—but not to let it sit there gathering moss and mold.

Often we have swept away the built environment with the kind of gusto once applied to clearing the land. The preservation movement of recent decades has changed that, and I suspect the cyber revolution may, paradoxically, strengthen our new antiquarian impulses. In a time when half the new businesses in America don't even require storefronts—just run themselves in the ether—the constructed landscape may begin to change less fast than it used to. We may start to cherish hard reality more, not less, in our ever-more-virtual days. Perhaps we're seeing this in the current public appetite for auctions; we have a growing, sometimes fetishistic taste for the real thing, be it Mrs. Kennedy's pearls or Marilyn Monroe's dress. The E-book is not going to replace our desire to see and touch the actual volumes that figures from the past have seen and touched, leaving their annotations and

who-knows-what traces of DNA as they fingered the pages. The poet William Carlos Williams famously pronounced against abstraction by declaring "no ideas but in things." We know instinctively that the strongest connection to the past runs through man-made matter.

The present has begun to seem so futuristic that what used to be two phases—present and future—now feel like a single entity. The past, at last, is the only other place, a development that may account, among other phenomena, for a resurgence of historical fiction: The reader's imagination wants to take the one trip left to it. Of course, once you arrive in the past, its most stimulating feature proves to be its similarity to the present—what was Lincoln's Anderson Cottage if not today's Camp David?

In her book on ruins, Rose Macaulay quotes the 15th-century Florentine writer Poggio Bracciolini, who composed this agitated reaction to witnessing the wreckage of Rome:

> *The hill of the Capitol on which we sit was formerly the head of the Roman empire, the citadel of the earth, the terror of kings, illustrated by the footsteps of so many triumphs, enriched with the spoils and tributes of so many nations. This spectacle of the world, how is it fallen! how changed! how defaced!*

The American experience—more involved with progress and redemption than anything else—has been very different. But our own still-new liberties (and continuing follies) proceed from somewhere, and it helps to see their launching points. In a letter written to Ebenezer Hazard in 1791, Thomas Jefferson recommended reproduction of those documents crucial to the new nation's story:

> *Time and accident are committing daily havoc on the originals deposited in our public offices. The late war has done the work of centuries in this business…let us save what remains; not by vaults and locks which fence them from the public eye and use in consigning them to the waste of time, but by such a multiplication of copies, as shall place them beyond the reach of accident.*

The Declaration of Independence retains most of its power even on newsprint reproductions each Fourth of July. But a replica of Independence Hall—or even a live-cam shot of the real thing—has but a fraction of the suggestive force to be experienced from standing outside the actual place on a sweltering July day. It's helpful to remember that the ghosts inside, like all ghosts, are curiously local creatures. One might think the spirits of the dead would exercise the prerogative of mobility, but, in fact, ghosts always seem to stay put, pacing only the places they walked in life. If we would meet them, we have no choice but to preserve their haunts.

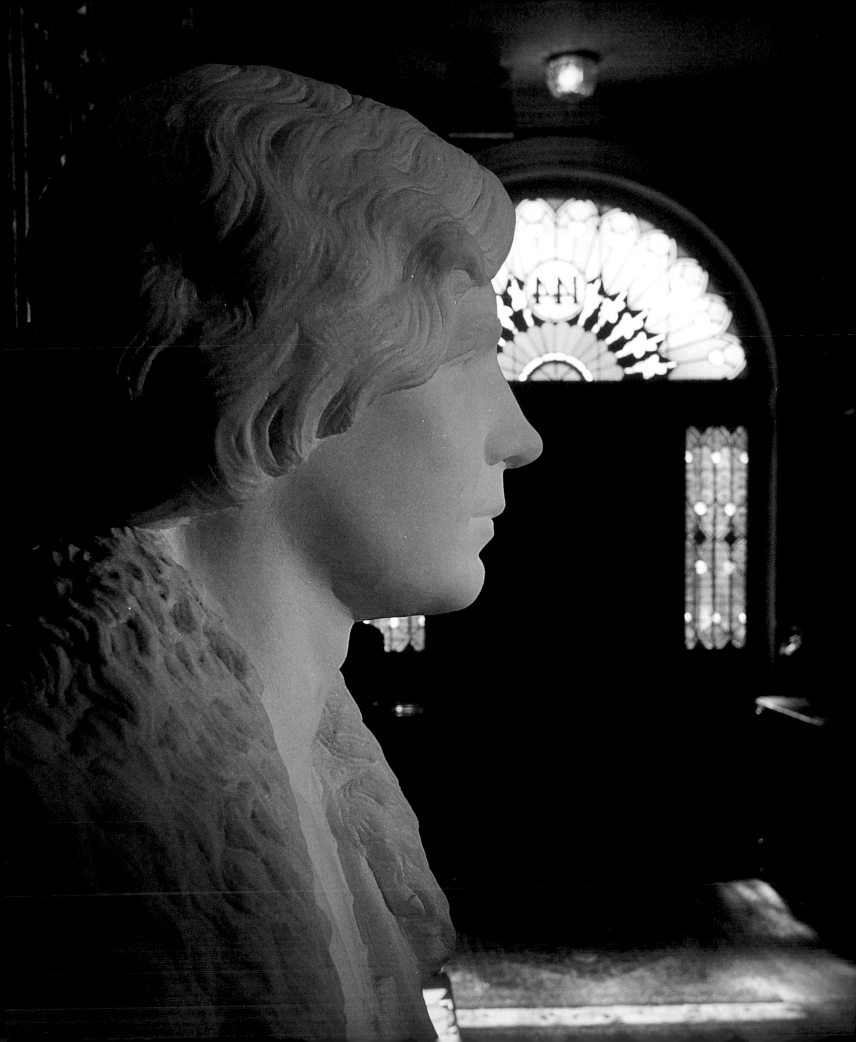

SEWALL-BELMONT HOUSE

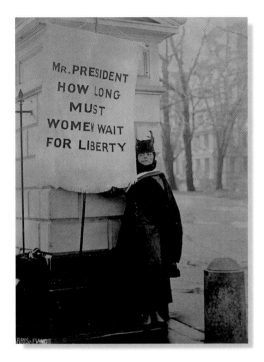

At the beginning of the 20th century, as one writer has noted, women in America "had fewer rights than a raving lunatic...in an insane asylum." The law considered them the property of their husbands. Most professions were closed to them. They couldn't serve on a jury or own property in their own names. And they couldn't seek political redress of these wrongs, because they couldn't vote. By 1912 women's status had improved, but the ballot box was still off-limits in all but a handful of states.

Enter Alice Paul.

As a student in England, Paul had joined the militant British suffrage movement. Back in the United States, she persuaded the National American Woman Suffrage Association (NAWSA) to send her to Washington as a lobbyist. As one of her first acts, she organized a parade of 5,000 women on the day before Woodrow Wilson's 1913 inauguration. On Pennsylvania Avenue, the marchers were spat upon and roughed up—a spectacle that generated invaluable publicity for the suffragist cause.

Splitting with NAWSA, Paul founded the National Women's Party and made this Capitol Hill house its headquarters. To focus public attention on Wilson's refusal to endorse suffrage, NWP members picketed the White House, carrying banners shaming "Kaiser Wilson" for crusading to "make the world safe for democracy" while ignoring the plight of American women. They were arrested by the dozens. While these tactics offended many, NWP's confrontational approach was an effective counterpoint to the quieter work of the mainstream branch of the suffrage movement. Both sides could claim a share of the victory that came in August 1920, when the 19th Amendment became the law of the land.

On November 2, 1920, more than eight million American women cast their votes in the presidential election. Alice Paul—who had been jailed, force-fed, and interrogated by doctors seeking to impugn her sanity—devoted the rest of her life to an unsuccessful effort to secure enactment of the Equal Rights Amendment.

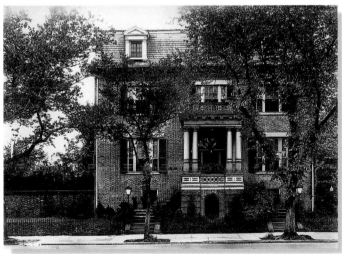

Top: A suffragist pickets the White House in 1917.
Above: Sewall-Belmont House around 1920
Opposite: A bust of Alice Paul stands in the house that serves as headquarters of the National Women's Party she founded.

ORIGIN	CONDITION	PROJECT SCOPE
• 1750, house; 1900-present, collections	• Serious deterioration of roof, foundation, and building systems; critical conservation needs for fabrics and photos in collections	• Preservation of the site and collections; make artifacts and research library accessible on-line, in films and exhibitions; and maintain public access of facilities

35

Poplar Forest

FOREST, VIRGINIA

There was something about an octagon that appealed to the wide-ranging, logical mind of Thomas Jefferson, architect. This fascination with eight-sided figures was given full rein at Poplar Forest, where the main house is an octagonal structure with four octagonal rooms surrounding a central hall. Even the privies are miniature octagons—with domes. Any geometry teacher would love Poplar

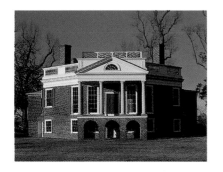

Forest, but Jefferson loved it more. It was a refuge from the stream of visitors that plagued him at Monticello, a modern-day Roman villa where he could indulge the passions that occupy many men in what today would be called their "golden years": reading, gardening, and grand-fathering. He entertained rarely, preferring to spend his days at Poplar Forest in a rustic idyll that allowed him plenty of time for the life of the mind. He wrote happily in 1811, "I have fixed myself comfortably, keep some books here, bring others occasionally, am in the solitude of a hermit and quite at leisure...."

Construction of the house began in 1806 when Jefferson was 63 years old and midway through his second term as President. While he enlivened the building with ideas—alcove beds, floor-to-ceiling windows, a skylight—derived from many sources, he drew his primary inspiration from the works of the 16th-century Italian architect Andrea Palladio. Surrounding the house was an ornamental landscape whose strong cross-axial symmetry was probably inspired by Palladian examples as well.

After Jefferson's death, a fire and changes in ownership brought significant alterations to Poplar Forest. Now, however, a meticulous restoration aims to recreate the original design of the place its architect once pronounced "the best dwelling house in the state" (you can almost hear him pausing archly) "except that of Monticello."

ORIGIN
- 1806-1826

CONDITION
- House and landscape altered through the years

PROJECT SCOPE
- Restoration of first octagonal house in America and landscape; construct educational facilities for visitors

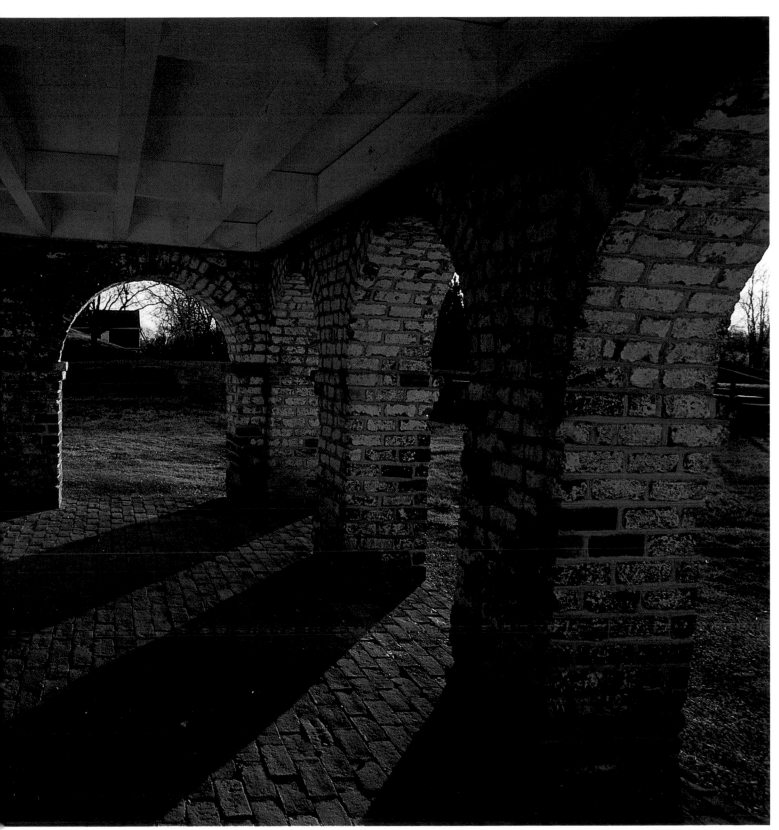

The architecture of Andrea Palladio inspired this loggia on the south facade of Jefferson's beloved rural retreat.

LEWIS AND CLARK HERBARIUM

PHILADELPHIA, PENNSYLVANIA

Anyone who ever picked a flower, marveled at its intricate structure and fragile beauty, maybe even took it home to press between the pages of a book, will recognize the sense of discovery and wonder that pervades this collection.

When Thomas Jefferson sent Meriwether Lewis and William Clark on their journey westward in 1803, he instructed them to examine and document "the soil and face of the country, its growth and vegetable productions." In obedience to this mandate, the explorers—in addition to hunting game, scaling mountains, fighting treacherous river currents, enduring murderous heat and cold, negotiating with Indian tribes, and leading the Corps of Discovery across thousands of miles of unfamiliar and unforgiving territory—took time to pick flowers, pluck leaves, and gather seeds. Of the specimens they collected, almost half turned out to represent species previously unknown to science.

The herbarium is unspectacular at first glance: just brittle bits of botany mounted on 226 yellowing sheets of paper. In fact, each sheet is a bona fide treasure, offering not only a tangible link with one of the world's great epics of exploration (many pages bear notations in Lewis's own hand), but also a wealth of firsthand information on plant and animal life, indigenous cultures, and climatic conditions that existed 200 years ago.

The survival of the collection is something of a miracle. After Lewis committed suicide in 1809, a botanist who had been hired to draw and classify the plants stole several dozen of the sheets. They eventually wound up in England, where they were put up for auction in 1842. An Amherst College professor (and unsung scientific hero) named Edward Tuckerman, Jr. recognized their importance, bought them and donated them to the Academy of Natural Sciences in Philadelphia, where the herbarium is housed today.

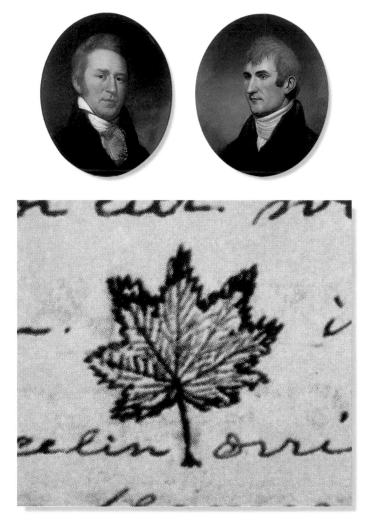

Top: *Portraits of Lewis (right) and Clark (left) by Charles Willson Peale*
Above: *Drawing of a maple leaf from Lewis's journal*
Opposite: *Plant specimens gathered by the expediton gave Americans their first hint of the botanical riches of the unknown West*

ORIGIN
● 1803-1806

CONDITION
● Extremely fragile plants damaged and mounting papers ripped, worn, or stained; damage from insects, handling, and environment

PROJECT SCOPE
● Professionally conserve and secure preservation of plants in environmentally controlled area; make material available through print and electronic media

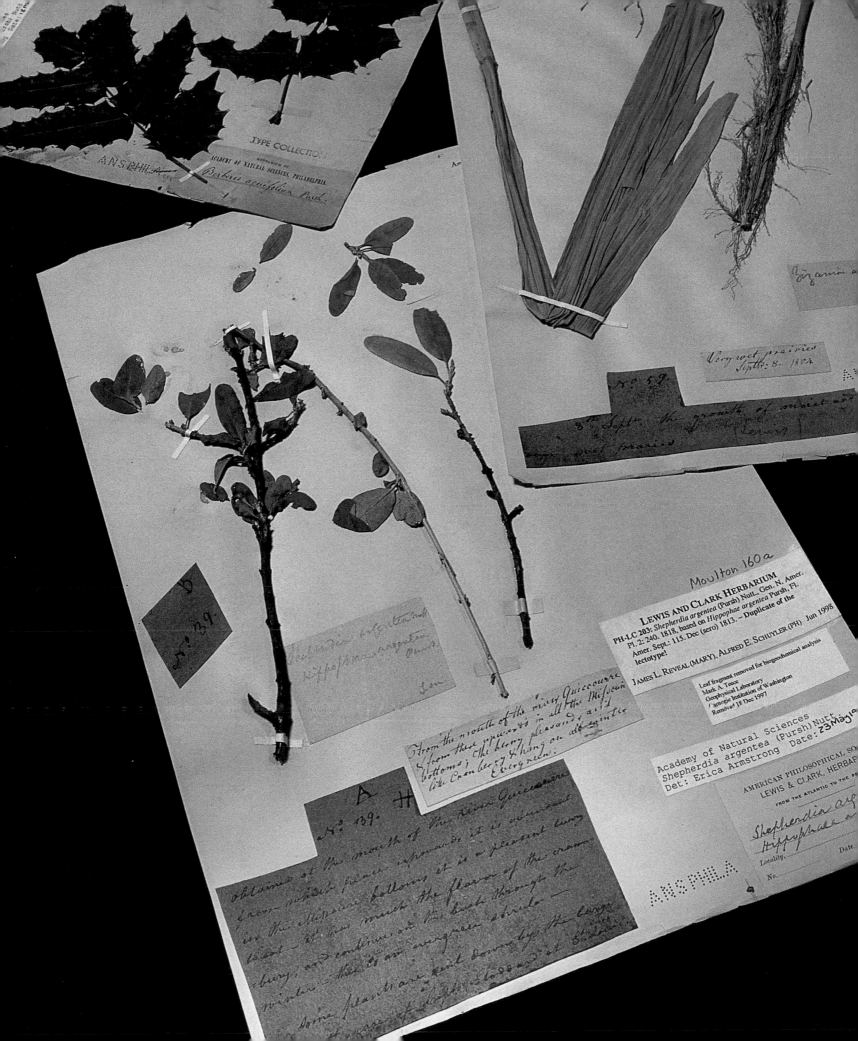

A shady porch overlooks the lawn where Lincoln relaxed with his family during the dark days of the Civil War.

THE LINCOLN AND SOLDIERS' HOME

When Abraham Lincoln first visited this house on the leafy grounds of the Soldiers' Home on the outskirts of Washington, his beloved son Willie had recently died of typhoid fever in the White House. The grieving President recognized that the modest frame cottage was exactly what he and his family needed: a refuge from the heat and stench of the city, the constant press of visitors and favor-seekers, and the heartbreaking memories that haunted the big white house on Pennsylvania Avenue.

Each year from 1862 to 1864, the Lincolns spent the months from late June to early November at Anderson Cottage, with the President commuting daily between the Soldiers' Home and the White House. From the window of the office where he worked, Walt Whitman frequently watched Lincoln ride past with his cavalry escort. "I see the President almost every day," Whitman wrote in August 1863. "He never sleeps at the White House during the hot season...but has quarters at a healthy location some three miles north of the city...."

For Lincoln, burdened with personal tragedy and the cataclysm that was turning tranquil farms and villages into bloody battlefields, the cottage was a haven where he could romp on the lawn with his son Tad or read in the shade of a great copper beech. But even here, the demands of the Presidency and the realities of the war sometimes intruded. The final draft of the Emancipation Proclamation was completed at the cottage in the summer of 1862.

In August 1864, as the President was riding alone near the Soldiers' Home, he heard a gunshot and spurred his horse through the main gate at a gallop. When his stovepipe hat was found in the road, it had a bullet hole in it.

Other Presidents also used Anderson Cottage as a summer retreat, but it is Lincoln's presence that permeates it. Here, the Great Emancipator found contentment as husband and father in a dark time when contentment was hard to come by.

Above: *View of the cottage, 1863*

41

ORIGIN
• 1840-1842

CONDITION
• Structurally sound; interior converted to heavily used office building with antiquated mechanical systems

PROJECT SCOPE
• Transform into a premier historic site with links to other Civil War and Lincoln attractions

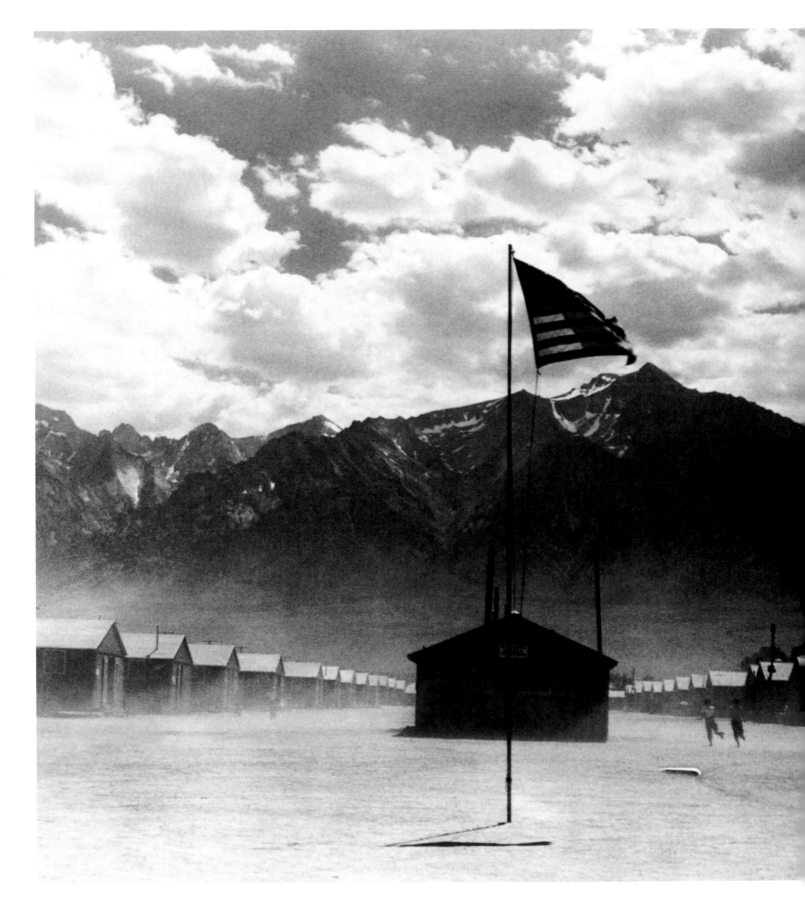

MANZANAR INTERNMENT CAMP

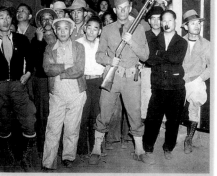

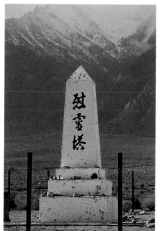

Top: *Internees under guard, 1943*

Above: *Monument in the Manzanar graveyard*

Left: *Dust-laden wind whips the flag at Manzanar, 1942.*

What does injustice look like?

Here at Manzanar, it looks like an isolated valley dotted with scrubby bushes and scoured by clouds of wind-borne grit. It's an austerely beautiful setting for an ugly, shameful memory.

Manzanar was the first of ten facilities constructed by the U.S. government to house Japanese-American internees during World War II. These places were called "war relocation centers." "Concentration camps" would be a more accurate label.

When President Franklin Roosevelt signed Executive Order 9066 a few weeks after Pearl Harbor, he set in motion a process that eventually uprooted some 120,000 Japanese Americans from their homes in the western United States. Most of them were American citizens, either native-born or naturalized. They were not charged with any crime. There was no evidence that they posed any danger to public safety. They were imprisoned on the basis of ancestry alone. They were "Japs," and in the racist-tinged atmosphere of near-hysteria that prevailed at the time, that label was enough to justify their being locked up.

More than 10,000 men, women, and children were confined at Manzanar between March 1942 and November 1945. Bewildered, stripped of jobs and homes and belongings, torn away from everything secure and familiar, they arrived here and were herded into barracks made of wood and tar paper. Most of them had learned about democracy in school, but that was all gone now. In its place there were watchtowers and searchlights and guards with guns. There was a barbed-wire fence. The world was reduced to a few hundred acres.

There isn't much left today: a weathered auditorium, the foundations of the long-vanished barracks, a couple of stone guardhouses, a cemetery. Most of the security fence is gone—but when surviving internees and their descendants come here on pilgrimage, they can still hear the wind whistling through the barbed wire.

Here at Manzanar, injustice looks like a mirror.

43

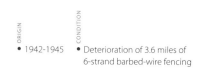

ORIGIN	CONDITION	PROJECT SCOPE
• 1942-1945	• Deterioration of 3.6 miles of 6-strand barbed-wire fencing	• Protect and interpret the historic, cultural, and natural resources associated with the relocation of Japanese Americans during World War II

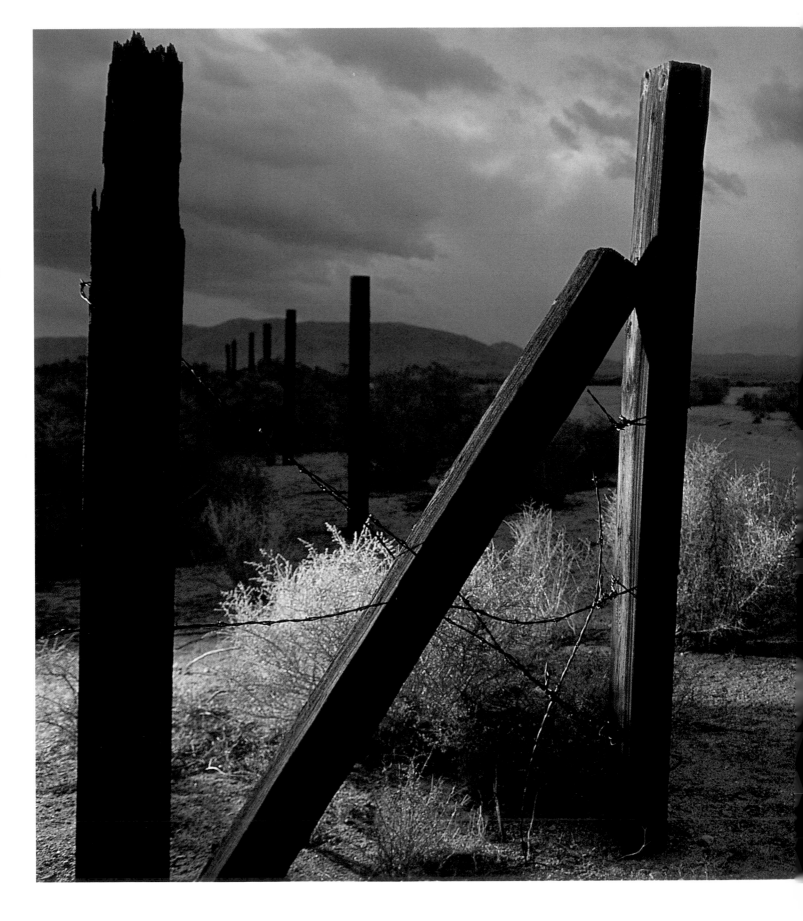

Rusty strands of barbed wire
mark the perimeter of the isolated
camp where thousands of Japanese
Americans were interned during
World War II.

Harriet Tubman Home

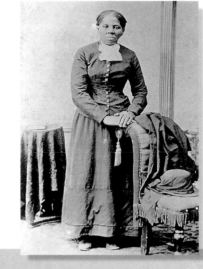

In the few photographic images we have of her, she glares fiercely at the camera, her face alight with zeal and determination and something that looks like fury. She is impatient, unwilling to stand immobile for another second, unable to rest while there is so much work still to be done.

Born a slave in Maryland, Harriet Tubman escaped to Pennsylvania in 1849. The very next year she returned to the South on the first of many trips to bring other slaves to freedom. Between 1850 and 1860, as the best-known and most successful conductor on the Underground Railroad, Tubman led as many as 300 men, women, and children—including her own family—out of bondage. People called her "Moses."

She traveled light. She carried a supply of paregoric to quiet crying babies and a gun to convince her charges that she meant business and would tolerate no faintheartedness. She carried a price on her head, too, and was probably proud of it. When someone asked her if she was ever afraid for her life, she replied, "I can't die but once."

When the Civil War ended, Tubman settled in Auburn, New York, with her parents. The crusading flame that had made her a scout, guide, and spy to be reckoned with still burned brightly, and she was not about to settle into tranquil domesticity. She raised money for schools for newly freed blacks in the South, became a staunch supporter of the women's rights movement, and busied herself in church work. Eventually she bought some property at auction, established a home for the aged, and deeded it to the AME Zion Church.

She died here in 1913 at the age of 93. She had earned a rest, but it probably didn't come easy to her. There was still so much to do.

Top: Studio photo of Harriet Tubman

Above: Harriet Tubman Home for the Aged, early 1900s

ORIGIN	CONDITION	PROJECT SCOPE
• 1858	• General deterioration, water damage, and deteriorated roof drainage, downspouts, and gutters	• Full restoration and development as interpretive site

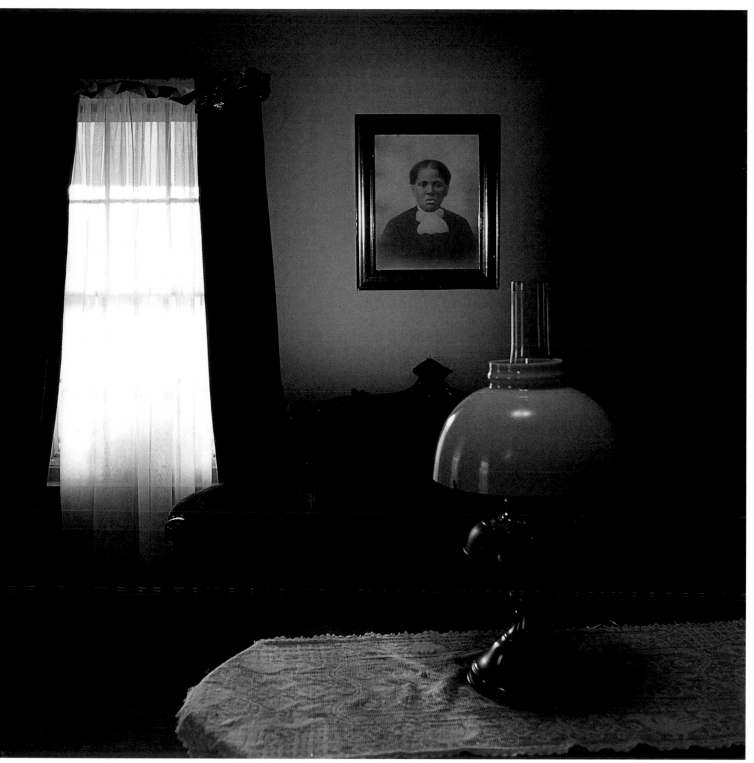

A portrait in Tubman's quiet parlor shows the fierce determination that drove her work on the Underground Railroad.

Above: *Stirling's Quarters is one of five remaining buildings that sheltered Washington's army at Valley Forge.*

Opposite: *Legend says Washington knelt in the snow at Valley Forge to pray for help.*

VALLEY FORGE

VALLEY FORGE, PENNSYLVANIA

When George Washington's troops went into winter quarters here in December 1777, the prospects for American independence slumped to an absolute nadir. The Continental Army—so ragged and ill-equipped that it barely deserved the name—was exhausted after the battles at Brandywine and Germantown. The British had occupied Philadelphia. The heady excitement that had greeted the publication of the Declaration of Independence was now a distant, mocking memory. Stumbling into Valley Forge, the men built crude huts for shelter and thought about survival more than victory.

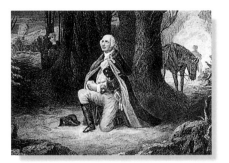

Washington wrote admiringly of "the incomparable patience and fidelity of the soldiery," but patience and fidelity couldn't protect them from the cold, the snow, and the wind. The general even considered disbanding the army so that the men could fend for themselves. In all, some 2,500 soldiers died of disease and exposure during that terrible winter.

But in the midst of misery, a miracle began to unfold. The veteran Prussian drillmaster Friedrich von Steuben arrived in February and began an intensive training program that molded the dispirited men into a disciplined fighting force. Supplies and reinforcements began to trickle in. May brought news of the alliance with France and its guarantee of military aid. When the British left Philadelphia in June, the reinvigorated Continental Army marched after them and defeated them at the Battle of Monmouth.

Orator Henry Armitt Brown, speaking on the 100th anniversary of the army's departure from Valley Forge, described it as "this place of sacrifice...this vale of humiliation...this valley of the shadow of death...." It was all of these, certainly. But it was also the birthplace of something determined and strong and ultimately triumphant.

ORIGIN
• 1777-1778

CONDITION
• Wood shingle roofs are failing; general deterioration

PROJECT SCOPE
• Repair rafters, replace flashing and gutter systems, and re-roof to stabilize the buildings

AVIATION NOSE ART, WWII

MIDLAND, TEXAS

You can't do justice to this airborne pulchritude without employing language that is both quaintly outdated and politically incorrect. *Red-hot mamas,* that's what they are. *Babes. Wolf-bait. Curvaceous cuties* with *gorgeous gams* and *a whole lotta oomph. Hubba-hubba!*

Nowadays, we classify these earthy images as folk art, populist variations on a theme that found a somewhat more refined expression in the famous Varga and Petty girls in *Esquire* magazine and the

femmes fatales in Milt Caniff's "Terry and the Pirates" comic strip. The pictures were created by men who were bartenders and shoe salesmen before they had to become bombardiers and tail gunners. But what are they for? What are they doing here, these luscious, lusty ladies posing in their bathing suits and negligees on the noses of B-17s and B-24s? They are talismans.

A man who was ordered to fly a bombing run over Dusseldorf or Tokyo needed—in addition to a crew he could depend on and a parachute that worked—a guardian angel. He certainly didn't want to put a picture of his real wife, sweetheart, or sister out there on the nose of his plane and then fly it, exposed and vulnerable, into that hell of shell burst and fiery extinction. So he reached into his imagination, drawing on memories of what he'd left behind at home or fantasies of what he hoped to find someday, to create potent images so joyously carnal that even Death himself didn't stand a chance with them.

You can still hear them, the pilots and navigators, so young and scared and trying not to show it. Above the boom of the flak and the roar of the engines, you can hear them crooning and whispering to these images as if to a petulant lover: *"Come on, baby, you can do it. Don't let me down. Take me home, baby. Atta girl. Atta girl."*

ORIGIN
• 1941-1945

CONDITION
• Rescued from WWII aircraft fuselages; severe oxidation and deterioration due to improper storage

PROJECT SCOPE
• Construct onsite conservation lab and gallery; restore, preserve, and exhibit collection

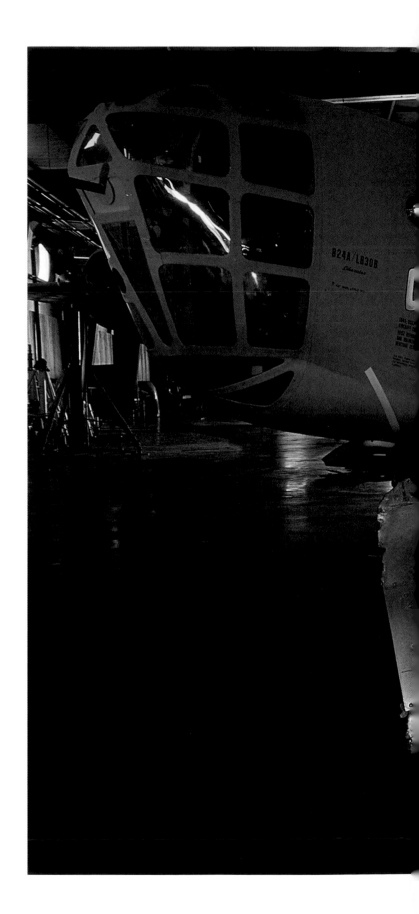

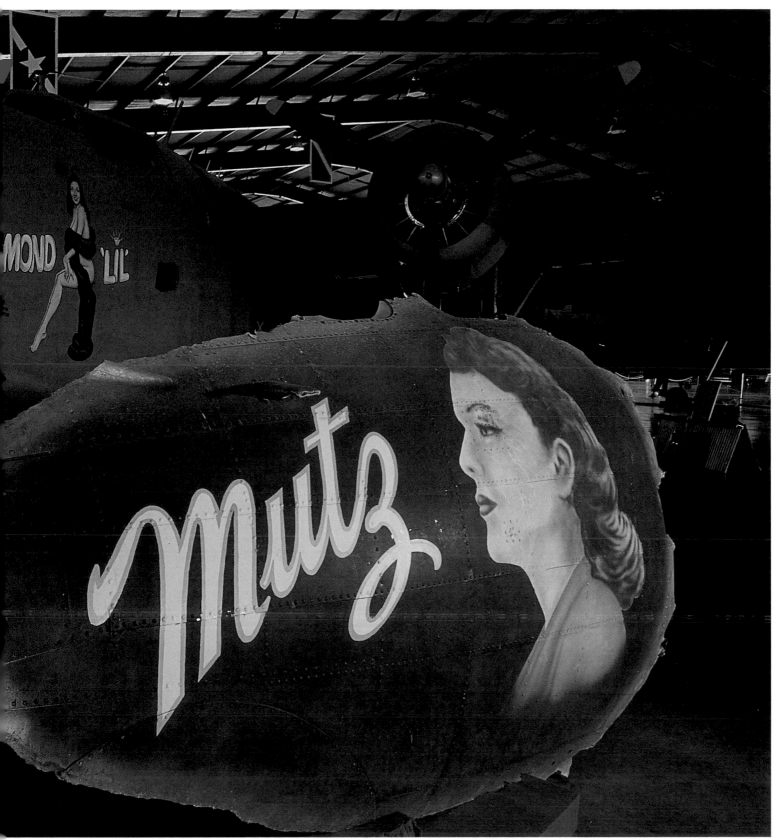

Above: "Diamond 'Lil'" and "Mutz" are two of the beauties whose painted images were talismans for World War II flyers.

Opposite: Pilot "Nobby" deGravelles and "Nobby's Harriet Z," 1945

OLD CHARLESTON CITY JAIL

This building is a sobering reminder that at any given time in this self-proclaimed Land of Liberty, a sizable segment of the population is not actually free.

Jails and prisons have been a fact of American life ever since the earliest days of European settlement, and the theme of incarceration has long exerted a powerful influence on both history and popular culture in works ranging from Martin Luther King's "Letter from Birmingham Jail" to Johnny Cash's "Folsom Prison" and Elvis Presley's "Jailhouse Rock"—not to mention all those black-and-white B-movies about tough cons doing time at Sing Sing and Alcatraz.

Historian Henry-Russell Hitchcock has pointed out that this country's first contribution to world architecture was the innovation in prison design necessitated by the adoption of a penal system that placed prisoners in solitary cells until they achieved penitence—the root of the word "penitentiary." The pirates who were locked up in the Charleston jail in the 1820s no doubt needed a salutary dose of penitence, but it's hard to say the same for the members of the 54th Massachusetts Regiment who were imprisoned here after their bloody defeat at Fort Wagner in 1863.

The design of this gloomy pile is sometimes credited to Robert Mills, better known as the architect of the Washington Monument, but Mills actually was responsible only for a wing that was replaced long ago. The building served as a jail until the 1930s and has stood largely unused since then. Converting an old jail to new uses isn't easy, but it can be done—as witness, to name only two examples, the former jail in Louisville, Kentucky, that is now an office building and the one in Menominee, Wisconsin, that has been turned into apartments. Local supporters are working to convert the Charleston jail into a home for the School of the Building Arts.

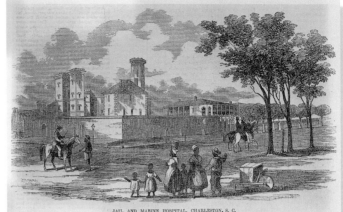

JAIL AND MARINE HOSPITAL, CHARLESTON, S. C.

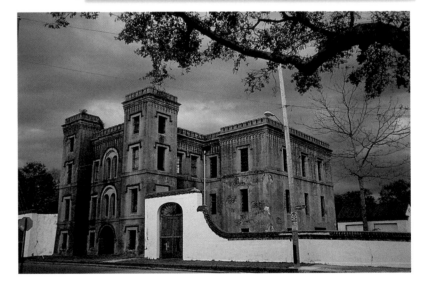

Top: *View of the jail and Marine Hospital, 1857*

Above: *The vacant jail broods under a stormy sky.*

Opposite: *For more than a century, these dim corridors and stout-walled cells housed inmates ranging from pirates to Union soldiers.*

ORIGIN
- 1796-1802

CONDITION
- Jail boarded up from 1938 to present; roof, foundation, and the majority of walls are stable; floor system continues to deteriorate.

PROJECT SCOPE
- Stabilization, master planning, and long-term strategic planning to create training facility for artisans nationwide

52

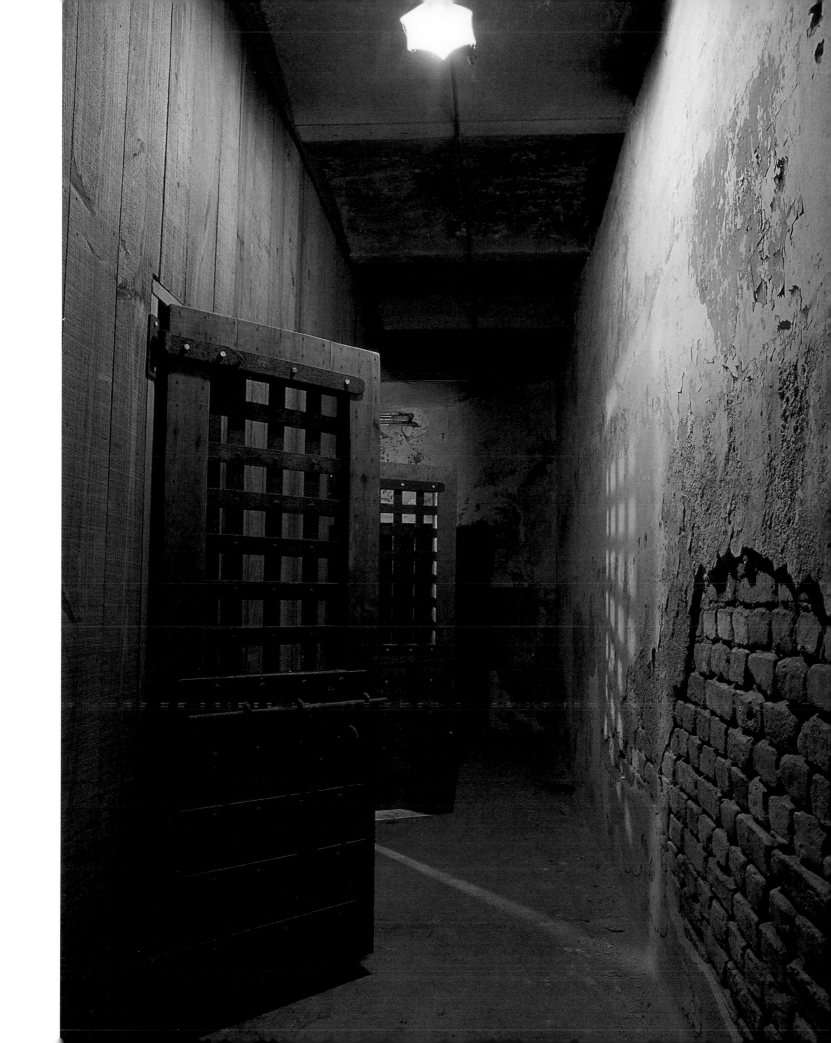

54

Above: *Rambling and unostentatious, Val-Kill Cottage gave Eleanor Roosevelt what she had never had: a home of her own.*

Opposite: *Mrs. Roosevelt at Val-Kill, with her mother's portrait in the background, 1958*

Val-Kill Cottage

Hyde Park, New York

It's easy to think that Eleanor Roosevelt didn't have a self, that she was so thoroughly devoted to the needs and interests of others that she let herself slip through her own fingers. In fact, while she took pains to shield her feelings from public view, there was a real personality—a real person—behind the icon that we have made of her, and Val-Kill is where it is most clearly revealed.

The New York house into which she moved as a bride had been bought and furnished by her mother-in-law, and the mansion at Hyde Park was the redoubtable Sara Roosevelt's domain as well. The White House, where she lived longer than any other First Lady, was a beehive of visitors and reporters, more like a hotel than a home. But Val-Kill was hers. When she moved in in 1937, she had a home of her own for the first time. She was 52 years old.

For the rest of her life, especially after her husband died, Val-Kill was Mrs. Roosevelt's refuge and refueling-place. She was always on the go— her Secret Service code name was "Rover"—but she recognized the value of roots. "We need to feel there is one place to which we can go back," she said. Even here she was rarely alone, entertaining a steady stream of guests ranging from schoolchildren to prime ministers, giving them all simple meals, stimulating conversation, the crackle and warmth of a lively mind and an enormous heart.

Today, Val-Kill looks exactly like what it was: the home of someone who was much more interested in life than interior decoration. The rooms are cluttered with knicknacks and mismatched chairs and dime-store drinking glasses. Framed photographs cover walls and tabletops. On her desk is a nameplate she displayed proudly even though the boy who made it misspelled her name: "ELANOR," it says.

ORIGIN
• 1925-1962

CONDITION
• Damage to infrastructure; ongoing need for maintenance of cottage, furnishings, books, and decorative items

PROJECT SCOPE
• Assure ongoing maintenance of the rooms, effects, and vistas of Val-Kill; acquire dispersed historical objects; document and preserve historical collection

Mrs. Roosevelt loved the simply
furnished sleeping porch of her home
at Val-Kill and always slept here until
the first snowfall of the year.

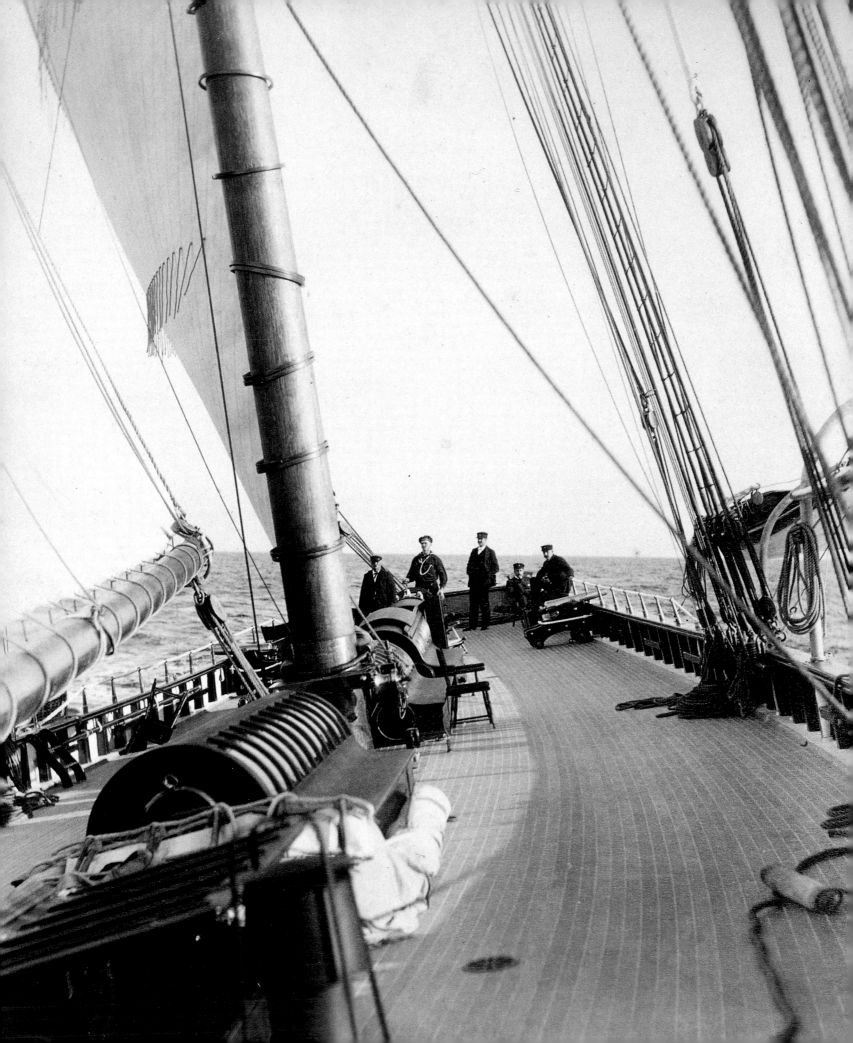

Coney Island Reverie

Francine Prose

IT WAS DECEMBER, ALMOST NEW YEAR'S, AND THE UNSTOPPABLE passage of time had most likely crossed everyone's mind even before our host looked around the table and asked his guests: Which would we choose, if it were possible to travel backward and forward in time? A voyage to the future, or a journey into the past? I knew at once which route I would take, and as my fellow time-travelers mapped their distant (the age of the Pharaohs, Classical Athens) or historic (the Wright brothers' first flight at Kitty Hawk, the storming of the Bastille) destinations, I opted for something temporally and physically closer to home.

I wanted, as I have wanted for years, to revisit Steeplechase, Coney Island—Steeplechase, the Funny Place, not merely rebuilt or restored but precisely the way it was when I went there as a child, at the end of August, every August, all through the late 1950s, as a reward for having survived those broiling, interminable summers that seemed so much hotter and longer than any summer before or since.

We were brought there on yellow buses from the still functioning but soon-to-be-abandoned public elementary school that doubled, during vacation, as a summer day camp. The Dickensian red brick structure smelled of chalk dust, sour milk, and the boredom and disaffection of generations of city kids who had ascended its dark creepy stairwells to haunt the old-fashioned classrooms, watching the seconds tick by, carving pleas for rescue and declarations of love in the wooden desks. All summer, we campers had amused and tormented each other in the schoolyard and, on rainy days, in the gym, we were watched over by our counselors—mostly teachers-in-training—who regarded us morosely, trying not to think that they were looking at their future.

But the gloomiest student teacher and the weepiest camper seemed almost sparkly on that day—the much discussed and anticipated high point of the summer—when the yellow buses discharged us into another world, a world presided over by the comic, demonic (all grinning mouth and teeth, those middle-parted wings of hair and

The schooner yacht Coronet *has probably known more of the world's waters and weathers than any other vessel. Now undergoing restoration, she is the oldest registered vessel in the United States.*

science-fiction ears) cartoon portrait of the park's founder, George C. Tilyou.

A successful Brooklyn realtor who had a sort of business inspiration/conversion experience during his honeymoon at the 1893 World's Columbian Exposition in Chicago, Tilyou gradually constructed and enclosed the 15-acre Steeplechase around the turn of the century, and rebuilt it in 1908 after it was destroyed by fire. He continued to add grander and more ambitious structures, more elaborate rides, until he died in 1914, leaving the park to his son Frank who, like the times in which he lived, was drawn to the wilder, jazzier entertainments. With its planned and spontaneous theater, its bathing beauty contests and talent shows, its jugglers, its circus, and its gargantuan swimming pool, the pleasure park by the sea survived two World Wars and the Great Depression.

But it succumbed in the early 1960s to the middle-class white fears about the fact that Coney Island was becoming increasingly African-American and Puerto Rican. This was not, as it happened, coincidence, but a result of the city's encouraging the building of low-cost, high-rise housing projects in Coney Island—and the moving of certain segments of its citizens as far as possible from the center of the city. This changing population was reflected in the complexion of Steeplechase's visitors, a factor which even further decreased the numbers of white pleasure seekers.

On the 20th of September, 1964, Steeplechase marked its own death in an appropriately carnival fashion: a ceremony that included the singing of "Auld Lang Syne" and ended with the dramatic snuffing, section by section, of the park's ornate and extravagant fairy lights.

But in the late 1950s, we happy day campers had no idea that we were hearing Steeplechase's swan song, observing its final years, no more than we knew exactly how long it had existed before we came along. Who cared? That's not what we were there for. We did, however, know (or sense) that Steeplechase was old, many times older than we were, and without consciously realizing it, we must have intuited how much the park's age (its antiquity, in our terms) contributed to its overall effect— to its mystery, its enchantment, its terrors, and its pleasures, and to our feeling of having been transported out of our lives and into another, brighter world, directly through the looking glass from that gloomy Victorian school.

The architecture thrilled us. The Pavilion of Fun, built in 1908, was as huge and grand as the ballroom of a royal palace, so glittery that by comparison the Hall of Mirrors in Versailles was, when I first saw it, a bit of a disappointment. As large as a modern convention center, a football field enclosed in wood and steel and glass, capacious enough to house several dozen major rides and the crowds that had

come to enjoy them, the space was vast and barnlike, detailed and ornate, tricked out in gilt and enamel, carnival colors, cotton-candy pinks and blues, merry-go-round reds and yellows, and all against the dull, beautiful green of 1930s and '40s kitchens. The rides were mostly wooden, the curved slalom-like slide polished by decades of human bottoms, the whirling discs of the Human Pool Table, a rapidly spinning surface on which people, shrieking with laughter, tried to stand and kept falling. There is a painting by Reginald Marsh of one such ride that captures the blur of motion, the off-balance, high-speed chaos of flailing legs, the hysteria and the embarrassment of being thrown against random strangers' bodies.

Much of it was terrifying. More so than the excitement and the anticipation, I remember the shivers and panicky flutterings in my stomach as we approached the outer gates. Everything was vaguely alarming and promised both pleasure and danger: the crowds; the bustle; the clamor; the noisy periodic arrivals of the clattering horses on tracks; the gravity-drawn race horses that circled the park, neck and neck, and gave Steeplechase its name. Our camp forbade us to ride the horses because there had been accidents in which (or so the dark, whispered rumors went) children had been killed.

Also officially off-limits was the Parachute Jump, a prohibition I was grateful for, since I was a timid child and would otherwise have needed to find my own excuse to stay safely on the ground, far beneath that dizzying height from which I was sure I would plummet—instead of float—down.

But by far the most alarming so-called attraction was the Insanitarium and Blowhole Theater, specifically, the gust of air that blew up from under the floor as you exited the Steeplechase course: the clownish wind that lifted women's skirts, showing their underwear, the sort of public humiliation (people could watch from the sidelines) that was, and is, a preadolescent's worst nightmare. Even this ritual was already antique, the hilarity of an earlier time, a cultural leftover from the era before the age of Eisenhower and Ozzie and Harriet had widened and firmed up the line between "vulgarity" and family entertainment.

Part of the terror, it seems to me now, had to do with the fact that the park was so old, and therefore strange, that its existence (and its architecture) proved, beyond doubt, that idea so frightening to children: the possibility that the world existed before they were born and will continue after they die. This too is a form of time travel—a journey to the world without you in it, before you came aboard. Of course, it wasn't something I consciously thought about as I made my slow, hesitant, awestruck way through the Pavilion of Fun. It was a more subliminal feeling, a particular variation on the encounter with the past that takes

place whenever we visit a historic place.

The importance and the almost otherworldly peculiarity of the (somatic, cerebral, spiritual) experience of encountering an old site, of having contact with history and with the world as it used to be, is one reason we should care profoundly and passionately about preserving our landmarks. There is simply no way of recreating or reproducing—there is nothing to compare with—the light, the detail, the interior space of the Pavilion of Fun. And no one now—not my children, or their children—will ever know what it was like.

Like Steeplechase, the ten treasures pictured in the following photographs represent the physical manifestations of our most basic and transcendent human passions for fantasy and diversion. Together, these sites and collections span much of the spectrum of American entertainment, from high art to popular culture, from Cà d'Zan, in Sarasota, John Ringling's faux extravaganza of a Venetian Doge's palace to the Mount, Edith Wharton's elegant and aristocratic Lenox, Massachusetts, home; from the Vista House, overlooking the dramatic depths of Oregon's Columbia River Gorge to the luxury yacht, the *Coronet*, skimming on the water from Newport to Cape Horn; archives documenting and celebrating lives as disparate as Babe Ruth's and Louis Armstrong's; a foundation dedicated to the preservation of the earliest films. These places tell us something about ourselves and about what we as a nation have wanted, and continue to want, when business hours are over. They reveal what results when a culture still partly ruled by the Puritan work ethic relaxes and lets loose, and (insofar as it is able) turns its attention to pleasure and fun.

How much of our history these treasures embody, and how precisely they illustrate the aspirations and self-conceptions of our widely divergent social and economic classes! The robber-baron industrialists who commissioned the schooner *Coronet* in order to possess the largest and most innovative grand yacht in the world; the refined New York aristocracy that nurtured and formed Edith Wharton; the middle- and working-class millions that flocked to Asbury Park, and the fans (rich and poor, white and African American) of Babe Ruth and Louis Armstrong, two prodigiously gifted men who represented dissimilar, though not mutually exclusive, ideas about what to do with your spare time.

But perhaps what's most striking, as one looks through these photos, is the degree to which nearly all of them express fantasies of one sort or another, fantasies born of exuberance and of a sweet American hopefulness about the ways in which diversions (and the structures that supported them) could enrich the lives of the privileged and the masses. They speak to us of a time when people still believed that the

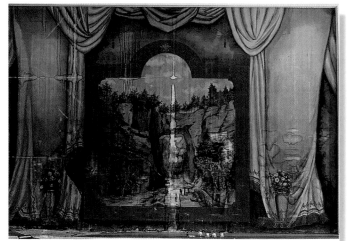

Hyde Park Opera House Grand Drape, Hyde Park, Vermont

Hand Painted Theater Curtains of Vermont

ORIGIN • circa 1880-1940

CONDITION • Tears and damage caused by use threaten overall stability

PROJECT SCOPE • Statewide project to survey and stabilize painted stage curtains

world was full of wonders, that it was possible to speak of the wonders of the world.

These endangered architectural and historical treasures give concrete form to our most ethereal dreams of mission and purpose. Vista House still expresses the aims of the architects who built it in 1916 on the summit of Crown Point—to celebrate the beauty of God's handiwork and the daring ambition of their own, that marvel of engineering, the Columbia River Highway. According to Samuel Lancaster, the assistant county engineer in charge of the highway project, the domed observatory perched upon the hill—a structure strongly reminiscent of the ancient, squat brick Slavic churches one sees on the hilltops of south central Europe—was a place for motorists to pause and contemplate the divine, an eagle's nest from which "the view both up and down the Columbia could be viewed in silent communion with the infinite."

Other sites embody fantasies of a lost, aristocratic Europe, of a magnificence that our young country and new-money aristocrats could only dimly imagine, and hope to re-create. Not unlike John Deere's Vizcaya on the opposite coast of Florida, Cà d'Zan was John and Mable Ringling's 1920s fancy of a Venetian palace in which costumed doges and their ladies danced at masked carnival balls, surrounded by murals and ceilings on which their painted counterparts reveled: an opulent, over-the-top chateau that, despite itself, reflected some of the hucksterism and the delirious excesses of the circus, "the greatest show on earth," which Ringling—along with Barnum and Bailey—had launched on its peripatetic circuit.

Similarly, the interior of Pittsfield's Colonial Theatre, where star attractions included Rachmaninoff and Sarah Bernhardt, recalls the lavish opera houses of Paris and Vienna, scaled down and restrained for its new incarnation in the provinces of the new world, modified without sacrificing the old-country conviction that serious entertainment called for, and deserved, an appropriate and proper level of pomp and circumstance. Along with so many places of public entertainment, the Colonial Theatre—like the Conservatory of Flowers in San Francisco's Golden Gate Park and like the countless public libraries that still rise, massive monuments to culture, from the humblest small-town squares—attests to the democratic belief in the power and possibility of education and self-improvement.

The idea, of course, was that popular entertainment should not only delight, but also instruct, and that architecture should reflect the gravity and the importance of this faith in human progress and perfectibility. San Francisco citizens and visitors to the city could enjoy the fanciful dome and the pleasingly curved glass walls of the Conservatory of Flowers, even while applying themselves to the challenging task of identifying the different breeds and species of plants. Among the first films shown in the palatial theaters of the 1920s and '30s—the quasi-Moorish Alhambras in which Scheherazade spoke, like the Wizard of Oz, from behind the screen—were improving documentaries on, say, Marian Anderson's concert, as well as anthropological footage designed to take the audience beyond even those high mosque-like ceilings, those swirls and mirrors and tile.

Taliesin offers us another sort of fantasy: the vision of the individual artist, searching for and finding nothing less than a way to live in harmony with the natural order and our own inner sense of design and form, a way for structure and detail to harmonize in something that manages to be innovative and modern without sacrificing sheer beauty. And for those of us—and I am one—who believe that Edith Wharton was one of our greatest American writers, the Mount is the obvious mecca for the literary pilgrim hoping to find whatever we hope to find in the houses where heroes and geniuses lived.

Edith Wharton had a gift for making complicated things clear. In this case the house she left—the Mount, where she wrote *The House of Mirth*, and into which she sank her profits from the book as she worked to remake her surroundings according to an esthetic formed by her intimate and extensive knowledge of Italian villas and gardens—clearly and plainly illustrates the great importance of place. She worked in its rooms and its garden, and always regretted its loss after it vanished into the sordid pits of her divorce settlement with her husband, Teddy. It was the place she considered home, and from which she was exiled.

Even the least superstitious of us believes that something of Edith Wharton remains in that house on which she lavished so much love and time. Preserving the house seems as simple as good manners, a gesture of gratitude and respect to one of our national treasures. But ultimately, as with all landmark preservation, we are not saving a place for its original owners, but for its heirs—that is, for us. We need the Mount, in its utter uniqueness and irreplaceability. There is nothing else like it, and if we lose the Mount, its place will not, cannot, be taken by other walls at which Edith Wharton stared as she wrote *The House of Mirth* and sealed poor Lily Bart's fate.

In 1965 Marie Tilyou—George's only daughter, his last surviving heir, and the

last in the line of succession—sold Steeplechase to Fred C. Trump, a real estate developer, for $2.3 million. The park had closed the previous year, after a long slow dying hastened by the fact that the city planners—never fans of the spontaneous, the vernacular, and the racially mixed—had essentially put the ailing Coney Island under a do-not-resuscitate order.

Meanwhile, there was money to be made building low-income high-rises at the far edge of the borough. And if the neighborhood improved? Sea-front property was sea-front property. Trump was interested in the acreage, the investment, and not, obviously, in reviving a dead, decrepit, money-sucking amusement park. And so he encouraged the Tilyous to sell off whatever was left of the rides.

By the following year, it was rumored that the Pavilion of Fun was in immediate "danger" of being designated a historical landmark—which would, of course, have made the land worthless for development purposes. In September 1966 Trump leveled the pavilion to the ground, quickly, before the notoriously slow Landmarks Commission could act, though not fast enough to keep the Parachute Jump from being granted landmark status.

Which is why the Parachute Jump is still there, a solitary relic standing guard on the edge of the sea, alone and extremely beautiful, with its surprisingly lacy and ethereal tracery, like the ornaments on a gothic cathedral, like Gaudí's church in Barcelona. Half in ruins, it is still scary, though for the opposite reason. What's frightening now, more than 40 years later, is that this time you cannot imagine plummeting or floating down from its high canopy.

The Parachute Jump stands on the edge, nearest the water, of the vacant lot that is what has become of Steeplechase. The lot is grassy and shaggily mowed, like an eastern European park, and thus a perfect setting for the Soviet-style high-rise projects. The lot is surrounded by a well-kept, no-nonsense cyclone fence on which there is a official placard that says, simply: Steeplechase Park.

We all believe in progress, and some of us may even believe that progress is the most important thing: Ring out the old, bring in the new, what's past is past, let everything make way for the next thing, whatever is on the horizon. Others may take a more spiritual view: The first shall be the last, what was high is brought low, ashes to ashes, dust to dust.

Neither view, I have to say, can console or convince me. Nothing can persuade me that the Pavilion of Fun, a huge magical fantasy wonderland, a gorgeous architectural folly, carnival-colored, spinning with old-fashioned rides and with people—old and young, men and women, black and white—having a wonderful time isn't better than a vacant lot and a cyclone fence.

COLONIAL THEATRE

Like its counterparts everywhere, Pittsfield's Park Square Historic District is an open-air gallery of the vagaries and delights of American architecture. Dominating one side of the park is the Berkshire Athenaeum, a muscular Gothic pile that flaunts bold patterns in its stone walls and slate roof. The county courthouse next door is more subdued, with pale marble and a pediment lending a suitably dignified air. Churches with crenelated towers punctuate rows of storefronts with Italianate cornices, and there are houses in every style from Greek Revival to God-knows-what.

In the middle of this wonderful architectural muddle, just around the corner from the park, sits the Colonial Theatre. There was a time when almost every community had a showplace like this, a place where you could walk in from the street and be transported to a world far removed from the mundane rituals of everyday life. Most of them—magical venues with names like Grand or Tivoli or Majestic—are long gone, but the Colonial is still here.

Before the First World War, the Colonial was a regular stop for big-name entertainers: Sergei Rachmaninoff performed here, along with John Philip Sousa, Sarah Bernhardt, and the Ziegfeld Follies. In 1915 a new owner brought movies to the Colonial, and stage shows gave way to the looming, luminous visages of Mary Pickford and Bugs Bunny. The screen went dark for the last time in the late 1950s. Another new owner installed his paint and wallpaper store in the building, but he was careful to preserve most of the theatre's interior features intact. Today, above the store's dropped ceiling, out of sight of salesclerks and customers, chubby cherubs still flutter among swags of plaster fruit, while graceful figures in painted depictions of "Art" and "Music" still stand guard over the stage.

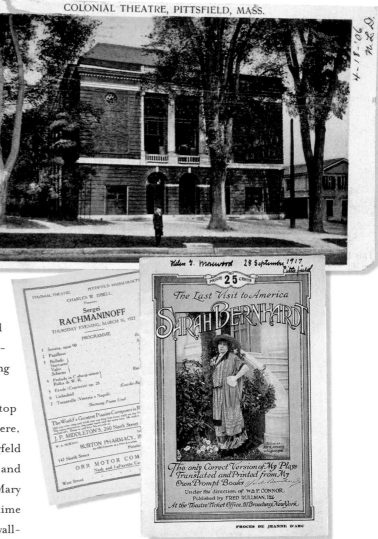

Clockwise from top: *Postcard view of the Colonial, 1906; script cover for Sarah Bernhardt's performance in Jeanne d'Arc, 1917; program insert for a performance by Sergei Rachmaninoff, 1922*

Opposite: *For almost half a century, the faded grandeur of the Colonial's interior has been hidden above the ceiling of a store.*

ORIGIN
• 1903

CONDITION
• Historic facade altered with addition of 1937 storefront, lobby, and marquee; substantial interior water damage; damage to interior artistry

PROJECT SCOPE
• Restoration into a vibrant year-round multi-use performing arts facility; restoration of facade, orchestra pit, theatre seating, and stage

66

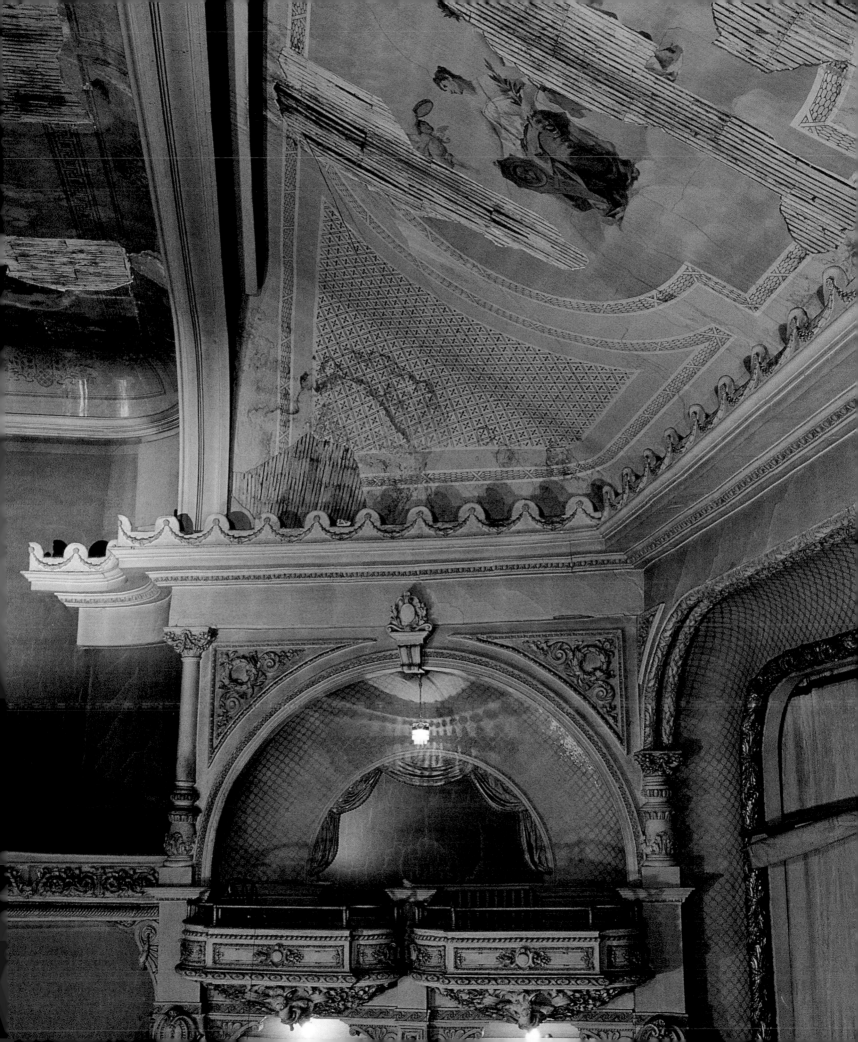

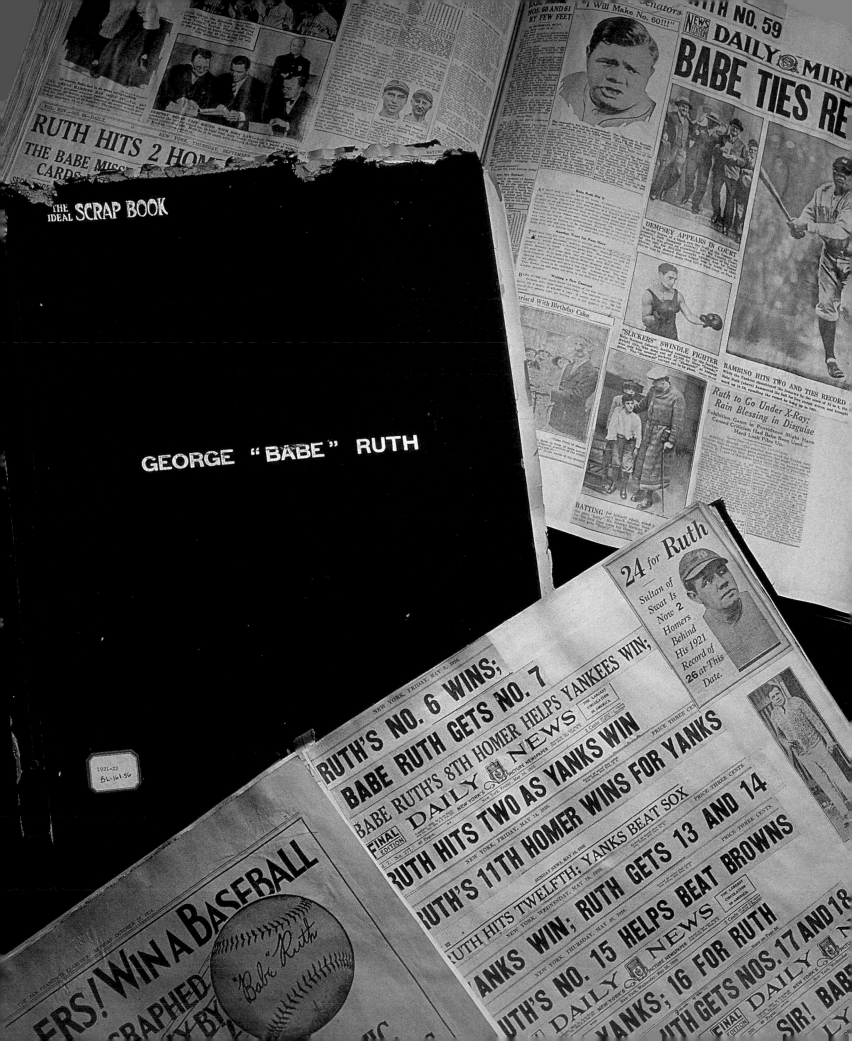

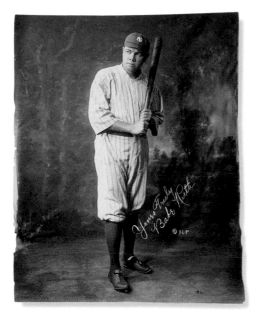

Above: *Studio photo soon after Ruth was sold to the Yankees in 1920*

Opposite: *Headlines in the scrapbooks kept by Ruth's agent trace the meteoric rise to stardom of the man they called "the Babe."*

Below: *Baseball autographed by Ruth in 1945*

He was a short-legged man with a genial nature, a fondness for good times, and a tendency to accumulate too much flesh on his bones. He didn't exactly look like an athletic idol, but George Herman Ruth consistently ranks at the top of sportswriters' lists of the most outstanding male athletes of the 20th century.

In 1920, after six years as a pitcher for the Boston Red Sox, he was sold (in one of the monumental blunders of baseball history) to the New York Yankees. In his 15 years with the Yankees, Ruth became a legend. More than any other player, he restored the faith that had been lost after the 1919 Black Sox scandal. The ticket sales he generated paid for Yankee Stadium. Fans gave him a string of affectionate nicknames—"the Bambino," "the Sultan of Swat," "the Babe"—and thrilled to his exploits: He caroused all night in a speakeasy, then went four-for-four in the next day's game. He pointed to a spot in the stands and smacked a home run right to it. He promised to hit a homer for a sick kid and wound up hitting two.

Behind all the hype there was stellar talent. Ruth was the American League home-run champion in all but two years of the 1920s. In 1927 he set a single-season record of 60 homers that stayed intact for 34 years, and his career total of 714 home runs wasn't broken until 1974.

It's all chronicled in these scrapbooks compiled by Ruth's agent Christy Walsh. There's a marvelous immediacy in these yellowing pages. Poring over them, you have the sense of being present as history is made. It's a summer afternoon, and you'd be happy to spend the rest of your life here, hearing the crack of that bat and watching that pudgy demigod trot around the bases.

69

ORIGIN	CONDITION	PROJECT SCOPE
• 1921–1935	• Damage from use, age, and deterioration of original materials	• De-acidify items on support pages, encapsulate, and reconstruct to original form, and make material available in microfilm

ASBURY PARK CONVENTION HALL

When talk of building a convention hall first surfaced here, some people didn't like the idea. They worried that construction and maintenance costs would impose a crippling financial burden on the town. They predicted that the hall would be a white elephant. After years of argument, the boosters won (by then it was 1926, and it looked as if the good times would last forever), and the city fathers hired the New York architectural firm of Warren and Wetmore to design the building.

Plagued by cost overruns, it was completed just in time for the stock market crash. During the first few seasons, most of the conventions and performances booked into the hall were flops. The city teetered on the brink of bankruptcy. In September 1934 hordes of sightseers flocked to the hall when the liner *Morro Castle* caught fire off the coast and eventually drifted aground (with the bodies of many of the 134 victims still aboard) at Asbury Park—"so near Convention Pier," according to one account, "that a gangway could have been placed between the two." Once the ghoulish hoopla died away the hall settled back into obscurity, with only an occasional sports event, beauty pageant, or Big Band performance to liven things up.

Then, in the 1970s, the hall became one of the East's premier rock-and-roll venues. Janis Joplin sang here and Linda Ronstadt and many others, including, of course, Bruce Springsteen, who put together his E Street Band right here in Asbury Park. You have to wonder which has given the hall a worse shaking: 70 years of pounding surf, or 25 years of cheers and ear-splitting guitar chords?

You have to wonder, too, what those boosters from the 1920s would think of a typical rock-concert audience. Would they be appalled at what's become of their Convention Hall? Maybe not. "This place put the town on the map," they'd probably say. "Smartest thing we ever did."

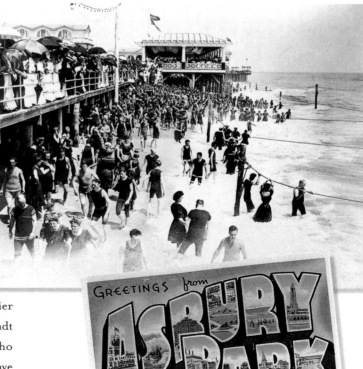

ORIGIN	CONDITION	PROJECT SCOPE
• 1928-1929	• In need of structural repairs and restoration	• Restore and preserve the Convention Hall along with the casino as entertainment venues

Top: *Bathers and onlookers, early 1900s*
Above: *Local landmarks adorn a postcard from the 1930s.*
Opposite: *At the entrance to the Convention Hall, winged seahorses frolic in the waves and a cast-stone ship rides above it all.*

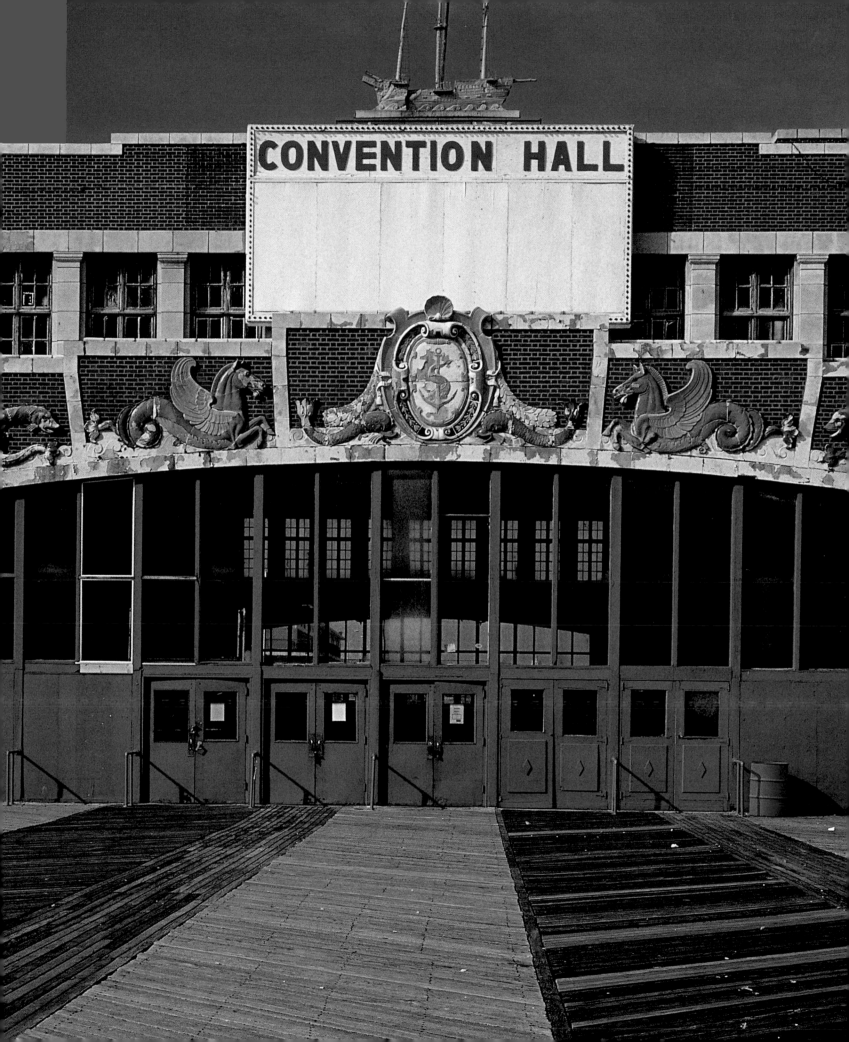

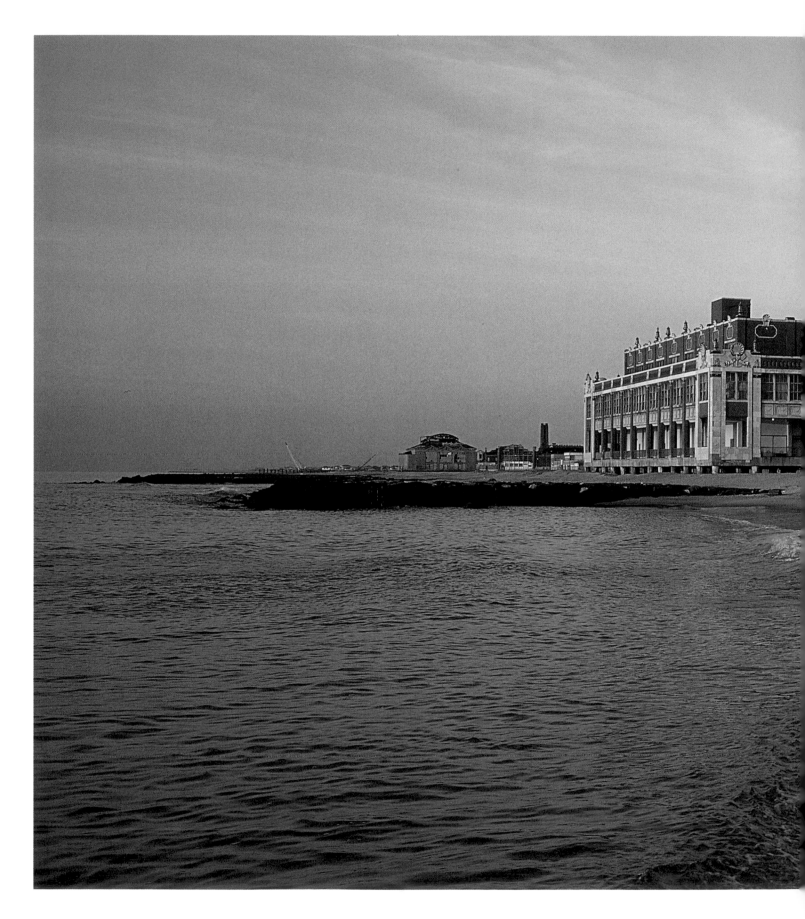

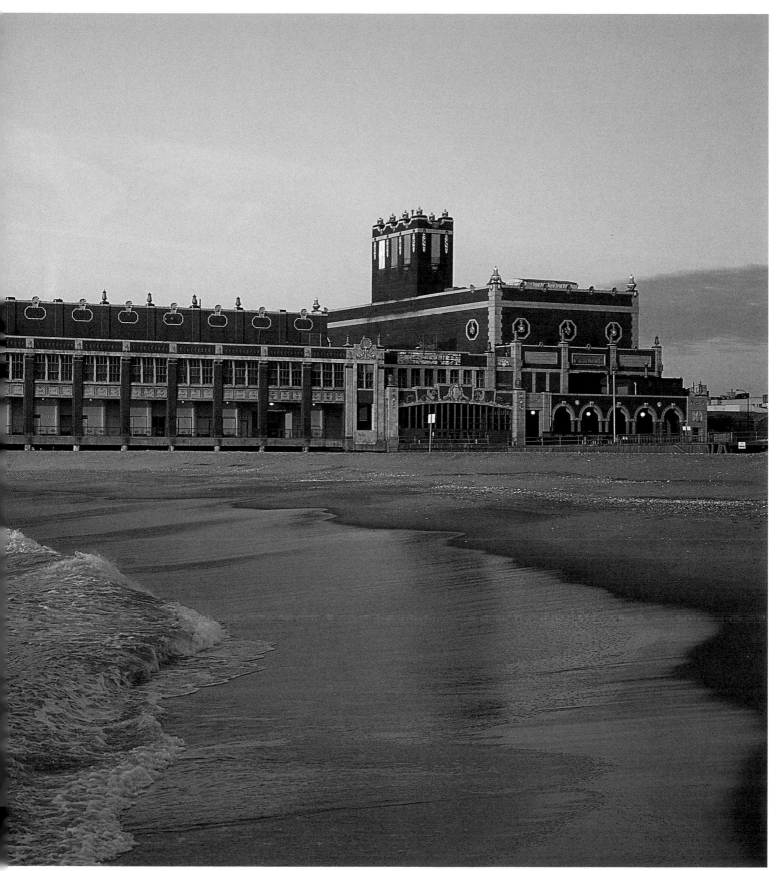

Having survived seven decades of beauty pageants, boxing matches, Big Band dances, and rock concerts, the Convention Hall greets another dawn.

AMERICAN FILM ARCHIVES

Think "film treasures" and your mind immediately fills with images retained from hours spent in movie palaces and shopping-mall multiplexes: A lone lawman faces down a gang of stubble-jawed outlaws on a dusty Western street. Platoons of tap-dancers *clickety-clack* across a glossy stage as big as a football field. Alien invaders wage war on the peaceful inhabitants of a galaxy far, far away.

After decades of neglect, most of the legacy of the big Hollywood studios is now being preserved—but America's celluloid heritage is much more than mainstream extravaganzas loaded with stars and special effects. Film archives all over the country house an amazing collection of "orphan films" for which there is no commercial market, no guardian angel to ensure they won't crumble into dust.

These little-known, out-of-the-way collections scattered across the country offer a wide-ranging—and staggeringly important—view of life in America that is largely unavailable anywhere else. There's a 1930s "community portrait" of Elkins, West Virginia, in which members of local congregations, stiff-collared and formidably hatted, file out of their churches to pose proudly for the camera. There's a hammy melodrama that was the first fiction feature shot in Alaska, and reconstructed newsreel footage of Marian Anderson's 1939 concert at the Lincoln Memorial. There are vivid newsreel outtakes, avant-garde experiments in color and motion, and a home movie showing Groucho Marx sending his children off to school. Even the briefest snippet can be a cinematic landmark: A one-minute scene of blacksmiths pounding away at an anvil turns out to be America's first commercially exhibited film, dating from 1893. Orphan films, all of them.

If we lost this glimpse into the mind and soul of a nation of filmmakers, we'd lose a major piece of America's memory of itself—and never even know what we'd lost.

Fade to black. The End.

Marian Anderson's concert at the Lincoln Memorial, 1939

The Chechahcos, 1924, the first feature film shot in Alaska

Georgia Shouters, 1930, by anthropologist Melville J. Herskovits

The Penalty, 1920, starring Lon Chaney

Opposite:

The 1939 amateur documentary Cologne: From the Diary of Ray and Esther *shows life in a Minnesota town.*

74

ORIGIN
- 1893-1986

CONDITION
- Various conditions and levels of preservation need

PROJECT SCOPE
- Preservation of publicly archived American films not preserved by commercial interests; make viewing copies available on site; release DVD set of orphan films

Cà d'Zan

SARASOTA, FLORIDA

When John and Mable Ringling (yes, he was *that* Ringling, as in "Ringling Brothers and Barnum & Bailey" and "The Greatest Show on Earth") decided to build a new house in Sarasota, they told their architect that they didn't want much, just "a little bit of a place." What they got was a mansion that Ringling's nephew later described as "riotously, exuberantly, gorgeously fantastic."

That thicket of adverbs barely begins to do the house justice.

Inspired by the Doge's Palace in Venice, Cà d'Zan ("House of John" in Venetian dialect) is exactly what the Doge would have built for himself—if he had been an American in the 1920s, a millionaire, enamored of Florida, and the owner of a circus. Much of the design can be credited to Mable, who sailed into the architect's office almost every day with a satchel full of sketches. She also supervised the planting of the formal gardens, toting a pistol to ward off snakes and alligators. John's role consisted primarily of vetoing his wife's more outlandish ideas (she originally wanted to top the house with a replica of the tower at the old Madison Square Garden) and paying the bills, which by his own reckoning totaled more than $1.5 million.

The palace's heyday was brief (Mable died in 1929, the year the stock market crashed) but memorable. At the parties John and Mable loved to throw, guests ogled John's extensive art collection, listened to concerts on the 1,200-pipe Aeolian organ in the Great Hall, and danced on the vast marble terrace overlooking the bay, where the Ringlings kept their yacht and a genuine Venetian gondola. In a sense, the party is still going on. If you know where to look, you can find John and Mable, surrounded by parrots in flight and dogs in frolic, beaming down from the playroom ceiling. They stand arm in arm, smiling broadly, dressed in carnival costume. You can tell they're having a marvelous time.

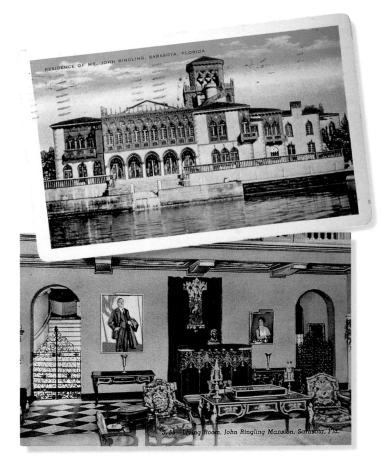

Above: Postcard views of the exterior (top) and the entrance hall
Left: John and Mable Ringling in carnival costume on the playroom ceiling
Opposite: In the Great Hall, seen here in the 1950s, rare tapestries vie for attention with a chandelier that once hung in New York's Waldorf-Astoria Hotel.

ORIGIN	CONDITION	PROJECT SCOPE
• 1924-1926	• Damage to interior, outdated mechanical systems, and failure of exterior materials	• Cleaning, stabilization, and conservation of oil-on-canvas ceiling paintings

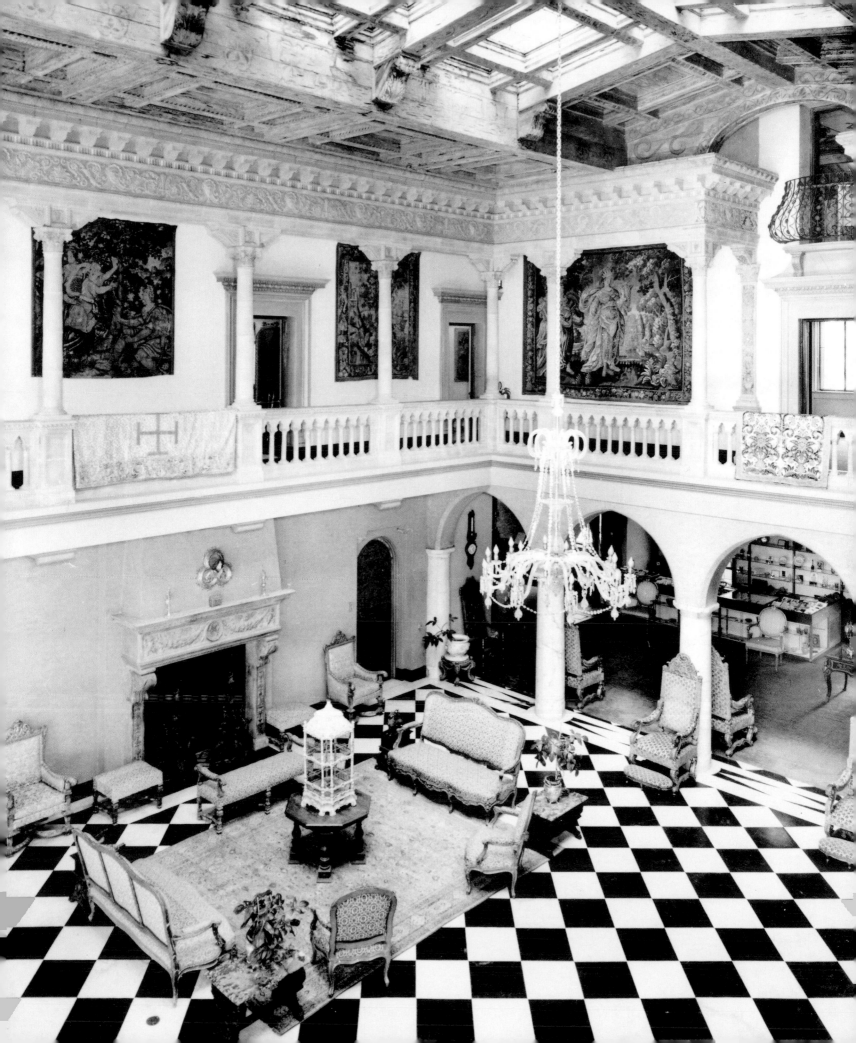

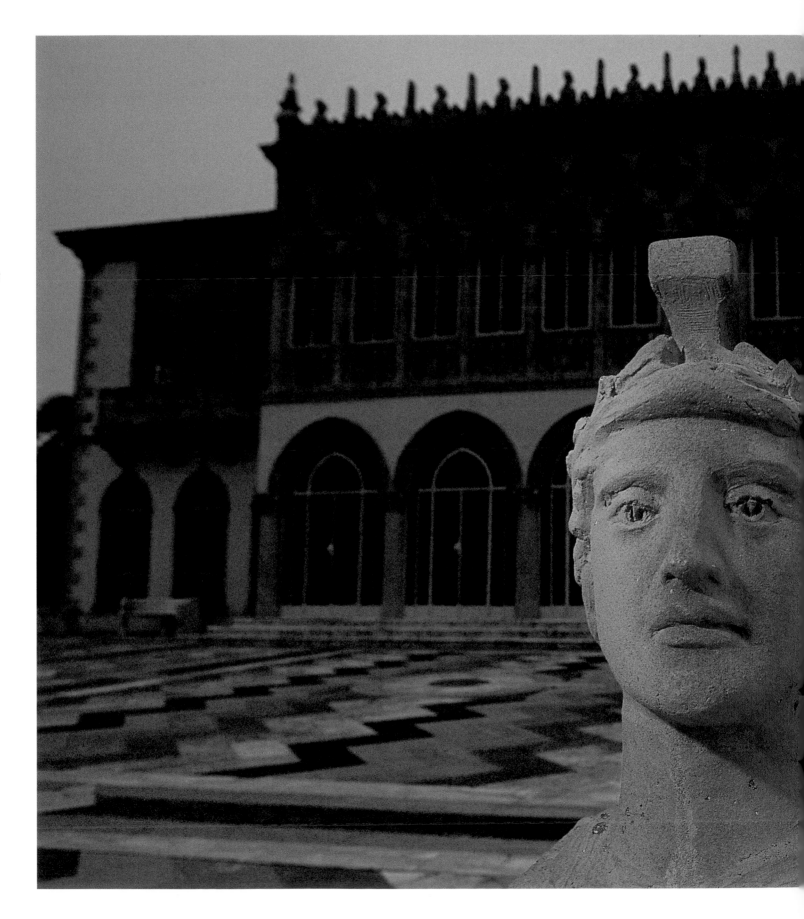

Backed by a riot of Venetian Gothic
architectural detail, a statue on
Cà d'Zan's terrace gazes impassively
over Sarasota Bay.

Conservatory of Flowers

San Francisco, California

Sheltered by an elegant canopy of glass and iron lace, shielded from the chill of outdoor breezes, you stroll through a bower of blossoms, an indoor Arden. The air is perfumed. Sound is muffled in greenery. If you're wearing a hat, you tip it to passing ladies. If you're carrying a fan, you wave it languidly, barely stirring the steamy air.

That's it. That's what a conservatory is all about—that and the protection of rare and endangered plant species in a carefully controlled environment that fosters both scientific study and public appreciation of the wonders of the botanical world.

San Francisco's Conservatory of Flowers has been playing the dual role of scientific laboratory and mecca for Sunday-afternoon strollers since 1878. This rambling, airy, high-domed confection of glass and wood (just try to look at it without thinking "wedding cake") is the oldest building in Golden Gate Park and the oldest facility of its type in the United States.

Many of the conservatory's ten thousand specimens come from the rain forests of Central and South America, where the onrush of development has placed their survival in jeopardy. The collection includes more than 700 of the 1,000 known species of high-altitude orchids. Rare carnivorous plants from Borneo are here. So is America's only example of the prehistoric *Zamia lindenii*.

These fragile plants are housed in a fragile building. Winter storms in 1995 weakened the structure and blew out thousands of panes of glass, making it difficult to maintain adequate climatic conditions inside. The doors have been locked for five years now. Today, banana leaves and palm fronds hang motionless in the warm air, dripping moisture onto bromeliads and orchids—but visitors can only peer in wistfully through the windows.

That's not what a conservatory is all about.

ORIGIN	CONDITION	PROJECT SCOPE
• 1878	• Damage from earthquakes, storms, fires, and excessive moisture; wood is rotting throughout, concrete floor is cracked, thousands of glass panes are missing.	• Restore America's oldest wood-and-glass conservatory, open it to the community, and protect the building's important plant collections

Top: Stereoscopic image, 1897

Above: *A pool holds lily pads and a reflection of the glass roof.*

Opposite: *The Conservatory's wood-and-glass structure blends functional form with fanciful Victorian embellishments.*

80

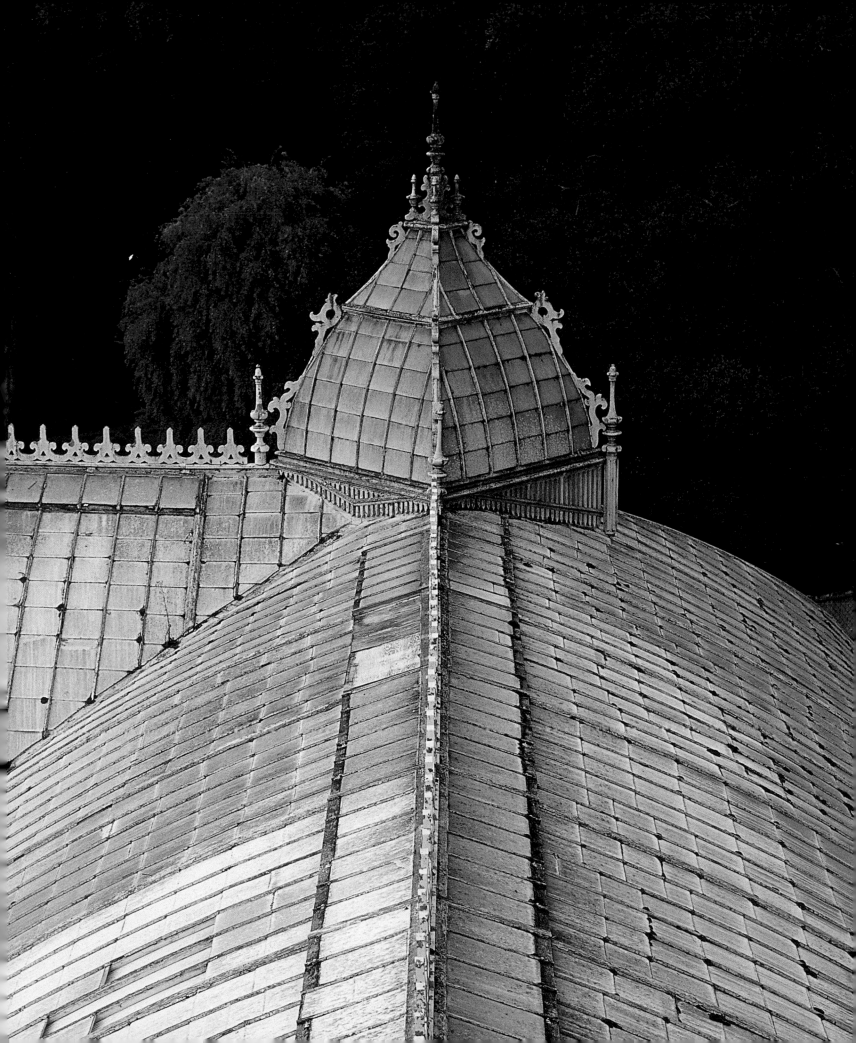

Schooner Yacht *Coronet*

NEWPORT, RHODE ISLAND

The sculptor Horatio Greenough wrote in 1843, "The mechanics of America have already outstripped the artists and have…entered the true track of beauty." He went on to say that the most beautiful things ever produced in America were the lighthouses and canals, the New England farmhouse, the clipper ship, and the trotting wagon. Greenough would have liked the *Coronet*.

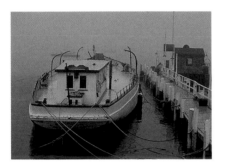

This sleek thing of sinew and bone was one of the most celebrated yachts of the 19th century. She was built for oil tycoon Rufus T. Bush, who decided in 1887 to test her mettle in a transatlantic race. He put up a 10,000-dollar purse, and firearms magnate Caldwell Colt accepted the challenge. The two yachts sailed from New York on March 12; two weeks later, *Coronet* reached the coast of Ireland 30 hours ahead of Colt's *Dauntless*. The *New York Times* devoted its entire front page to a breathless report of the feat.

The following year, Bush and some friends took *Coronet* on her first of many trips around the world—a voyage whose rigors were smoothed by the luxury of the yacht's appointments: She boasted six staterooms, along with a main saloon with a marble staircase, hand-carved mahogany paneling set with stained-glass windows, an open fireplace, and a piano.

In 1905 she was bought by the Kingdom, a nondenominational Christian organization, which used her to spread the Gospel and maintain mission stations all over the world. She continued to inspire intense devotion: In the midst of a howling gale off Cape Horn, one of her watch burst into the main cabin and shouted, "I love the *Coronet*! There is not another vessel like her on the water; she rides these waves like a bird!"

Top left: *Shorn of her masts,* Coronet *rests at dock*
Above: *The wood-paneled main saloon today (at top) and in the 1890s*

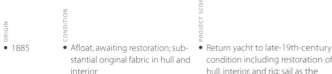

ORIGIN	CONDITION	PROJECT SCOPE
• 1885	• Afloat, awaiting restoration; substantial original fabric in hull and interior	• Return yacht to late-19th-century condition including restoration of hull, interior, and rig; sail as the International Yacht Restoration School flagship and a floating museum

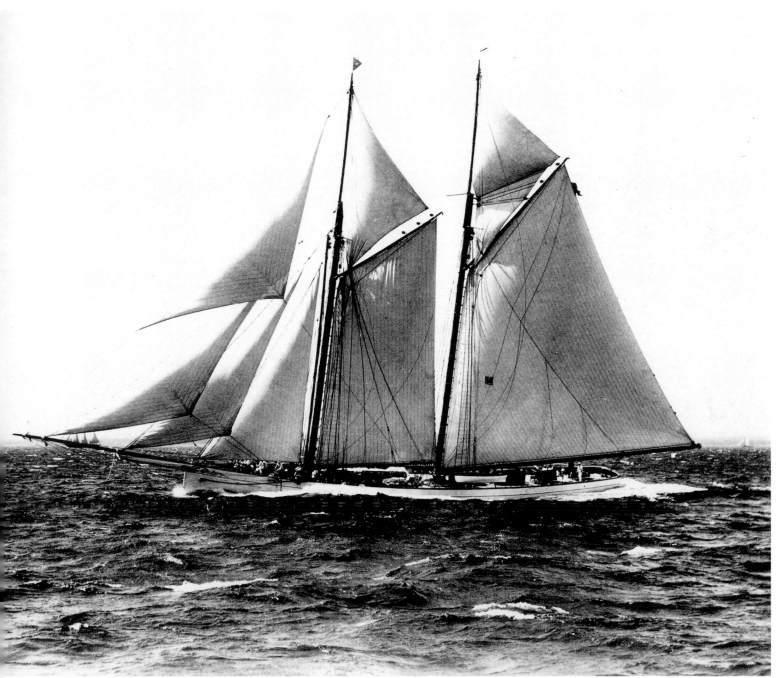

Under full sail, Coronet *rides the waves on Long Island Sound in 1893.*

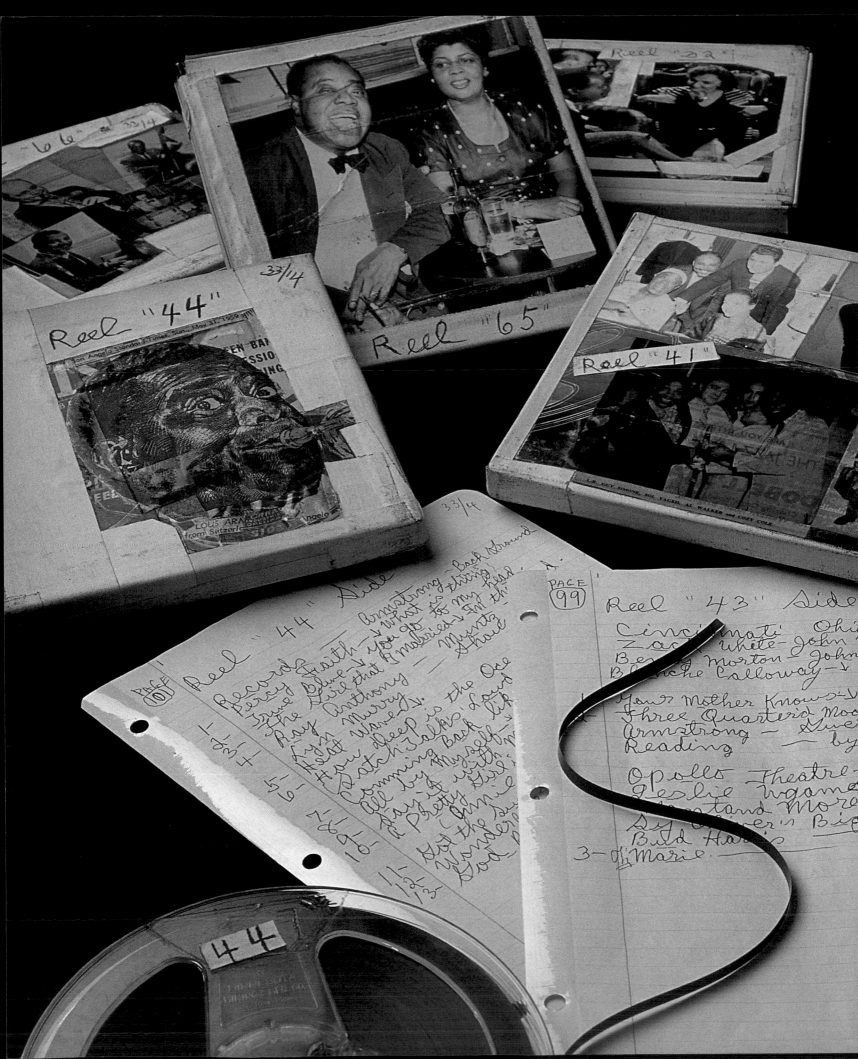

LOUIS ARMSTRONG ARCHIVES

Above: Satchmo in his collage-
decorated den, with his trumpet
and tape recorder, 1957

Opposite: Armstrong's flair for
collage is shown on the boxes that
held his vast collection of tapes.

The year after jazz legend Louis Armstrong and Lucille Wilson were married, the new Mrs. Armstrong bought a house in the Corona section of Queens, New York. The great Satchmo was skittish about settling down. On his first visit to the house, his wife recalled, "He left his bags in the cab and told the driver to wait for him. But to his surprise, he fell in love with the house."

It was here, as well as in countless hotels and backstage dressing rooms, that Armstrong spent hours with what one writer has called "his other favorite instrument": his tape recorder. From 1947 until his death in 1971, he recorded some 650 tapes, creating a unique audio diary of a zestful life. It's all here: raunchy jokes, rambling conversations with friends, family, and fellow performers, and snatches of music—including a remarkable duet in which a nostalgic Armstrong plays along with a record of "Tears" he made in 1923.

In addition to being a wizard with the trumpet and the tape recorder, Satchmo demonstrated a pretty deft hand with scissors and glue pot. He covered one wall of his den with an arrangement of pictures snipped from newspapers and magazines, but Lucille didn't like it and took it down. He worked on a smaller scale, too, creating scores of collages on the covers of his scrapbooks and the boxes that held his ever growing library of tapes.

Incorporating cut-out photographs, cocktail napkins, newspaper clippings, and other items, the collages are wonderfully lively and slightly surreal. One celebrates the career of Jackie Robinson. Another features a typewritten note anticipating "a couple of real precious dates" with "Papa Bing Crosby and that fine gal—and boss lady of the stage—Tallulah Bankhead.... Ooh—Gawd I would not want to miss it for the world...."

So is it art? Possibly. Is it a treasure? Definitely.

Is it Satchmo? Oh yeah.

ORIGIN
• 1943-1971

CONDITION
• Deterioration over time

PROJECT SCOPE
• Ongoing care of collections in a
state-of-the-art archival center

Louis Armstrong's collages are as engaging as his inimitable smile. The box
at bottom right holds the last tape he made before his death in 1971.

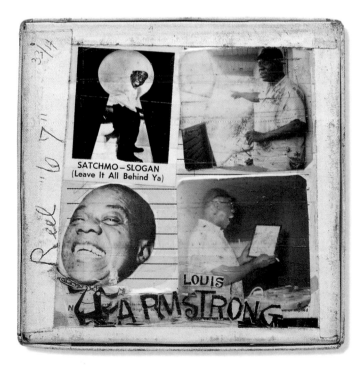

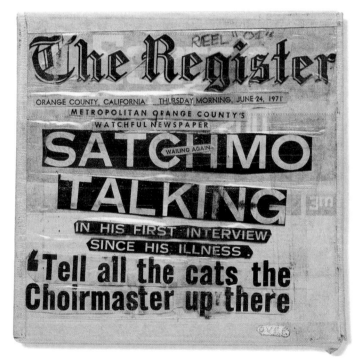

THE MOUNT

In his introduction to Edith Wharton's autobiography, *A Backward Glance,* Louis Auchincloss writes, "Mrs. Wharton was always determined to be surrounded with a beautiful world, even if she had to build it herself." She built that "beautiful world" in the flowing prose of a series of meticulously observed novels that depicted with unsentimental precision the manners and foibles of the privileged world into which she had been born. She also built it in wood and stucco and terraced gardens in the Berkshires of western Massachusetts, at the country estate she called the Mount.

In a sense, the place existed in her head long before it took shape on the ground. In her 1897 book, *The Decoration of Houses,* written with her friend Ogden Codman, Jr., Wharton laid down many of the design principles later embodied in the Mount. Innovation was not among those principles; tradition was, along with a clear sense of what was suitable. Demonstrating a firm command of the classical design vocabulary and disdaining showiness, the Mount's rooms and gardens are cool, serene, supremely self-assured. They are, in short, evocative links with the placid, long-vanished world that was disappearing even at the moment when Edith Wharton captured its essence in *The House of Mirth* and *The Age of Innocence.*

In 1921 she became the first woman to win the Pulitzer Prize for fiction. By that time, she had sold the Mount and settled in France. Though she lived an ocean away from it, she never forgot the beautiful world she had built in the Berkshires. Near the end of her life she wrote, "The Mount was my first home, and though it is nearly 20 years since I last saw it (for I was too happy there ever to want to revisit it as a stranger) its blessed influence still lives in me."

Top: *Wharton at her desk at the Mount, circa 1905*
Above: *Postcard view of the house and gardens, circa 1905*

ORIGIN
• 1901-1902

CONDITION
• Exterior restoration of mansion complete; interior and gardens undergoing restoration

PROJECT SCOPE
• Restoration of mansion, greenhouse, and gardens; installation of new mechanical systems

A glimpse of Edith Wharton's house from the walled Italianate garden.

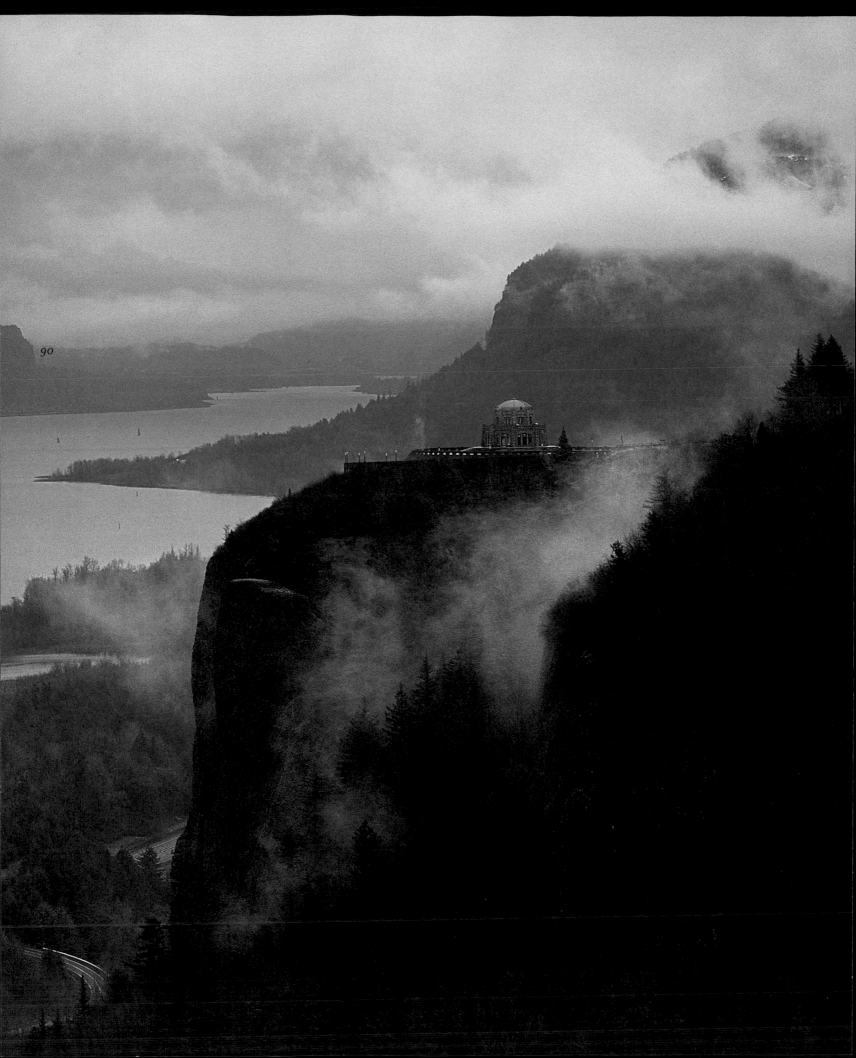

VISTA HOUSE AT CROWN POINT

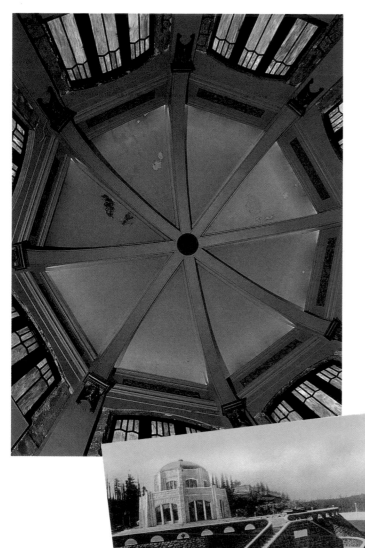

Stretching eastward from the edge of Portland, the Columbia River Gorge is one of nature's masterpieces, offering throat-catching views of river and forest punctuated with waterfalls and (if you're lucky and the weather is right) distant snowy peaks. Rolling easily through this magnificent landscape, the historic Columbia River Highway is something of a masterpiece in its own right, and Vista House is its crown jewel.

91

What are we to make of this little domed temple, built of concrete and faced with sandstone, that brings an engaging whisper of the German *Jugendstil* to the wide-open spaces of the Northwest?

On the most simplistic level, Vista House is merely a belvedere, a sheltered place from which to enjoy a view. But that "merely" doesn't do it justice. It offers sweeping vistas in all directions, but it is much more than a way-station. Far from being an intrusion in the landscape, the building was designed to be—and is—an ornament to its regal perch atop the aptly named Crown Point.

It is also a shrine to the pleasure driver, a link with the innocent days before terms such as "sprawl" and "gridlock" and "road rage" entered our vocabulary, days when it was still possible to think of the automobile as liberator instead of conqueror. More than a million visitors come here every year, almost all of them arriving by car. They park, gasp at the view, maybe buy a soda or a souvenir, then roar off for more of the quintessential American experience: enjoying the great outdoors from the air-conditioned comfort of a speeding metal cocoon.

Dedicated as a memorial to the pioneers who toiled westward and settled Oregon, Vista House is a monument to American restlessness, to our love of the journey and the open road. It might be appropriate to carve "Keep Moving" over the door.

Top: Interior of the dome and stained-glass windows
Above: Postcard view, circa 1919
Opposite: Vista House overlooks the Columbia River Gorge from mist-wreathed Crown Point.

ORIGIN
• 1918

CONDITION
• Dislodged facing stones and damage from moisture intrusion

PROJECT SCOPE
• Protect and preserve memorial to Oregon's early pioneers

TALIESIN

Even people who can't identify a single one of his buildings know his name. Ask somebody to name an American architect, and chances are the immediate response will be "Frank Lloyd Wright."

His students practically worshiped him. His fellow architects didn't know what to make of him. He was quirky, passionate, demanding, and highly opinionated, with an enormous ego and a magisterial confidence in his own infallibility—so, naturally, there are hundreds of stories about him. In one of them, an exasperated client is said to have telephoned the architect during a rainstorm: "Mr. Wright, the roof you designed leaks like a sieve. Water is dripping on my head." The great man coolly responded, "Move your chair."

Even if the outrageous (and mostly apocryphal) stories were all true, they can't detract from Wright's towering genius. In a roller-coaster career that lasted some 70 years, he designed some of America's most beautiful, engaging, distinctive, and influential buildings, a collection of one-of-a-kind landmarks ranging from the iconic house called Fallingwater to New York's Guggenheim Museum.

From 1911 to 1959, Taliesin—this hillside house whose name means "shining brow"—was Wright's principal residence, his office, the center of his world. Like Jefferson at Monticello, he was continually tinkering with the place, developing and refining his unique view of what a house should be and how it should be married to the landscape. In 1932 he established the Taliesin Fellowship here to train new generations of followers. Eventually, the complex encompassed buildings from every phase of his career.

Wright knew great tragedy here. His mistress, her two children, and four others were murdered by a deranged butler in 1914. The house was almost destroyed by fire on three separate occasions. But he wouldn't let the place go. He rebuilt his life and his house and went back to work, and American architecture was changed forever.

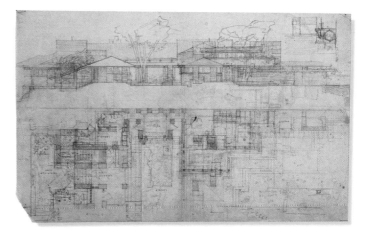

Top: A Wright drawing of the third house at Taliesin
Above: Wright's desk
Opposite: A statue of Kwan Yin, a Chinese diety, presides over the living room of Taliesin.

ORIGIN	CONDITION	PROJECT SCOPE
• 1911, 1914, 1925-1959	• Age and structural damage from drainage problems	• Master planning for entire structure; stabilization and restoration of main living quarters

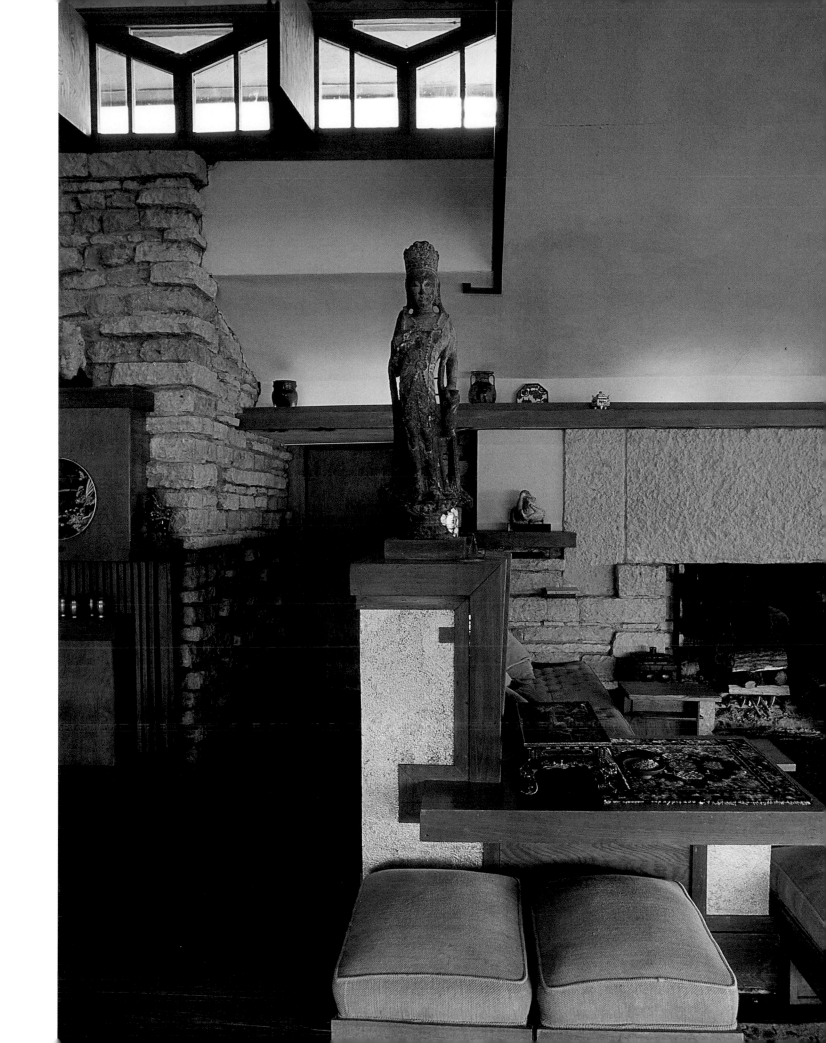

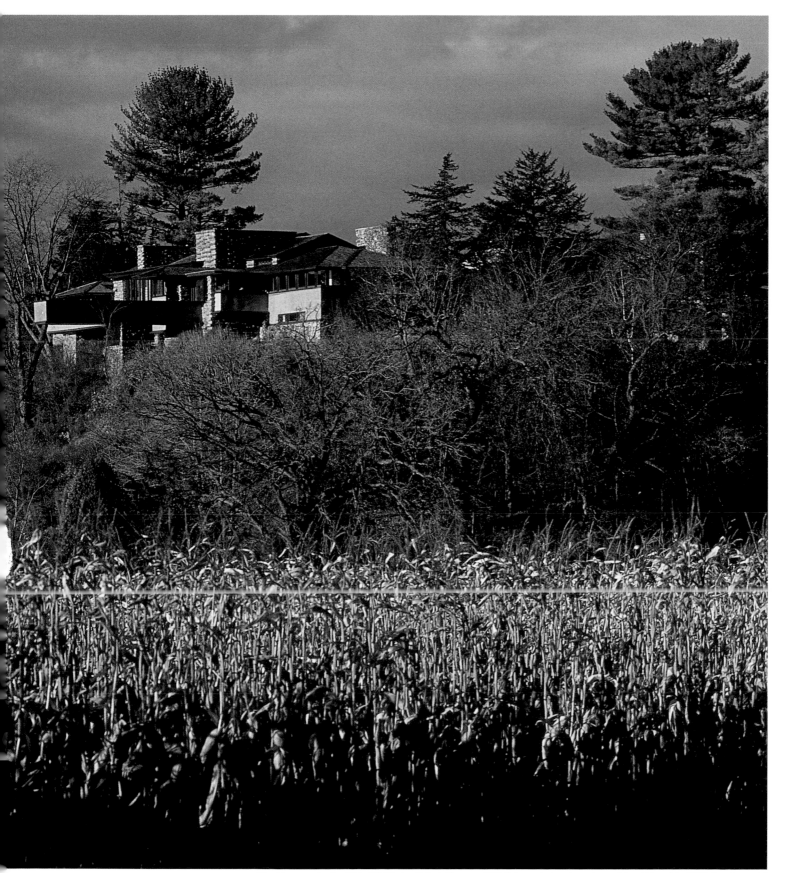

Blending seamlessly with its hillside site, Taliesin illustrates Wright's conviction that a house "should be of the hill, belonging to it."

Searching for Higher Ground

Phyllis Theroux

IN THE 1940S, WHEN I WAS GROWING UP IN SAN FRANCISCO, most people stayed within their own cultural square on the checkerboard. Catholics, (sub-divided into Irish and Italians) did not mix with Protestants. Jews were not accepted in gentile society. The blacks were not accepted anywhere. And the Chinese, who lived in their own curly roofed, lantern-hung section of downtown, were so removed from the mainstream that they came under the heading of a tourist attraction, like the cable cars or Golden Gate Bridge.

I was not particularly aware that I lived in a segregated city. On Mondays, I took swimming lessons at the Jewish Community Center. On Wednesdays, I followed my best friend to catechism class at St. Edward's Catholic Church, and on Sundays, when my parents thought to go, which wasn't often, I yawned my way through morning services at St. Luke's Episcopal Church on Van Ness Avenue. But the real spiritual center of the family was inside my aunt and uncle's house in Presidio Terrace.

It was there that my grandmother, my father's two sisters, their husbands and children all lived in a huge household that doubled as the San Francisco head-quarters for Moral Rearmament. Founded in the 1930s by a Lutheran minister from Pennsylvania, MRA was a quasi-religious international movement dedicated to fighting Communism and putting moral standards back into capitalist democracies. Almost anytime I walked through my aunt and uncle's front door, there was something interesting going on.

Moral Rearmament primarily appealed to upper-middle-class , internationally minded people who wanted to change the world without changing their material way of life. My aunt's tastefully slipcovered living room was routinely full of earnest, well-dressed men and women sipping coffee while they listened to delegations of foreign visitors in dirndls, kimonos, and dashikis talk (or sing) about how MRA and the "Four Absolutes" of honesty, purity, love, and unselfishness had revolutionized their lives.

A painting called "One Thousand Horses" honors those who contributed funds to build the Maui Jinsha Shrine in Hawaii.

I liked looking at the different national costumes, but after a while the various stories of how people found their way back to God and the virtuous life ran together in my mind. Beneath the catchy songs and boot-stomping plays, MRA was too full of current events, seriousness, and gray-haired spinsters in gabardine dresses to capture my imagination or loyalties.

Then my parents made two decisions that, linked together, radically altered my prospects and perspective. They moved the family out of San Francisco to Marin County and, a year later, enrolled me in a nearby Dominican convent school for girls. One minute I was slouched in the back of a noisy public school classroom, idly defacing a textbook while I waited for lunch. The next minute I was wearing a starched gingham uniform, standing to recite, and perfecting a small hiccup of a curtsy we were taught to execute whenever a nun swept past us in the hall.

It was a dramatic change of circumstances, like being inserted into a 19th-century English novel, where children wore pinafores and rolled hoops down sidewalks. Reinforcing this impression was the school, itself, which must have used up half the redwoods in northern California to construct. A massive, three-story Victorian birthday cake of a building, with cupolas, bell towers, turrets, and covered walkways, its most impressive feature was a wide apron of wooden steps that climbed from a circular driveway to a canopied, recessed entrance on the second floor.

I had never seen a building that was so intricate and important-looking, and the fact that I was now related to it, by virtue of being an enrolled student, with the right to enter its cool, marble halls with waxed staircases and high curved windows, filled me with dignity-by-association. On my first day of school, dressed in my new uniform, carrying my newly covered-with-oilcloth textbooks, I felt as if I had emerged from a trackless jungle onto a polished dance floor.

We were taught how to diagram a sentence, memorize a poem, dissect a frog, and explain the difference, in neat manuscript penmanship, between a natural and a supernatural virtue. The nuns' mission was to educate young women for a life of excellence. What I wanted was almost the same thing, an excellent life. Burdened with conflicting goals—to be saintly, popular, and get my own way—I longed to be in a community where it would be easier to be good. I was 11 years old. The year was 1950. The Dominican Sisters of San Rafael had been teaching the distinctions and difficulties of goodness to their students for a hundred years.

THE STORY OF HOW THE DOMINICAN SISTERS came to California began with one brave nun in Paris. When asked by a visiting bishop whether there were any volunteers in the Monastery of the Cross who would volunteer to come with him

to the New World to establish a school, only one sister, Mother Mary Goemaere, stepped forward. In 1850 she sailed across the Atlantic in a windjammer, traveled by mule and canoe across the Isthmus of Panama, took a steamer to San Francisco, and finally arrived, by stagecoach, at her final destination—the Spanish-speaking outpost of Monterey. Mother Mary spoke only French. She longed for the refinements and stability of her Parisian convent. But before the year was over she had been joined by two other nuns who helped her turn a rough adobe building into the first Dominican school in California. By the time I was enrolled they had established dozens of convents, hospitals, and schools, from kindergarten through college in California and Nevada.

Most communities of faith can tell the same kind of story. The Quakers of Philadelphia, the Mormons of Salt Lake City, the Christian Scientists of Boston—all of them began with a single person who stepped forward into the unknown, endured great difficulties in hostile circumstances, and laid the foundations for what eventually became a "house of many mansions."

One woman's decision grew into a venerable institution. I am now part of a world-wide network of graduates who regularly return to the school, like tributaries feeding into a river. We do it, not only to remind ourselves of how it used to be, but also to reinforce old connections that continue to provide support, guidance, and inspiration. Every community of faith, if it is to stay alive, must do the same.

LIFE IS NOT STATIC. I graduated from high school trained to fight for my faith against all those who would seek to destroy or dilute it. What I found was an empty battlefield. Nobody seemed to care one way or the other what I believed. The absence of a sharply defined adversary began to erode my own sense of self and mission. All my carefully learned answers were to questions nobody was asking. I began to wonder if God existed, whether I was anything more than a bunch of molecules inside a Shetland sweater.

The price for having lived in the equivalent of a walled garden during my younger years was paid in college, despite the fact that it was Catholic, too. But I was far from home, and it took me most of the four years I was away to find my feet, and something more—a network of friendships that, after my family, is one of the most bullet-proof support systems in my life.

The church that shepherded me through college showed its rigid, parochial face after I graduated. I sought refuge in a group of liberal Catholics who met for Mass in backyards under parachutes, collected money for Cesar Chavez's United Farmworkers, and petitioned the diocese to ordain women. The archbishop

responded by closing us down and excommunicating any priests who wouldn't go back to their parishes.

Next, I tried to pray my way into a conservative group of charismatic Catholics who met in the basement in a nearby church and spoke in tongues, which seemed like a shortcut to holier ground. But I never learned how to speak in tongues myself and finally dropped out, secretly wondering whether my presence in the room wasn't jamming the Holy Spirit's circuits.

I was married, with children, looking for a community in which to insert my fledgling family that was feeling the effects of modern life. A friend of mine suggested I try the newest "church" in town—group therapy. Almost everyone I knew, or their spouse, was flocking to therapists who were teaching people how to release their rage so they could get to the love trapped on the other side. Tears I couldn't shed for myself ran down my cheeks as I sat on a beanbag cushion and listened to other people's stories of hurt and humiliation. But I didn't know how to tell my own, and was accused by some of the group members of spying. I quit, but not before the therapist practiced what he preached and told me how angry he was at me for leaving.

Feminism was in the air. Magazines were full of pictures of Gloria Steinem smiling beatifically from behind her aviator glasses. She urged women to take responsibility for our own lives, share housekeeping with our husbands, bond with other women in consciousness-raising groups. I only went to one, but my timing was off. I had just had a baby and could not see beneath my own joy.

Like Forrest Gump, I seemed to wind up in the middle of every national upheaval, often by accident. Living in Washington, D.C., I took a job in the Civil Rights Division of the Justice Department shortly after the three civil rights workers were murdered in Neshoba County, Mississippi. When riots erupted after Martin Luther King, Jr. was murdered, I wheeled my children past National Guardsmen who leaned against bags of peat moss in front of our local supermarket. During the Vietnam War, my natural childbirth classes were interrupted by anti-war protestors who were staying at my Lamaze teacher's house.

Looking back is exhausting. What felt at the time to be an agonizingly slow search for a stable life seems, in retrospect, like a rushed and jumpy series of experiments. Where, given the fact that I had three little babies, did I find the time to learn transcendental meditation, become a born-again Episcopalian? Between the time I left college and sent my own children into the world, I wandered in and out of more faiths, fads, and folds than now seems possible. But in this I do not think I am so different from most women in my generation. We were living in a culture

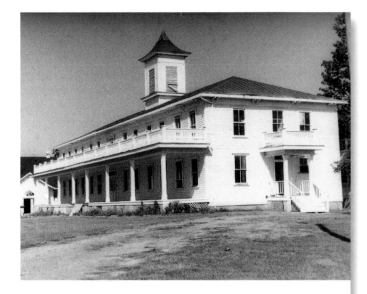

Wheelock Academy

LOCATION	• Millerton, Oklahoma
ORIGIN	• 1884-1944
CONDITION	• Water and wind damage to interior and exterior
PROJECT SCOPE	• Restore buildings to create a tribal community college, museum complex, and Choctaw Cultural Center

that was spinning out of control and leaving everybody to find their own context and community in a way that had not been true before.

"Tell me," asked a woman who sat next to me at dinner during an ill-fated weekend religious retreat. "What's your favorite television program?"

I wasn't sure why she wanted to know.

"The Carole Burnett Show" I replied.

"Any others?" she asked. Perhaps this was some kind of personality test.

"Why do you want to know?" I asked.

She kept her eyes on her plate when she answered. "I thought it might give us something in common to talk about."

People were beginning to look at television more than they looked at each other.

"I like you," confided Mr. Rogers, smiling kindly into the TV monitor, "just the way you are." It had been a hard day. Tears came to my eyes. I felt he was sincere.

WE ARE NOW IN THE 21ST CENTURY. Close to half the families in this country now have personal computers. We buy, sell, and communicate in cyberspace. Cyberspace is the new community, if not of faith then of convenience. The other morning a friend e-mailed me that his wife's father had died. I e-mailed back my condolences. He e-mailed me his thanks and a day later e-mailed me directions to the funeral home where services were going to be held. It was death by e-mail.

But not the death of religion, at least not architecturally. The town I live in has more churches than Montana has bars. The Baptists favor impregnable brick buildings that are more fuel-efficient than graceful. The Episcopalians, influenced by Monticello, have tall Palladian-style windows with deep sills, and the Catholics have just built a new church-in-the-round. There are several storefront ministries, and an Orthodox congregation whose plain stucco church hides a brilliantly decorated chapel inside. The slender New England steeple that punctures the tree line, like an important thought, belongs to the Presbyterians, and on a quiet summer night I can sit on my screened porch and listen to the Pentecostals singing their hymns beneath an open-air wooden pavilion at a nearby campground.

Americans worship in churches that mirror the tastes and aspirations of the

people within them. Pulled inside by the need for human connection in a structure that both comforts and upholds us, we have always been a nation of churchgoers, but whether the churches are providing the inspiration, guidance, and support that keeps communities of faith alive is another question. Increasingly, Americans are supplementing or replacing institutional religion with other kinds of spiritual communities that come together to pray, meditate, or study the works of a particular spiritual teacher. In this age of gurus on tape, we don't need to travel to India or Ireland to hear them. We can have them sent, in little cassettes, from Amazon.com or tune into the Oprah Show and become part of her daily "congregation."

Men and women from an earlier age belonged to a church or temple that bound them, some more tightly than others, to a code, a creed, and a culture that gave them whatever dignity and "blessed assurance" was available in this world. One strayed away from the fold at his or her peril. How different this is from today, when it is very possible for someone to belong to many communities of faith that overlap and reinforce each other without actually touching.

Consider, for instance, the woman who takes a weekly yoga class, belongs to a book club, and meets once a month with a group of other women who get together to share their writing. Or consider the man who volunteers at a downtown soup kitchen and goes to weekly AA meetings. None of these activities is specifically religious but they are spiritually rewarding, and anybody who has wrestled with the dark forces of addiction knows that Alcoholics Anonymous is probably the most effective nondenominational religion in the world.

NOT LONG AGO I returned to California to give a writing workshop (a major source of spiritual community these days) and attend a millennium reunion at my old Dominican school which, in fact, does not exist anymore. Ten years ago, the entire building went up in flames, which was a terrible blow to the surrounding neighbors who wept at the loss of such an elegant landmark. The nuns were sad but philosophical. It was not the first time they had lost everything and had to depend upon Our Lord and His Blessed Mother to make it up to them. They saw no reason to lose confidence now.

Rising from the ashes of the old Victorian building is a sleek, shingled complex of convent and offices that manages to look both airy and functional. Nestled nearby, in 500 acres of untouched hills, is the new school, staffed almost entirely by lay teachers and a few elderly sisters who are still working.

On reunion day, hundreds of women assembled beneath a giant tent for the luncheon. To hear one's name called, to turn and see a face, brush the cobwebs

from it, and recognize the friend beneath, and then to wrap one's arms around 40 years of history is a joy that my 20- and 30-year-old children must simply wait their turn to know.

I used to think, even though I knew it was not right to do so, that there were human beings who unfurled like flowers, and others human beings who did not flower at all. Less and less do I think this is true. We will, all of us, get to where we are meant to go, realize what we are meant to realize before the end. But looking into the faces of my old comrades makes me think it is better if we travel together.

For four days before the reunion, I lived on the school's campus. At breakfast, I sat with the remaining members of the order (they get very few vocations now) and asked about some of the nuns I remembered from school. Sister Damien, "died, quite young," recalled one of the nuns, "of cancer. It was very hard, but at the end she found the strength to sing the 'Salve Regina' with all of us. It was beautiful."

Sister Francis Xavier, also gone. "Oh," said another nun, "she had such terrible arthritis. She used to wait until the pain wasn't so bad before she finally came into the study hall for singing practice. But then, one day, it went away."

It was a miracle they said. She changed her diet. They remember seeing her every morning before Mass, forcing herself to jog around the playing field, and she prayed—all of the sisters prayed—for the pain to go away. And finally it lifted and never came back. The sisters at the table talked as easily about the departed members of their community as if they were at the table with them, or only separated by the thinnest of veils.

"She is with me all the time," confirmed Sister Gervaise, about her former superior who died a few years ago.

"Does she give you advice?" I asked.

She laughed. "Sometimes," she replied, "but mostly she just says 'you must figure it out.'"

After so many years of doing without, making do, cobbling together temporary support groups, and shopping between churches until I finally gave up the search, I had forgotten what it was like to be in a real community with people who worked, ate, slept, and prayed for each other under the same roof.

"Did you know," said a friend of mine at the reunion, "that nuns get less Alzheimer's disease than any other group of people?" The woman who told me this is married, with grown children and a thoughtful, satisfying life.

"I think," she said, "it's because nuns live in a community."

In the case of the Dominican Sisters of San Rafael, that community extends into Heaven.

African Meeting House

Beacon Hill has long enjoyed a reputation as one of Boston's toniest addresses. Less well known, however, is the fact that the northern slope of the hill was home to a large, thriving African-American community throughout most of the 19th century. Members of this community, tired of the discrimination—such as being restricted to balcony seats—they experienced in Boston's white churches, determined to build a church of their own. They bought land in a small court just off a street called Joy.

The $7,700 cost of the building came from both black and white donors, but actual construction was carried out almost entirely by black laborers. Ironically, at the dedication ceremonies on December 6, 1806, pews on the main floor of the sanctuary were reserved for white guests who were "benevolently disposed to the Africans," while black members of the congregation found themselves once again relegated to the balcony.

Over the next few decades the church echoed to the rumble of social and political upheaval. William Lloyd Garrison founded the New England Anti-Slavery Society here in 1832. In 1860, when an abolitionist convention was driven from another church by a mob, it reconvened here for a spellbinding dose of oratory from Frederick Douglass. Three years later Douglass returned to the pulpit for a recruitment rally for the newly formed 54th Massachusetts Regiment led by Col. Robert Gould Shaw. The church became known as the "black Faneuil Hall."

By the turn of the 20th century most black residents had moved away from Beacon Hill. Reflecting the changing makeup of the neighborhood, the African Meeting House served as a synagogue for many years. Today, the country's oldest extant black church is a museum of African-American history, a showcase of 19th-century black craftsmanship, a shrine to a people's determination to worship and live in freedom.

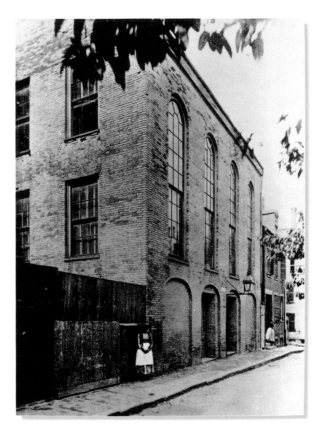

Above: African Meeting House, circa 1895

Opposite: Its windows aglow at twilight, the Meeting House nears the end of its second century as a landmark of freedom and faith.

ORIGIN
• 1806

CONDITION
• General deterioration

PROJECT SCOPE
• Masonry repair; provide handicapped access; refurbish interior; restore pews; develop permanent exhibitions

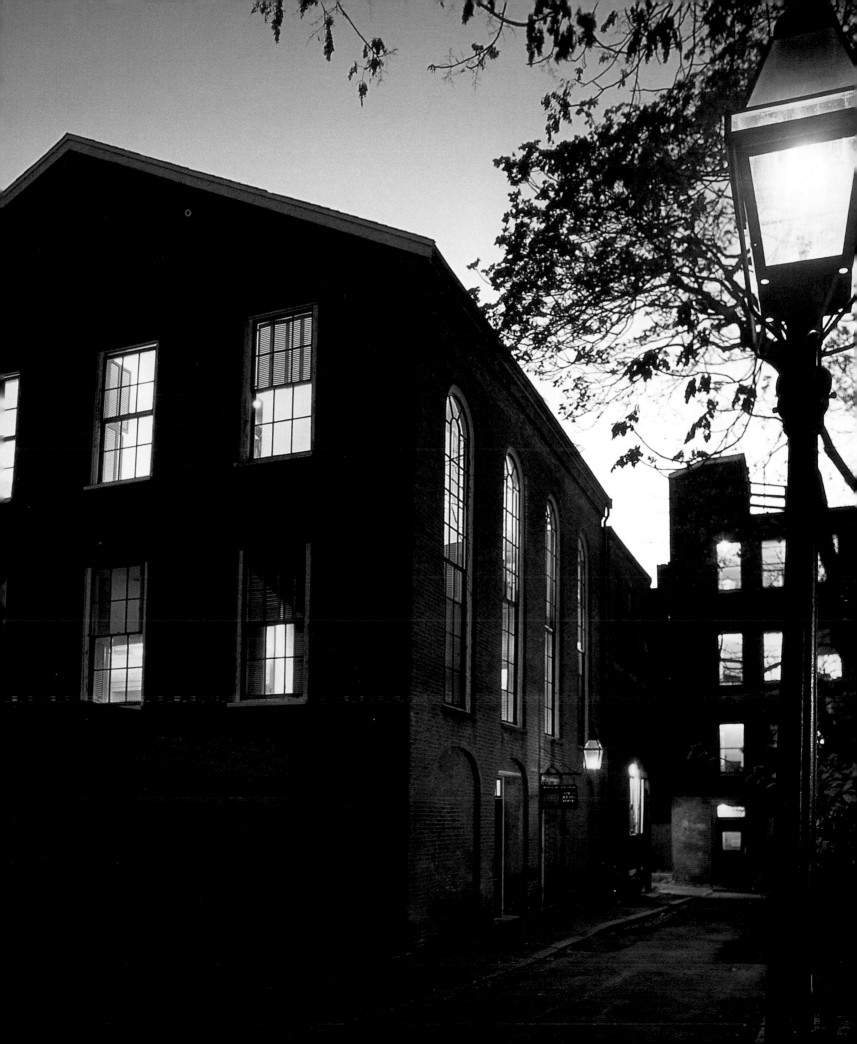

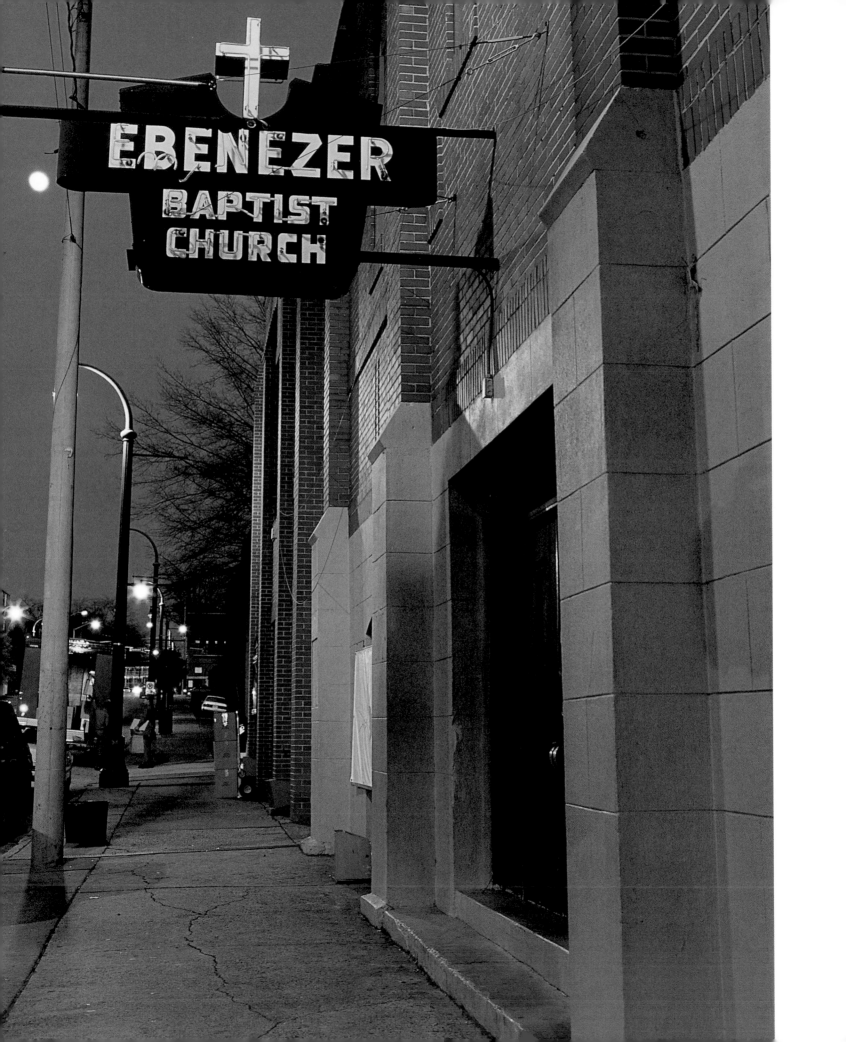

EBENEZER BAPTIST CHURCH

ATLANTA, GEORGIA

At rest beneath a block of snow-white marble, he is silent now. But old-timers remember how he could rattle the windows with the mighty thunder of his voice, how he could—and did, and still does—shake the very foundations of a segregated society with the implacable power of his convictions.

Born just a short distance down the street, Martin Luther King, Jr. received his early religious instruction here at Ebenezer, where both his grandfather and father served as pastor. King himself was co-pastor here from 1960 to 1968, years of passion and struggle when the great red-brown church was cradle, crucible, and flash point of the growing civil rights movement. King traveled widely during those years—to Alabama, to Washington, finally to Memphis—but his journeys always ended here, at home, at Ebenezer.

Ebenezer: King Samuel gave the name to a stone he set up to commemorate a great victory over the Philistines. This church named for that stone became the platform from which King (and others, but none more memorably than he) rallied an army to do battle against the enemies of justice and equality. He spoke—such a mundane word to describe what he accomplished with lips and tongue and voice!—in the rolling cadence of Old Testament prophecy, but his message was inescapably simple, urgently rooted in the here and now: *This is wrong, and we must labor together to make it right.* His message was heard, and an awesome, unstoppable wave of human power was marshaled and set loose across the land. When that wave passed over America, nothing was ever the same again.

He is silent now. But in the great vaulted space of the church, and in the streets and houses that surround it for thousands of miles, the echoes of his thunder have not yet died.

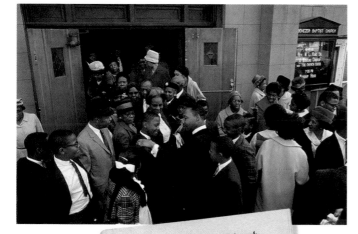

Top: *Martin Luther King, Jr. greets the congregation after Sunday services in 1964.*

Above: *Program from King's last Sunday service at Ebenezer: February 4, 1968.*

Opposite: *A full moon hangs over Auburn Avenue, outshining Ebenezer's broken neon sign.*

ORIGIN
• 1914-1922

CONDITION
• General exterior and interior deterioration, including exposed electrical wiring, unsound structural elements, and water damage

PROJECT SCOPE
• Install fire-protection system and HVAC system; upgrade electrical system and ceiling and roof structure; replace exterior stairs; restore main entrance door and sanctuary stained-glass windows

MORMON ROW

If you sought a single image to illustrate the story of homesteading in the West, you couldn't do much better than this: a weathered barn in an isolated valley, the sharp peak of its roof echoing the craggy shapes that loom behind it, icy, aloof, alluring.

It's a setting made for Technicolor and CinemaScope, a breathtaking vista of rugged mountains and level meadows, air that sparkles, and space that seems to go on forever. It's a national park now. But not long ago, before there were SUVs or visitors' centers or any other trappings of mass tourism, it was something simpler, deeper. It was home.

Mormon Row has a brief history: The community was founded, flourished, and died in the span of two generations. The first homesteaders arrived in 1896. Within 30 years, more than a dozen families, most of them Mormons from Idaho, had settled here. They lived a hard-scrabble life—the growing season was less than three months long—and they relied on one another. Neighbors banded together to grub sagebrush, cut timber, raise barns, dig irrigation ditches, plant and harvest crops, tend cattle and sheep, build a school and a church. They worked hard, and some of them wore out. In the lean years of the 1920s and '30s, they began moving away. Many of them sold out to the Snake River Land Company, founded by John D. Rockefeller, Jr., to protect the land from commercial development.

In 1950 Mormon Row was made part of Grand Teton National Park. A few buildings were moved outside the park, and others were burned or allowed to fall down in an effort to return the area to its "natural" state. The buildings that remain, though less than a century old, have a look of great antiquity about them. The fields that were so painstakingly cleared, so carefully tended, are still clearly visible amid the sagebrush.

Above: *Sunday School group at the May house, where services were held before construction of a church in 1916*
Right: *A weathered barn and fences are relics of the once-thriving Mormon community at the foot of the rugged Tetons.*

ORIGIN
• 1896

CONDITION
• General deterioration

PROJECT SCOPE
• Preserve the 20th-century farming community site and interpret the Mormon pioneer experience in the American West

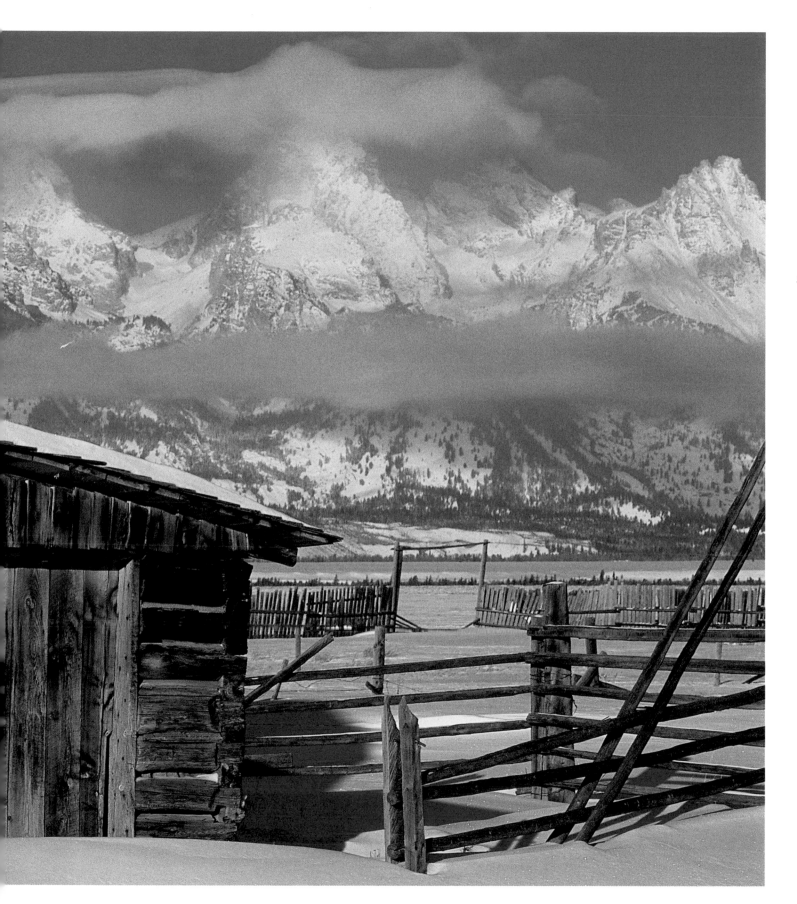

MAUI JINSHA SHRINE

Opposite: Using traditional Shinto construction methods, the Jinsha Shrine was built in Kahului in 1915 and moved to Wailuku in 1953.

Top: Daiwa Fujinkai *(Great Peace Women's Association)* members, 1937

Bottom: Stone lanterns flank the entrance to the shrine.

In the middle of the 19th century, John Ruskin wrote that architecture "is to be regarded by us with the most serious thought. We may live without her, and worship without her, but we cannot remember without her."

Imagine that you're a Japanese immigrant to Hawaii, making a new life on the island of Maui, tackling the daily challenge of a new language and strange faces and unfamiliar ways of doing things. Maybe you're making a success of it, but still sometimes you find yourself longing for something that isn't new and strange and unfamiliar. You need to remember the way it used to be in the place where you once knew yourself well.

Walk through the tall wooden torii gate at the entrance to this shrine, and you're home again.

Cross the veranda and gaze up at the painting called "One Thousand Horses" above the doorway, and you're reminded of the thousand people who gave a dollar each to build this shrine in 1915. You realize you're part of a vast family of people who know and understand you because they're just like you, with a shared heritage and a shared need for reaffirmation. You remember that you're not alone.

Climb the stairs and step into the shrine, and you're in a serene place in which everything opens a window into memory. The Hawaiian sunshine pours down outside, but inside, the smell of incense, the dim glow of unpainted wood, the soft chime of a bell, even the traditional construction methods employed (the structure has no nails)—all are comforting links with other times, other places that suddenly don't seem so far away.

John Ruskin said, "There are but two strong conquerors of the forgetfulness of men, Poetry and Architecture."

Memory is what this little jewel box of a building is all about. It's poetry in wood, architecture as reminder.

111

ORIGIN
• 1915

CONDITION
• Termite damage and deterioration of structure, decorative elements, and "1000 Horses" mural

PROJECT SCOPE
• Stabilization and restoration of only remaining Shinto Shrine on Maui

SAN ESTEBAN DEL REY MISSION

ACOMA, NEW MEXICO

Originally settled by the middle of the 12th century, Acoma may be the oldest continuously inhabited community in America. As if that weren't distinction enough, it may also have the most dramatic setting of any town in the country: atop a 365-foot-tall mesa overlooking a vast desert-and-mountain sweep of northern New Mexico.

Coronado's expedition visited Acoma in 1540, describing the place as "one of the strongest ever seen, because the city was built on a high rock." Secure in its mesa-top aerie, the town resisted Spanish conquest until 1599. Thirty years later, work began on the building that stands at the symbolic heart of Acoma: the great mission church of San Esteban del Rey.

The mission was founded by Friar Juan Ramirez, who, according to legend, walked alone from Santa Fe to Acoma carrying only a cross for protection and gained the community's respect by rescuing a young girl who had fallen or was about to fall (the legends differ) from the mesa. Some describe the construction of the church as a great act of faith on the part of Friar Juan; others say it was a great labor of love on the part of the people of Acoma. In either case it was an enormously difficult undertaking, as every piece of the building had to be carried to the top of the mesa on laborers' backs.

San Esteban is a somber hymn to the warmth and tactility of adobe. Examine the frequently patched skin of mud that covers the adobe blocks, and you may see handprints: the literal imprint of three centuries of devotion. Look: The building is literally a part of the landscape, its rough brown walls looming like a miniature mountain—a mountain on top of a mesa—against the impossible blue of the New Mexico sky. Listen: When the bell chimes from its stubby tower it sounds like time itself.

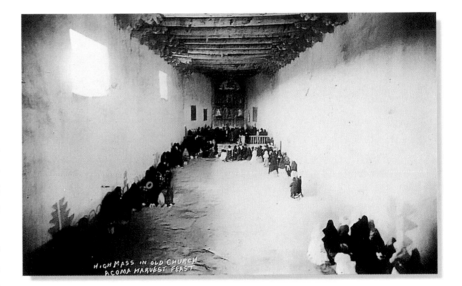

Above: High Mass at the mission, 1904

Opposite: Massive and unadorned, the facade of San Esteban del Rey looms above the cemetery's simple wooden crosses.

ORIGIN

CONDITION

PROJECT SCOPE

• circa 1630

• Faulty roof structure and other structural problems in adobe walls

• Technical assessment and restoration

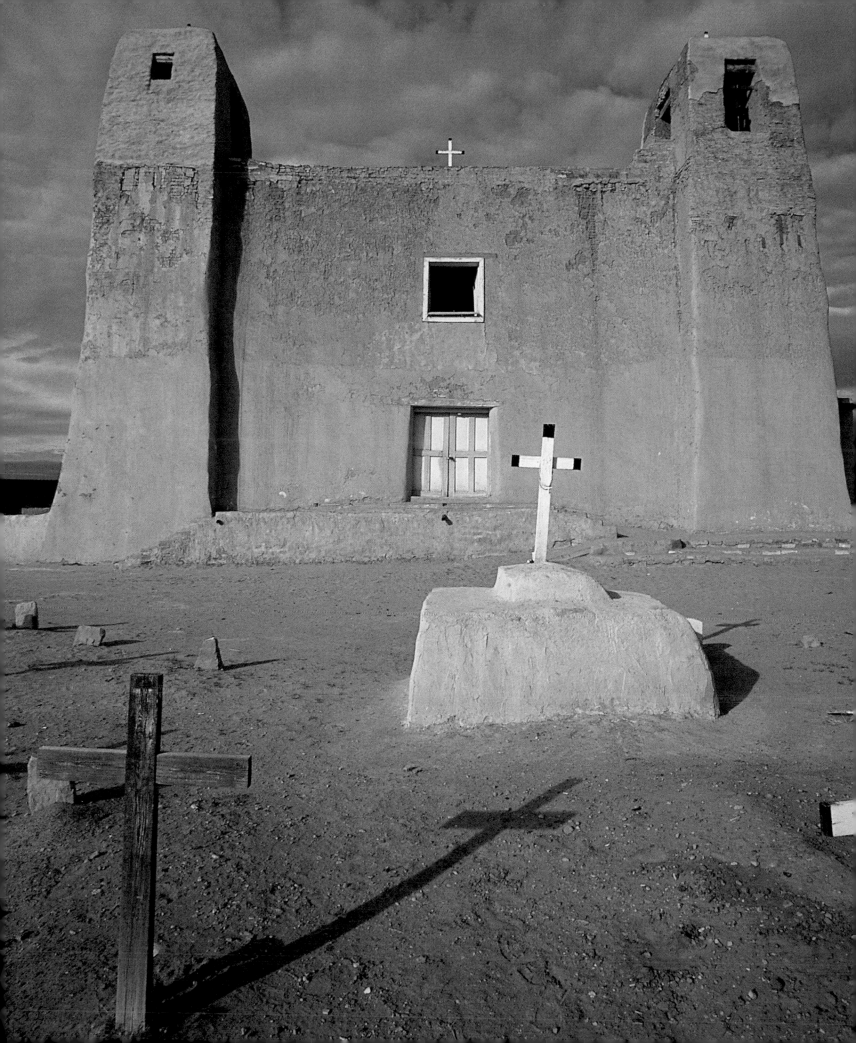

Prairie Churches

In the windswept vastness of North Dakota, the churches are the paperweights that keep the landscape from blowing away. Out here where the horizon is ruler-straight and ankle-high, the smallest rural steeple looms large—just as the church itself looms large in the weekly rhythm of community life.

To be a farmer in this part of the country, you need faith— faith that the rains will come when they're supposed to and the hail won't flatten the wheat and the blizzards won't kill all the cattle and the wind won't send all your topsoil whirling off to somebody else's farm. And you need help—neighbors and family that you can count on to pitch in when they're needed, and a bit of divine intervention is always welcome to make sure things go right.

Church is where it all comes together. You come in here on a Sunday morning, and you're surrounded by people who understand what you're up against. You listen to a sermon about how to live a better life. You breathe a prayer for the right kind of weather and continued good health for your family and a few more months' use out of that tractor. And then you walk out the door and go home to a good dinner, and you're somehow ready to start it all up again.

But now the small farms are disappearing, people are moving away, the life is draining out of the little towns. Who will be left to open the church doors, to dust the pews and the organ keys, to mow the tidy little lawn, to repaint the walls and the steeple? And where do you go for fellowship and hope and reassurance if the church is abandoned and there's only the wind and the fields all around as far as you can see?

115

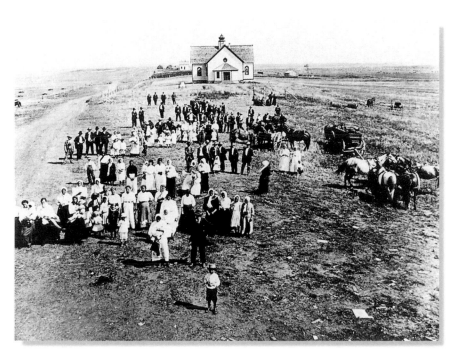

Above: *Congregation of St. Josaphat Ukrainian Church near Gorham, 1912*

Opposite: *Clear prairie light illuminates the spare interior of St. John's Lutheran, also known as South Wild Rice Church, near Galchutt.*

ORIGIN
● 1875-1950

CONDITION
● 1,200 churches in various states from abandonment to needing minor restoration

PROJECT SCOPE
● Revitalize historic rural churches through community-supported projects, publications, technical assistance, and resources

BREED STREET SHUL

Like many buildings, this one offers to the street a facade that, while handsome enough, offers only a hint of the wonders inside. Walk through the doors into a timeless world illuminated by stained glass, enlivened by decorative painting and occasional glints of gold, and you can see why this place—its formal title is Congregation Talmud Torah—was called "the queen of the shuls."

When construction of this building began in 1922, Boyle Heights was home to the largest Jewish community on the West Coast. Some 75,000 Jews, most of them working-class immigrants from Eastern Europe, lived here. The intersection of Brooklyn Avenue and Soto Street was the heart of their world—a world of kosher butcher shops and street-corner philosophers, live chicken markets and Yiddish theaters.

But a neighborhood is a dynamic thing, and nothing stays the same for very long, especially in a booming, zooming place like Los Angeles. After World War II, Jews moved to other parts of the city, leaving Boyle Heights to a new wave of immigrants. Brooklyn Avenue is now Cesar E. Chavez Avenue. People in the stores don't speak Yiddish anymore, and the names on mailboxes are more likely to be Morales or Garcia than Silberberg or Cohen.

Of the 30 synagogues that once lined these streets, only this one is left. The last religious services were held here in 1994, but the building is poised for rebirth as a museum and community center that will celebrate the vanished culture of the old neighborhood and address the needs of the new one.

That's a good thing. A place that's changing with the times needs something timeless.

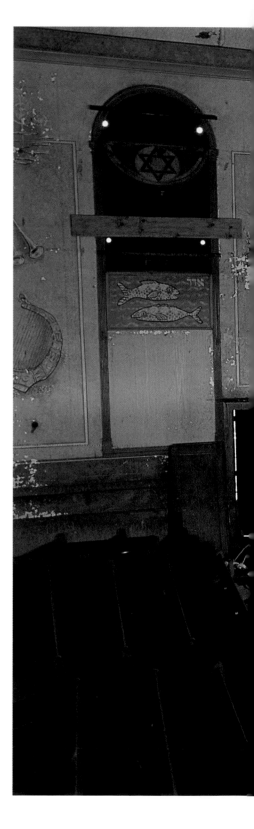

Top: *Congregation Talmud Torah Ladies' Auxiliary, 1920s*
Above: *A stylized beast surveys the sanctuary from a dirt-streaked window.*

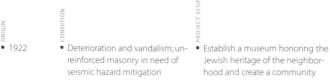

ORIGIN
- 1922

CONDITION
- Deterioration and vandalism; unreinforced masonry in need of seismic hazard mitigation

PROJECT SCOPE
- Establish a museum honoring the Jewish heritage of the neighborhood and create a community education and cultural center

116

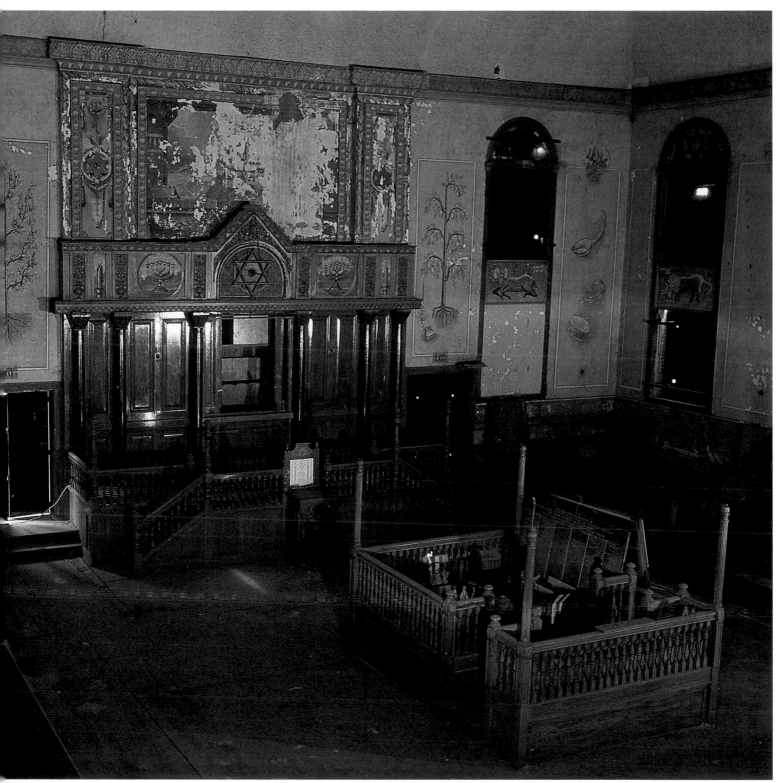

With boards covering the windows and paint flaking from the lavishly decorated walls, the sanctuary awaits restoration and reuse.

ST. LOUIS CEMETERIES, 1 AND 2

Mark Twain wrote, "There is no architecture in New Orleans, except in the cemeteries." Lovers of the French Quarter's filigreed ironwork and the Garden District's gracious mansions might disagree with Twain's curmudgeonly opinion, but they'd doubtless agree that the Crescent City's cemeteries are among its most fascinating places. The 19th-century "rural cemetery" movement created park-like burial grounds with curving paths, lush landscaping, and uplifting vistas. New Orleans has its own splendid versions of these pastoral places, but there's nothing "rural" about St. Louis Cemetery No. 1, founded in 1789. It's an intensely urban place, with tombs packed side by side in regimented ranks, their gabled facades making them look like rowhouses in a once-elegant neighborhood that is now showing its age. Shade is at a premium here. Stucco and white marble reflect the glare; encircling walls trap and magnify the heat. Perspiring visitors move with a lassitude befitting a place of mourning and memory.

Many notables rest here in the city's oldest cemetery. The family tomb of Louisiana's first American governor, William Claiborne, is here, along with that of Homer Plessy, plaintiff in the landmark 1896 Supreme Court case *Plessy* v. *Ferguson* that sanctioned racial segregation in the United States. Not far away lies chess champion Paul Morphy, who once played 12 consecutive matches blindfolded—and won. The best-known resident is "voodoo queen" Marie Laveau, her tomb defaced by visitors who scratch an "X" on it in hopes of having their wishes granted.

The symbolic sculptural vocabulary of death so prominently displayed in other cemeteries is a bit skewed here. In addition to crosses and heavy-lidded angels, tombs are likely to be decorated with empty whiskey bottles, melted candle stubs, even Easter baskets and Christmas ornaments. Surprising signs of life in a city of the dead, perhaps—but after all, this is New Orleans.

Above: *All Saints' Day at St. Louis Cemetery No. 2, 1885*

Opposite: *A grieving figure kneels atop a crumbling family tomb at St. Louis No. 1.*

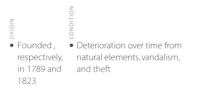

ORIGIN
- Founded, respectively, in 1789 and 1823

CONDITION
- Deterioration over time from natural elements, vandalism, and theft

PROJECT SCOPE
- Restoration of deteriorated tombs in New Orleans' two oldest cemeteries; public outreach, programming, and creation of research database

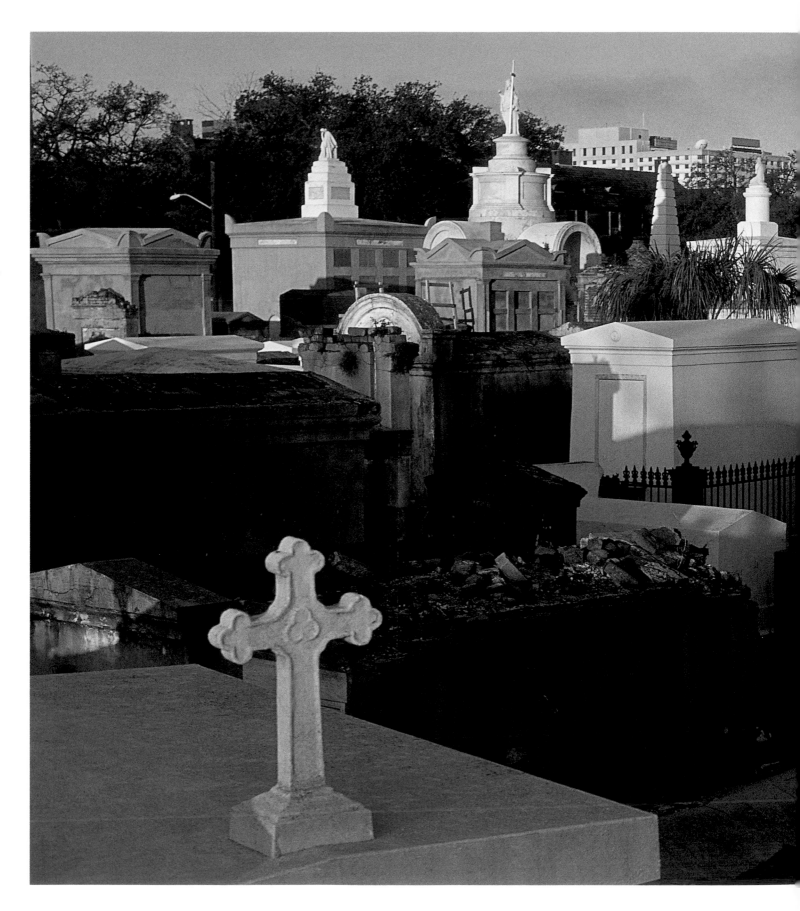

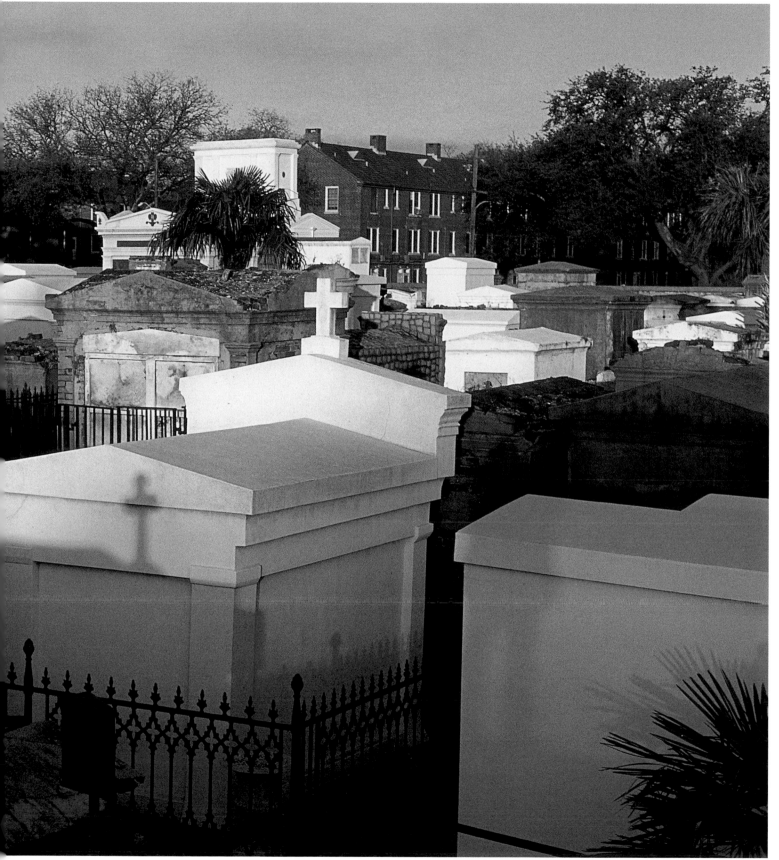

Rows of gable-roofed tombs on narrow "streets" give St. Louis cemetery No. 1 the look of a miniature city.

Temples of Industry

Henry Petroski

SOME STRUCTURES ARE MEANT TO BE TEMPORARY—LIKE THE canopy of green that two lines of great elm trees might throw over a street to shade it through the summer—while others are meant to stand a long time—like the redwoods with trunks so wide that roads are cut through their enormous bulk. But just as there is room in a forest for deciduous and evergreen trees to coexist, so there should be room on the industrial landscape for the ephemeral and the lasting to be admired and to flourish side by side.

One of the most significant of all 19th-century buildings was designed to be temporary, but it has had a continuing worldwide influence as an icon of our engineering and architectural imagination and heritage. The Great Exhibition of the Works of Industry of All Nations was held in London in 1851. More than six million people visited this fair during the five months it was open in Hyde Park, and on the busiest days more than 60,000 visitors packed the aisles and galleries of the single, large exhibition building to view the almost 14,000 exhibits, which came from around the world. From America, there was the McCormick reaper and the Colt revolver, along with many lesser known products of Yankee ingenuity.

The innovative building was to hold the products of factories, but it itself was certainly not a factory, even though the construction site had materials stacked like so many mass-produced, interchangeable machine parts, any one of the girders ready to be fit to any of the columns piled in another section of the yard. Indeed, the building had been allowed to be erected in Hyde Park only on the condition that it would be disassembled after the fair's single season had ended. It was because of this condition that the structural components were designed, at least in part, for ease of assembly and disassembly.

The exhibition building had been conceived in a flash of inspiration by the gardener Joseph Paxton, whose experience with growing tropical plants in the sun-poor English countryside lay behind his proposing the iron-and-glass masterpiece that would capture the imagination of London and the world.

A fork secures the hasp on a weathered door at the Teeple Barn, one of America's few 16-sided barns.

What made the Hyde Park structure remarkable for its time were the factory-like features of its scale and the repetitive nature of its construction. The visual impact of the enormous building—it was more than six football fields long—was enhanced rather than diminished by the regular repetition of wall panels, containing a minimum of decoration, and the great long roofline, broken only by the arched transept, which was included as an afterthought. It was added to accommodate trees on the site so as to avoid delaying construction until the resolution of a dispute with some early environmentalists over cutting the trees down.

The building itself was much more graceful than its awkward official name—the Building to House the Great Exhibition of the Works of Industry of All Nations. Fortunately, it was given the nickname Crystal Palace by the humor magazine *Punch*. Whatever it was called, however, it added a new architectural aesthetic to the mechanical legacy of the Industrial Revolution, an aesthetic that was characterized by simplicity in multiplicity.

The building itself echoed the revolution that was embodied in the exhibits it held, and the exhibits also presaged the revolution in architecture that would follow the eventual disassembly of the building and the reerection of its iron and glass components away from the center of London. The Sydenham Crystal Palace, as the reincarnation was known, would serve as a recreational mecca for Londoners and other Britons for three-quarters of a century. There were also to be derivative crystal palaces, erected in cities seeking to attract the same attention and tourist trade that London had enjoyed in 1851.

The Great Exhibition was such a success that other countries moved quickly to hold international fairs, exhibitions, and expositions of their own. The first of these took place in New York in 1853, just two years after the Great Exhibition, on the site of what is now Bryant Park behind the New York Public Library. It was at this exhibition that Elisha Otis conducted his famous demonstration of a safety device that paved the way for the development and large-scale adoption of the elevator and, in turn, the skyscraper. In 1876 a Centennial Exhibition was held in Philadelphia, and many of its exhibits have been preserved in the Smithsonian Institution's Arts and Industries Building, which was built in a contemporaneous style.

What remain more enduringly admired than the contents of these expositions, however, are the buildings erected to house them. Even in replica they are captivating. Not a few visitors to the Smithsonian's Arts and Industries Building on the Mall in Washington, D.C. can be found looking up at the grand Victorian structure and marveling at its iron, wood, and glass construction. The cast-iron columns,

the graceful gallery, the high roof, the windows that were designed to let light stream in on the days before electric lighting, and the striking colors that emphasized and highlighted it all—these are among the pleasures of the building itself that compete with the exhibits that it houses and shelters.

Many an exhibit of manufactured goods took the form of a graceful display of all the variations on a theme of what that one company produced, whether the product be axes, brushes, or combs. The virtuosity of manufacturing had come to be manifested in trade catalogs, which offered an enormous number of small variations on an invention, so that virtually any need of any potential customer could be satisfied. To put it otherwise, no customer could object that the product line did not satisfy the most unusual of needs or anticipate the most persnickety of tastes.

It became somewhat of a fashion of display at great exhibitions to array a company's line of scissors, knives, or pencils as if it were a naturalist's collection of all the known species of butterfly, beetle, or snail. The gracefully fanned-out panoplies of hardware showed the versatility of the new age of manufacturing and the subtle differences that were possible. And all of the wonderful products came out of factories that had a purpose as uniform and repetitive as the execution of their facades and roofs. Exhibition buildings had been grand statements for a passing crowd, but there also had been rising up all around the country the far more practical and permanent and capacious structures that a still-young nation needed to fuel its prosperity and declare its stability.

America developed its own aesthetic of mills and factories, of course, and they were more often than not made of brick and lumber, rather than of iron and glass. Masonry had actually been the material of choice for what became the Crystal Palace, until it was pointed out that laying 15 million bricks and erecting a dome larger than that of St. Paul's Cathedral would have produced, if the mortar could possibly have dried in time, a behemoth that would hardly have been temporary. Thus iron and glass became the materials used in the London exhibition building, but they were not to be so for structures erected—not for a fair—but for a factory of the future.

What American industrial structures did share with the Crystal Palace was the severity of the facade, punctuated with windows and other repetitive features too numerous to count without losing count. That is not to say that these buildings were without character. The mere size of some of them was often character enough, but they also had a character in the small, in the details visible only at such close range that the building could not be seen for its parts: the corbeled sill and wedged

lintel brickwork, the brick dentils and ornamented fascias and soffits, the arched doorways and grand entrances to loading docks.

It is amazing what can be done with common bricks, those 2- by 4- by 8-inch elements of baked clay that can be assembled into walls and floors and archways and chimneys that outlast the useful life of the machinery that they surround. Simple bricks in the hands of a master mason with a trowel transformed the expanse of what might otherwise have been a blank wall into an artist's canvas of tone and texture. Striking bricks with the side of the trowel to crack them into halves, into quarters, into whatever were the appropriate shapes and sizes for the purpose at hand, enabled the mason to create a monochromatic mosaic of subtle beauty. These works of art are things we often take for granted today, but when we just take the time to look at the facade of a factory building, a textile mill, or a harbor warehouse, we can see not only admirable brickwork but also architecture.

The details of historic buildings are often lost in the space between windows, under eaves, over lintels. These spaces are given a vastness by the scale of their covering. In addition to the tessellation of bricks, the clapboard siding, the shingled facade, the shaked roof can take on the majesty of texture that is beaten flat by the mallet of distance. As the grains of sand become a beach, so the individual pieces of brick or shake or slate become a wall or a roof. The contribution of the parts can only be seen up close, where their individuality becomes apparent in the joints in the siding, the mortar between the bricks, the overlaps in the shingles.

Seeing a historic building from touching distance brings home the obvious but often forgotten fact that this structure was constructed one brick at a time, one board at a time, one joist at a time, one shingle at a time, one nail at a time. And each brick, each board, each joist, each shingle, each nail was held in the hand of a worker, who picked it from a pile, carried it to its place, installed it or handed it to another to install—and then returned to the pile for another brick, board, joist, shingle, or nail. The seemingly countless acts that added countless parts to the building are in fact countable, the parts having been handled one at a time in the process of construction. Not one structure of our historic past has been built in any other way, not the Pyramids, not the Gothic cathedrals, not the stone bridges, not the Crystal Palace, not the lighthouses, not the factories, not the mills, not the cottages that our fathers' fathers or our mothers' mothers were born in, beside, or in the shadow of and grew up around, worked in, and retired from.

So our historic buildings, whatever their purpose or intent, are more than mere buildings, they are our ancestry. They are our connection with a past way of living and working that is at the same time different and yet the same. And even

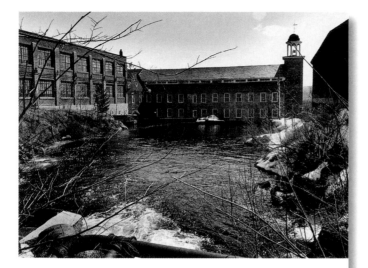

Cheshire Mills Complex

LOCATION • Harrisville, New Hampshire

ORIGIN • 1847

CONDITION • Structural failure of roof trusses; open mortar joints;
slate roof at end of useful life; sash deteriorated

PROJECT SCOPE • Restoration of Granite Mill, part of the Cheshire Mills
Complex

though we build in more efficient ways now, using concrete and steel that are too fluid and too heavy to lift with a single hand, it is still the hand of the worker that steadies the form and shapes the reinforcement over which the concrete is poured and that guides the steel girder that must be bolted to the steel column, one bolt at a time.

And inside the factory or mill or store or office building, whether modern or historic, workers still often handle one part at a time, one product at a time, one order at a time. The repetitive nature of the work mirrors the repetitive nature of the factory or mill, and just as there is beauty in the bricks so there is beauty in the process inside.

What the Great Exhibition did not show, what subsequent international expositions did not highlight, what world's fairs even today do not always emphasize is the simple fact that industrial buildings are filled not only with machines and raw materials and finished products of manufacture but also with people who operate and maintain the machines, who regulate the flow and mix of the raw materials, and who inspect and package and ship the finished product. If conditions were not always ideal in the factories and mills of the 19th century, all the more reason to preserve our heritage, despicable as it may sometimes seem, to remind ourselves of what abuses may have been wrought in the name of business and commerce.

The scale and purpose of the buildings everywhere echo repetition and replication. The millions of bricks, hundreds of thousands of window panes, tens of thousands of pieces of iron, and thousands of workers convey an inescapable sense of awareness that numbers, sheer numbers of people and things were necessary to make such a works work. A view down any one of the alleys between the buildings of a factory complex presents the essence of a manufactory and its essentially reiterative character. Railroad track after railroad track, window after window, brick after brick, each revealing a pride of workmanship and a fitting together into a purposeful whole. These same alleys were, of course, also filled with a multitude of workers at quitting time, and with them the image of the factory is complete.

There is perhaps no more moving image of a nation at work than that from the factory gate at the end of the work shift. The crowd of workers literally flows

with the alacrity of a whole and of a mind toward a single goal. Paradoxically, there are undertones of weariness to their quick steps, for they have battled with the hypnotic repetitions of assembly, of rivet after rivet all day, and are ready for a change. But there is also a sprightliness of spirit, as they head to a recreation or to an amateur toil, home to a garden or garage or to throw a line into some expanse of water or to enjoy a larger expanse of land and water and leisure. No matter to where, as the workers stream out of the factory gate, the factory buildings recede behind them, ready for another shift or for another day.

Empty, as after the very last shift, is the way we see so many of our old industrial buildings today. The factory or the mill has closed, perhaps because of obsolete machinery or skyrocketing costs, perhaps because of cheaper labor elsewhere or changing patterns of fashion and taste, perhaps because of poor management or foreign competition, perhaps because of a decaying infrastructure or an inadequate maintenance program. Whatever the reason, the once bustling buildings remain mere shells of their former selves. They are everywhere, but mostly in our older industrial towns and cities, places once favored by the railroad but now on back roads away from the truck-friendly interstate highway. Some of these older buildings have found new lives as condominiums and apartments, office buildings and professional offices, but there are more of them than there are doctors and lawyers and stockbrokers to fill them.

Durham, North Carolina, used to be known as the City of Tobacco, and the centerpiece of the city seal was a tobacco leaf. On the Duke University campus stands a statue of prominent Durhamite James Buchanan Duke, whose endowment rooted in the city's American Tobacco Company is memorialized by the cigar in the benefactor's fingers. Ironically, J. B. Duke now stands amidst smoke-free buildings. The city has refashioned itself as the City of Medicine, and it is the repetitive architecture of the hospitals for patients and motels for their families that now dominates the city's image and its economy. Many of the tobacco factories and warehouses that once symbolized the principal economy of Durham, whose air was redolent with the sweet smell of tobacco at auction time, are now structures without a purpose. Some of them have been reclaimed as urban shopping malls or condominiums, and there are plans to make more into upscale office complexes and apartments. This is fortunate, for the workmanship that went into so many of these buildings is a source of constant pleasure for those who view and visit them.

Brightleaf Square, named for the type of tobacco that once was traded in Durham's markets, is a model of what can be done with old industrial buildings

whose industry has been superseded. The elaborate brickwork on the facades conceals an equally elaborate system of timber columns and warehouse-rated plank floors whose scale is so fitting for the great spaces that they divide. Thoughtful and respectful restoration and renovation of the Brightleaf Square warehouses has provided a landmark magnet for restaurants and shops and brought commercial success again to the area. The city's tobacco heritage, as much as city image-shapers now might like to ignore it, lives on in an unobtrusive way in the buildings that so many citizens once proudly called their workplace.

Even those more sternly handsome structures with no-nonsense features are as much a part of our heritage as are the more artistic creations of our ancestors. As Walt Whitman wrote in the preface to his *Leaves of Grass*, "The United States themselves are essentially the greatest poem.... Here at last is something in the doings of man that corresponds with the broadcast doings of the day and night." The lines of the old factory buildings are written in the poetry of industry, in the feet of stone and brick that constitute not the iambic pentameter lines of the traditional sonnet but the breathless lines of a manufactory verse, the likes of which Whitman sang:

Out of the cradle endlessly rocking,
Out of the mocking-bird's throat, the musical shuttle.

That sound coming from behind the facade of the old mill where textiles were once woven is the sound of work. Even in the silence of abandonment, the factory shells sing of industry.

Today, we hear that we live in a service society, one whose products are less hardware than software, less durable than consumable goods. The watchword is fast: fast modems, fast chips, fast cars, fast food. The workplace is not always much of a community, and electronic communication has replaced substantive conversation. Increasingly, as successors to commuters, we hear of telecommuters. Coworkers can be faceless and living in different time zones or even across the international date line. There is the image of individuals working alone at home before a screen that casts an eerie glow on their silent faces.

But no one really works alone in an Internet-worked world. Today's factory may be a virtual one, but it is a factory nevertheless. The pixels are the bricks of e-commerce and the windows on the networked computer screens that we sit before are as repetitive, either metaphorically or in reality, as those in the abandoned factory or mill. Behind either set of windows has been, is, and will be a nation, and increasingly a world, at work. The preservation of our industrial heritage keeps all of this, and more, in perspective.

PULLMAN FACTORY AND TOWN

CHICAGO, ILLINOIS

The community that the *Times* of London once pronounced "the world's most perfect town" was built in the 1880s by George M. Pullman for workers in his famous Pullman Palace Car Company. Envisioning a town "so attractive as to cause the best class of mechanic to seek that place for employment" (and eager to isolate his workforce from the pernicious influence of labor organizers)

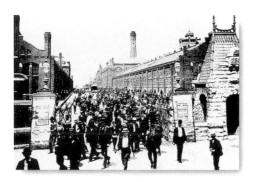

Pullman tried to provide everything his employees needed. The spire of an interdenominational church overlooked neat blocks of houses in a variety of styles. A handsome Market Hall was ringed by arcaded apartment buildings. The Hotel Florence welcomed guests with a spreading veranda, and a library, hospital, theater, and school stood nearby. Manicured parkland surrounding a man-made lake offered a respite from the smoke and clangor of the factory.

The thin veneer of utopianism cracked in 1893, when a severe economic depression led the company to lay off many workers. The following year, growing unrest culminated in a strike so violent that Federal troops were called in to break it. George Pullman died a few years later. The Illinois Supreme Court eventually forced the company to sell the town, whose residents up to then had not been permitted to own their homes. The factory shut down in the 1980s.

Today, Pullman struggles to deal with disinvestment, deterioration, crime, and the rest of the too-familiar catalogue of urban woes. In December 1998 an arson fire destroyed much of the old factory and administration building, gutting the clock tower that rose so proudly over this most ambitious of company towns.

ORIGIN
• 1881-1976

CONDITION
• Serious deterioration and damage from arson to huge portions of Pullman Clock Tower and administration building, and North and South Factory in 1998

PROJECT SCOPE
• Preservation and stabilization

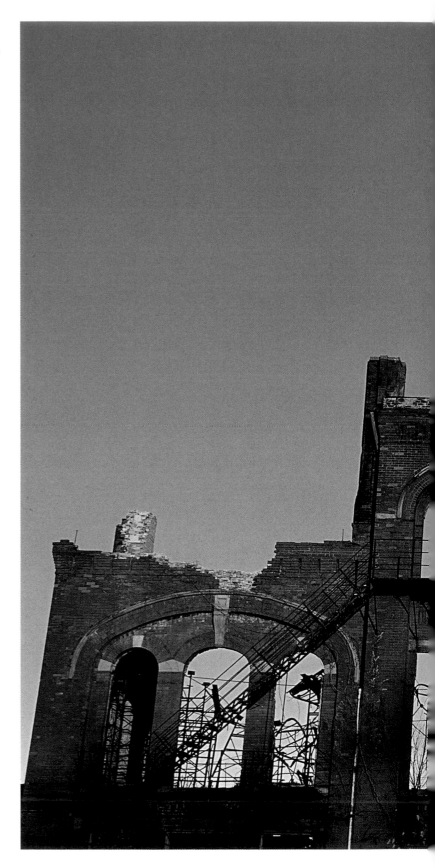

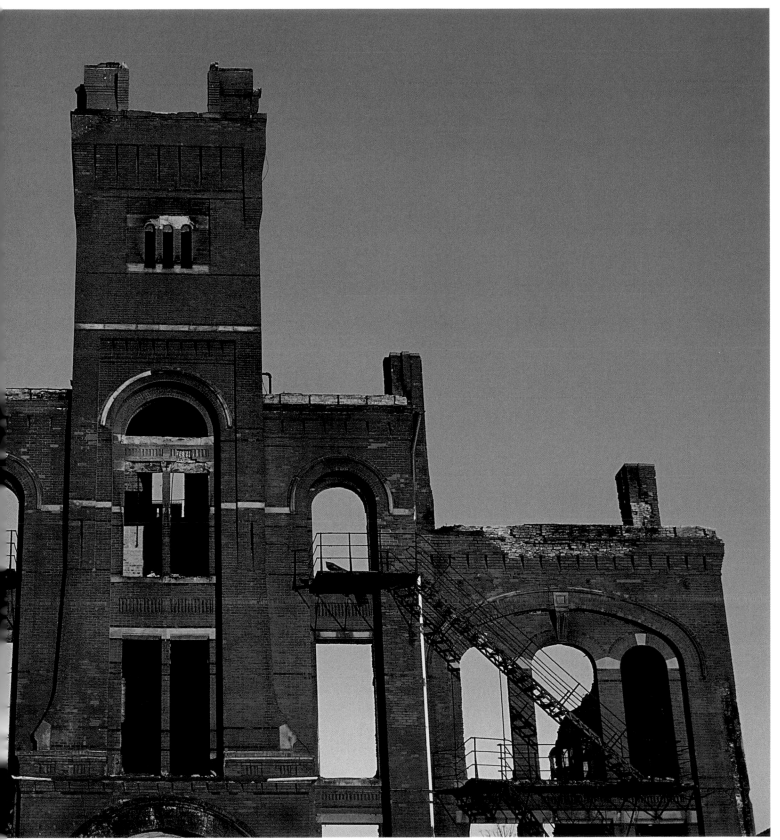

The fire-gutted Administration Building symbolizes Pullman's former grandeur and current plight.

Opposite: *Workers stream through the main factory gate, circa 1900.*

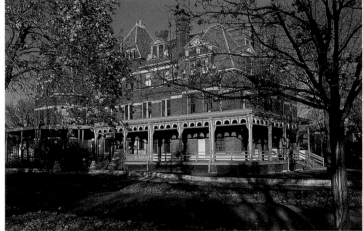

Left: *The unrestored second floor of Pullman's Hotel Florence has changed little since the beginning of the 20th century.*
Above: *The exterior (top) and stained-glass entry (bottom) of the hotel*

EDISON'S INVENTION FACTORY

He's been called "the man of the millennium," and for once the hyperbole is justified. In a career of unparalleled creativity, Thomas Alva Edison was responsible for more than a thousand patents. Among his inventions are devices and processes that have shaped and enriched the lives of millions of people around the world: a practical incandescent light bulb, the storage battery, the phonograph, an improved fluoroscope, the motion picture camera and projector. Seven decades after his death, his genius touches us every time we flip a light switch or go to the movies.

Edison set himself a lofty goal: a minor invention every ten days, a major one every six months. He almost reached it here at the complex he called his "invention factory." The sprawling main building had its own powerhouse, machine shops, and a three-story library of 10,000 volumes. Separate buildings housed chemical, metallurgical, and physical laboratories where 200 researchers tried out new ideas. In nearby factories, an army of employees turned ideas into mass-produced realities.

When Edison wrote that there was "no similar institution in existence," he wasn't exaggerating. This was perhaps his greatest invention of all: the prototype of the modern corporate research-and-development lab.

It's all still here, in staggering profusion. Storage cabinets bulge with thousands of reels of film, disc, and cylinder recordings, blueprints, sheet music, and personal correspondence. Ranks of flasks and beakers gleam in the chemistry lab. Fading photographs document the construction of the factory buildings and the visits of famous guests. Notes in Edison's own hand fill 3,500 lab notebooks.

This enormous trove of *stuff*—the largest archival collection in the national park system—offers mute but eloquent testimony to the restless, unquenchable spark of Thomas Edison's mind. Much of the collection is in fragile condition. All of it is priceless.

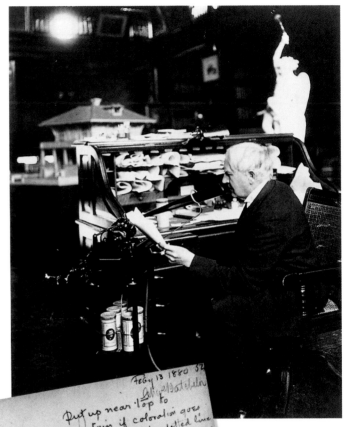

Top : Edison dictating into his Edison business phonograph, 1911
Left: Sketch of a filament design for an incandescent light bulb, 1880
Opposite: Edison's desk is cluttered with evidence of his productivity and his wide-ranging genius.

ORIGIN
• 1887

CONDITION
• Severe deterioration of laboratory complex, artifacts, and collections

PROJECT SCOPE
• Rehabilitate structure; open music room to the public; improve interpretive exhibits, classroom space, and collections storage

134

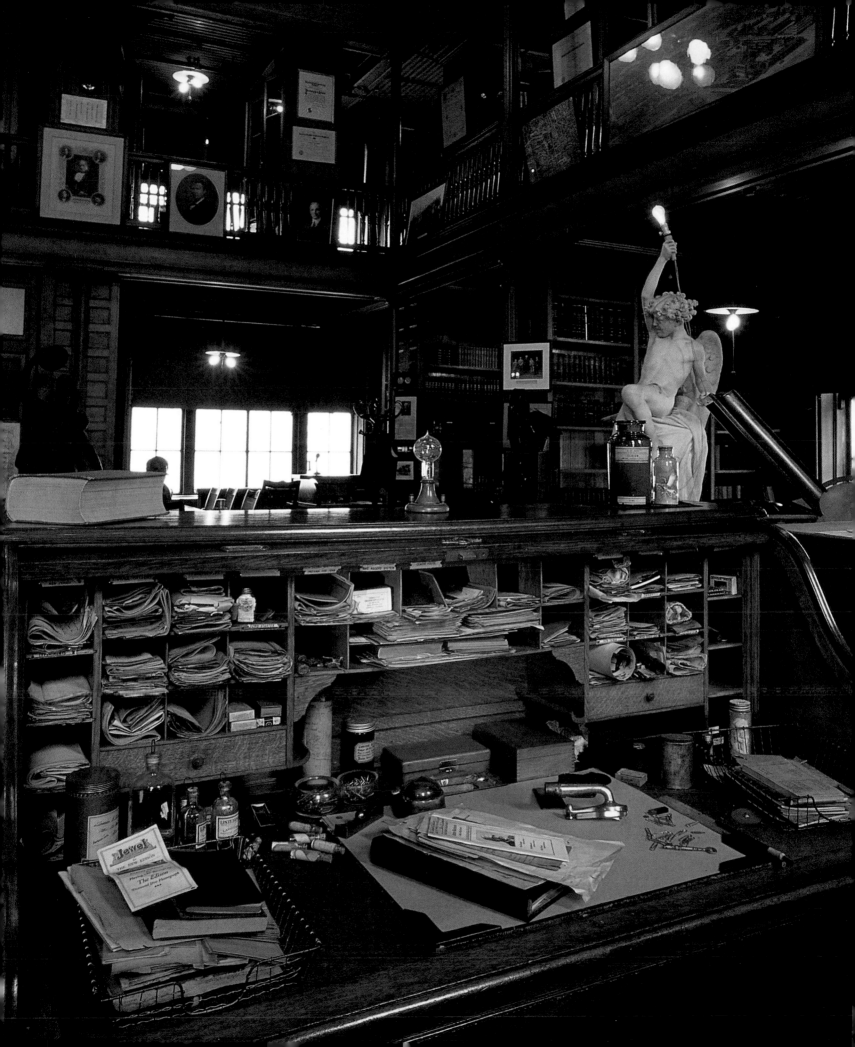

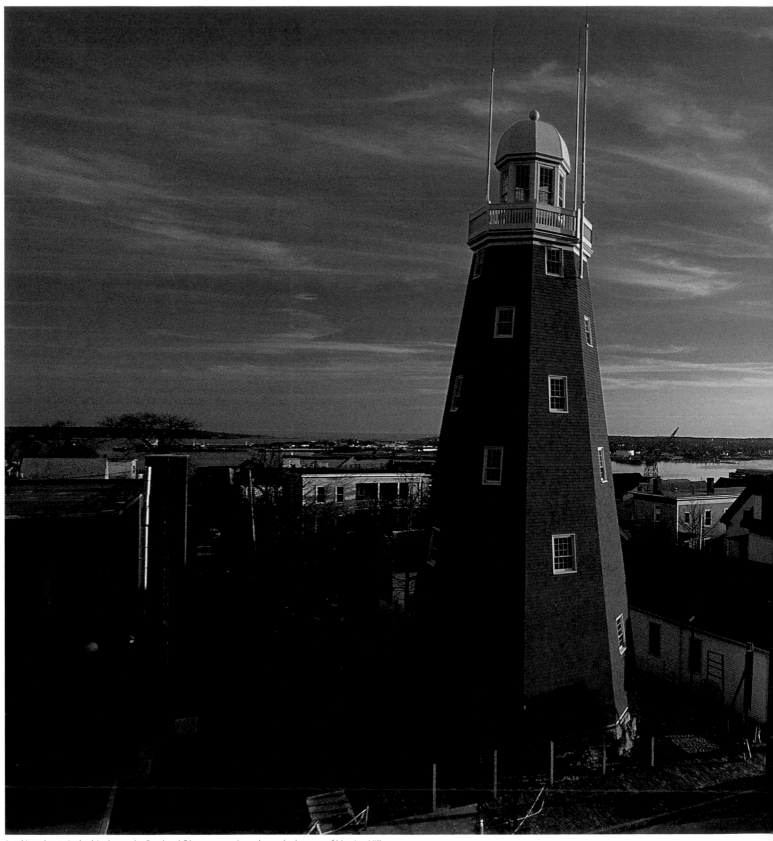

Looking deceptively shipshape, the Portland Observatory rises above the houses of Munjoy Hill.

Opposite:: *English-made pitcher depicts the Observatory's signals, circa 1807.*

PORTLAND OBSERVATORY

PORTLAND, MAINE

This observatory has nothing to do with star-gazing. Portland's merchants knew that their fortunes didn't come from the heavens. They built this observatory for looking out to sea.

Portlanders led by Capt. Lemuel Moody subscribed $5,000 to build the observatory. Their investment bought them shares in a structure whose materials and construction techniques were rooted in the city's seafaring traditions: The huge vertical timbers that support it are of the same white pine that was greatly prized for ships' masts, and the 120 tons of granite that anchor it to its hilltop perch are an echo of the ballast that ships relied on for balance and stability.

Ironically, the year of the observatory's construction—1807—also saw the enactment of President Jefferson's trade embargo, which kept ships bottled up in the harbor and brought financial ruin to the city. Good times eventually returned, however, and the observatory assumed the important commercial role its builders had envisioned. From the lantern atop the eight-sided structure on the crest of Munjoy Hill, lookouts scanned the horizon with a telescope. When they spotted a sail, they raised flags to notify townspeople of the imminent arrival of a ship—or to summon rescuers to the aid of a vessel in distress. As Portland flourished, the observatory was the barometer of its prosperity.

Its original purpose lost with the coming of wireless communication, the observatory has settled into the role of beloved symbol, revered both as a reminder of Portland's maritime heritage and as a survivor. The Great Fire of 1866 didn't touch it. Dozens of hurricanes and winter gales haven't toppled it. The footsteps of generations of visitors haven't worn it away. It is the last remaining signal tower of its kind in the United States.

137

ORIGIN
• 1807

CONDITION
• Closed in 1994 due to insect and water damage to structural timbers

PROJECT SCOPE
• Restoration to 1900 appearance including extended deck and repainting in original colors; installation of educational exhibits on America's maritime history

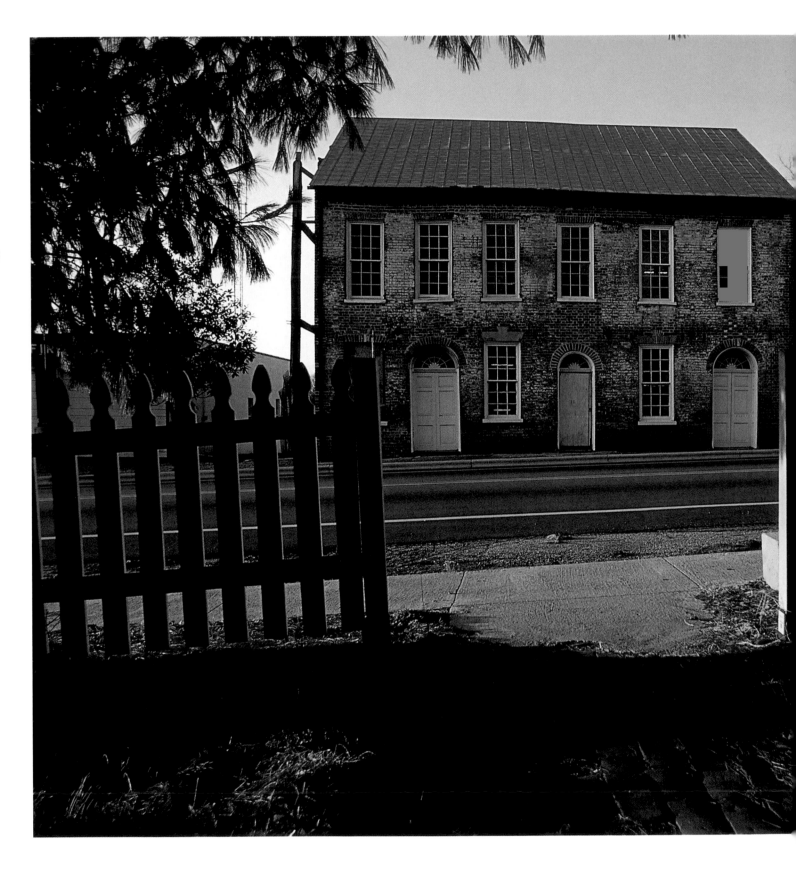

THOMAS DAY HOUSE

From 1848 to 1859, this trim little building was the home and shop of a free black man named Thomas Day, who was widely recognized as the most skilled cabinetmaker in the region and eventually had one of the biggest furniture-making operations in the state.

Here's how important he was: When a new law forbade black immigration from other states, Day's wife couldn't move from Virginia to North Carolina. Day threatened to move his business out of the state, setting off a scramble to prevent his departure. Many citizens, including the state attorney general, spoke in the cabinetmaker's behalf, and the legislature passed an exemption that allowed Day's wife to join her husband.

Commissions for Day's furniture poured in from area planters and at least two governors. His distinctive mantels, newels, and door frames grace homes throughout the region as well as buildings at the University of North Carolina. He produced pews for the local Presbyterian Church—in return, tradition says, for the right to sit on the main floor of the church instead of in the slave gallery.

Today, Day's furniture is proudly displayed in museums, but the man himself remains something of an enigma. He insisted on the respect due him as a free citizen, but he owned slaves. His artistry was acclaimed, but his life was hedged about by a thicket of laws and customs that provided constant reminders of his status as a black man. He couldn't even enforce debts against white customers. Did he brood over the injustice he experienced? Or did he find a way to put it out of his mind and just concentrate on the labor at hand, creating something proud and beautiful and lasting out of the hard, rough materials he had to work with?

The house tells us a lot, but it doesn't tell us everything. And even if we knew the answers, would we like them?

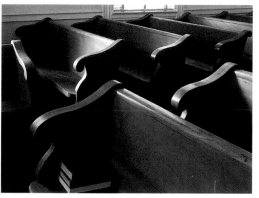

Top : *Day's distinctive pews in the Milton Presbyterian Church*

Above: *Advertisement in the* Milton Gazette, *1827*

Left: *Built in 1818, the building housed the Union Tavern before Thomas Day moved into it.*

ORIGIN
• 1810

CONDITION
• Severe fire damage

PROJECT SCOPE
• Complete exterior restoration and creation of museum

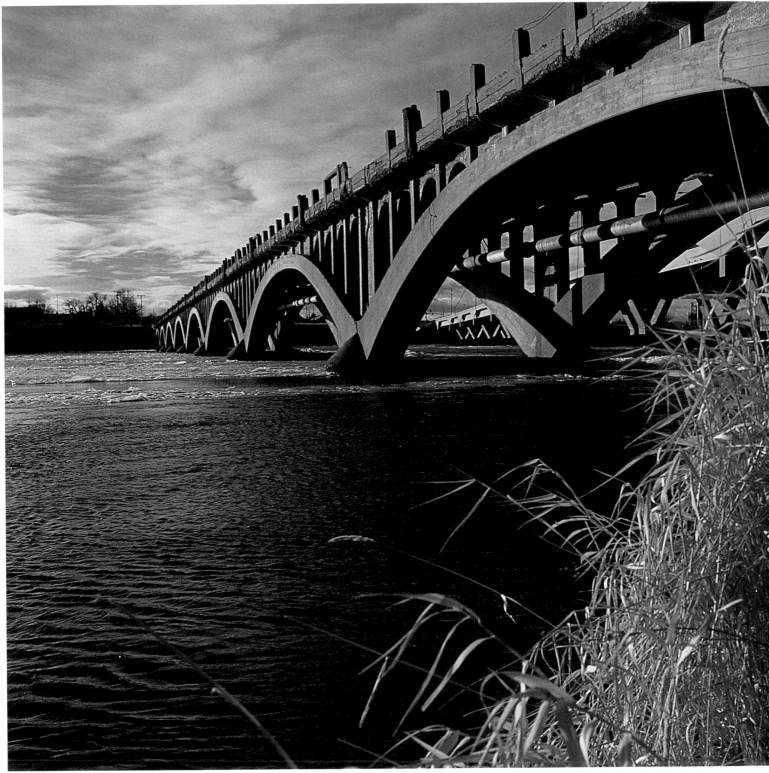

The bridge spans the Missouri River, not far from the falls that Meriwether Lewis called "the grandest sight I ever beheld."

TENTH STREET BRIDGE

GREAT FALLS, MONTANA

Skipping across the water like a flat stone flung by a small boy, the eight concrete arches of this bridge have linked the north and south banks of the Missouri River since 1920. Experts say it's the oldest and longest span of its type in the Great Plains.

People in Great Falls were enormously proud of the bridge when it was new, but then they forgot about it. They drove across

Above: *An arch under construction, 1920*

it every day, going to work or the drugstore or Grandma's house, and never gave it a thought—except maybe once in a while when the sun lit up those arches and the reflection in the water was really something to see.

In the mid-1990s the city built a new bridge and decided they didn't need the old one anymore, arches or no arches. The announcement of

141

impending demolition was an alarm bell, jolting many people with the realization that something familiar and beautiful, something important in ways they maybe couldn't even articulate, was about to disappear. Meetings were held, phone calls made, petitions circulated. An injunction halted the demolition with just six days to spare, and a court-appointed mediator helped broker an agreement to save the bridge.

It was a great victory—not just for preservationists but for everybody else too. Funds originally earmarked for knocking the bridge down will be used to renovate it instead. When the work is completed, the bridge—reserved for pedestrians and bicyclists—will be a tourist attraction, an important link in a new riverside trail, a site for concerts and flea markets, and a great place to watch a Montana sunset.

It's just like Joni Mitchell says in the song: "You don't know what you've got 'til it's gone." Happily, the people of Great Falls woke up in time, and they've still got it.

ORIGIN
• 1920

CONDITION
• Deteriorating concrete on spandrel arches, balustrades, and decking

PROJECT SCOPE
• Stabilize and repair bridge to original appearance and to safety standards; create a landmark pedestrian bridge

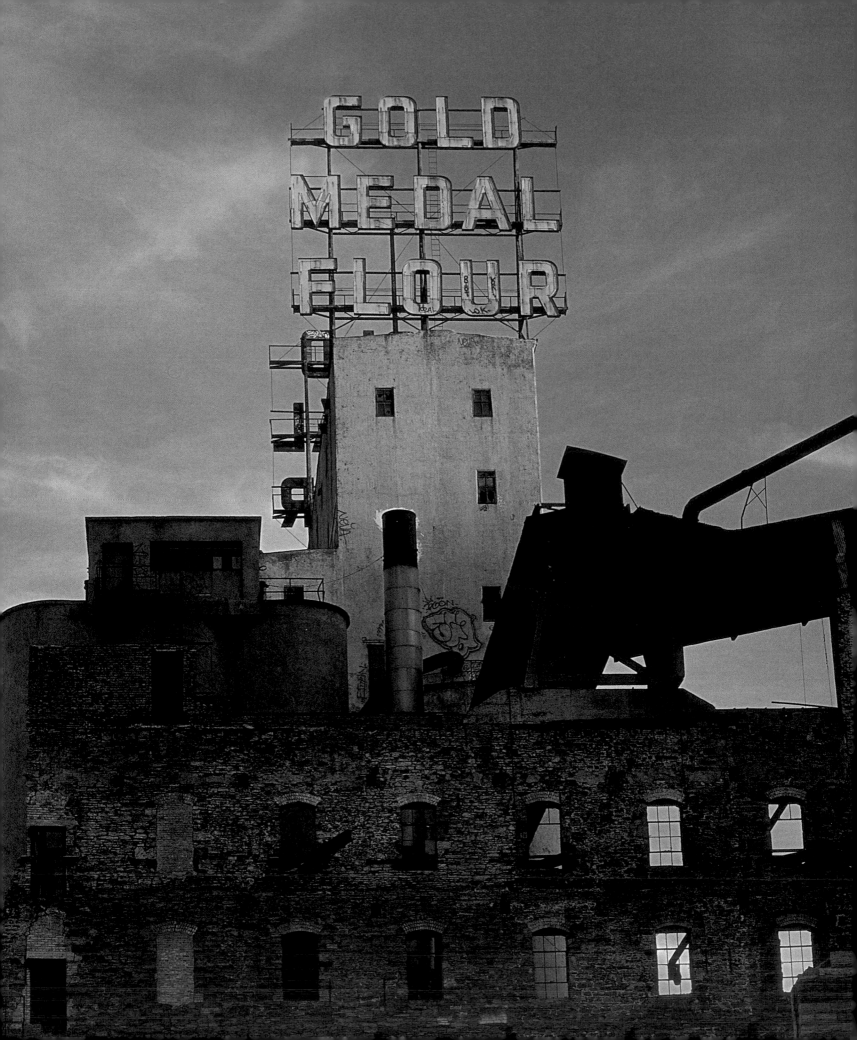

WASHBURN–CROSBY "A" MILL

MINNEAPOLIS, MINNESOTA

The first European explorers to pass this way must have heard the falls long before they saw them, the distant roar urging the tired men to quicken their pace until at last they stood awestruck at the sight of the great river crashing and foaming over the rocks. Later arrivals, drawn to the spot not by the falls' scenic allure but by their potential as a source of power, built a settlement here. The settlement became a town, then a city called Minneapolis, and the roar of the falls was the steady drumming of the city's industrial heartbeat.

In the mid-19th century, as rich harvests of grain poured in from the farmlands that stretched off to the horizon around the city, the power of the falls helped make Minneapolis the flour-milling capital of the nation. In the flour industry's heyday, 30 mills lined the riverfront, massive buildings with household names like "Pillsbury's Best" and "Gold Medal" painted on their walls or flashing from their roofs. None was more impressive than the Washburn "A" Mill, built in 1874 and rebuilt after a disastrous fire in 1879. By the time it ceased operations in 1965, the huge Washburn complex had become the birthplace of the industrial giant General Mills and the home of the company's famous symbol, Betty Crocker.

In 1991 another fire left the building in ruins, an imposing curiosity in a country so enamored of building and clearing and rebuilding that ruins are few and rare. There are plans to turn it into a lively museum and orientation center where visitors can learn about the milling district. For now, however, the shell of the great "A" Mill is quiet, an evocative reminder of the times when many of the nation's—and the world's—loaves and piecrusts carried inside them an echo of the thunder of the falls.

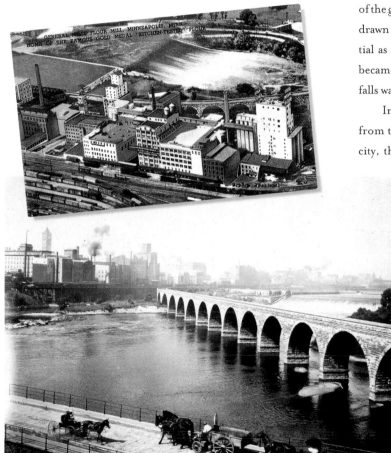

Top: *Postcard view of the huge mill complex beside the falls*

Above: *The graceful Stone Arch Bridge, 1905*

Opposite: *A familiar brand name towers over the burned-out shell of the Washburn-Crosby "A" Mill.*

ORIGIN
• 1879-80

CONDITION
• Fire-gutted ruin

PROJECT SCOPE
• New construction to create museum complex, incorporating remaining ruins of original building

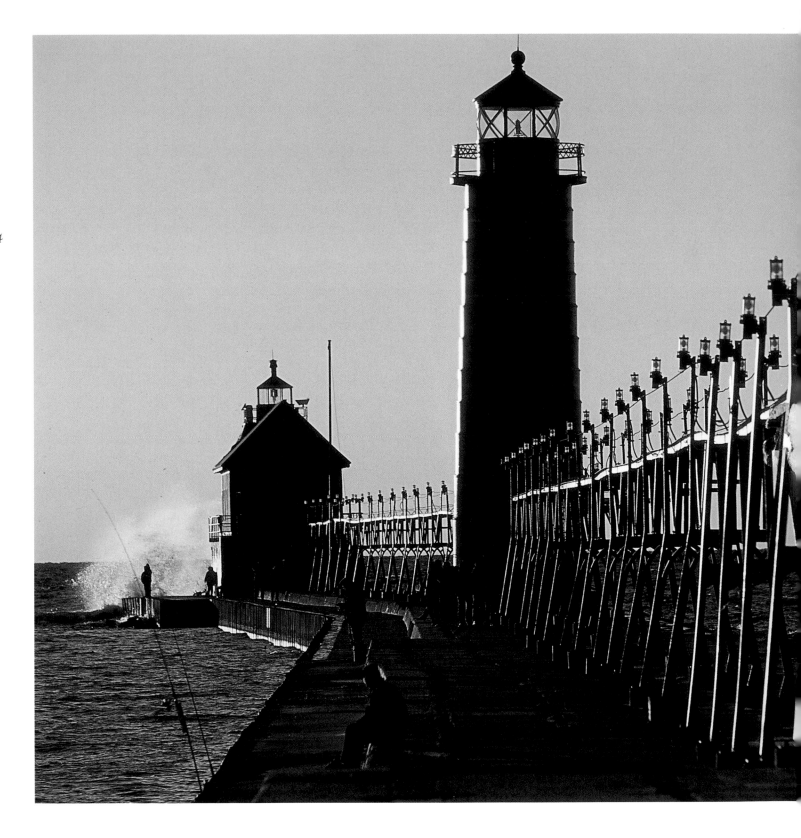

MICHIGAN LIGHTHOUSES

The word "noble" gets applied to lots of different kinds of buildings. Castles, banks, courthouses—with varying degrees of appropriateness, they've all been called "noble." If there's one building type that really deserves the label, it's the lighthouse, whose sole purpose is to save lives and property. What could be nobler?

The basic form—a bright light atop a tall tower—hasn't changed since the famed Pharos of Alexandria, one of the Seven Wonders of the Ancient World. The technology involved in producing, magnifying, transmitting, and maintaining the light, however, has changed a great deal—from the open flame used at Alexandria to a simple arrangement of lamps and reflectors in the 18th century, from the jewel-like Fresnel lens introduced in the 1820s to today's electric bulbs and automatic timers. Something else has changed, too: The stalwart lighthouse keeper, once a near-mythic popular hero, has been rendered nearly extinct by automation.

Given the romance and nostalgia with which we've invested them, it's a sad fact that lighthouses simply aren't as important as they once were. Advances in technology now enable ships to navigate precisely and avoid dangerous waters without the aid of stationary beacons. As a result, large numbers of obsolete lighthouses are being disposed of by the U.S. Coast Guard—some to be converted to private homes or inns or museums, others to be boarded up until a new owner appears with a viable new use.

Michigan has more lighthouses than any other state—about 120 of them, perched on bluffs and beaches and pier heads all around the state. Most of them look more or less like the Grand Haven light seen here, a compelling sculptural composition of pure geometry: cone and cylinder for the light, cube and triangle for the adjacent house. Many of them face an uncertain future.

145

Above: *Gratiot Light at Port Huron, circa 1900*

Left: *Grand Haven Light on the shore of Lake Michigan is one of many lighthouses that may be rendered obsolete by technological advances.*

ORIGIN	CONDITION	PROJECT SCOPE
• 1825-1940s	• Wide range of conditions from severely deteriorated to stabilized	• Facilitate the orderly transfer of 77 lighthouses from U.S. Coast Guard to local nonprofits for preservation

B & O ROUNDHOUSE

MARTINSBURG, WEST VIRGINIA

That soaring roof makes the interior of the roundhouse look remarkably like the inside of a circus tent. But this was never a place for fun. It was a noisy, steamy, dirty place where gangs of men sweated and swore in the hard work of keeping the trains running for the Baltimore & Ohio Railroad.

In 1877, 11 years after this roundhouse was built, workers here played a key role in an important event—one of those moments when the cogwheels of history stop with a *clunk* and then start moving in a new direction.

The mid-1870s were bad times for American railroad men. Wages were slashed again and again, and when new cuts were announced in July 1877, tempers finally boiled over. B & O workers in Martinsburg were the first to strike, bringing all freight traffic through the town to a halt. A few men were arrested, but when a crowd gathered in protest, the police (many of whom were former railroad workers) backed down. When the governor sent in the militia, there was a skirmish; a militiaman was wounded, and a striker killed. Increasingly desperate, the governor then asked President Hayes to send federal troops, and 300 infantrymen restored order.

The strike eventually spread across the country, and there were violent clashes in Baltimore, Pittsburgh, and elsewhere. It was America's first experience of industrial unrest on a national scale; one newspaper called it a "labor revolution." Labor lost this round—strikers everywhere finally went back to work at reduced wages—but it won a new and abiding sense of its own strength.

The Martinsburg roundhouse has stood vacant for many years now. Local supporters recently raised funds for its restoration with a benefit performance by dancers from the Kirov, Bolshoi, and Ukraine Ballets. The bloodied strikers of 1877 would have been astounded.

Top: *The original B&O Roundhouse, seen here, was destroyed by Confederate troops in 1862.*
Above: *This iron plate bears the date—1866— when the current roundhouse was built.*
Opposite: *Interior of the roundhouse, with the heavy wooden turntable in the foreground*

ORIGIN
• 1866

CONDITION
• Structurally sound with some water damage

PROJECT SCOPE
• Complete restoration for use as a multipurpose museum, cultural arts center, and transportation center for the region and state

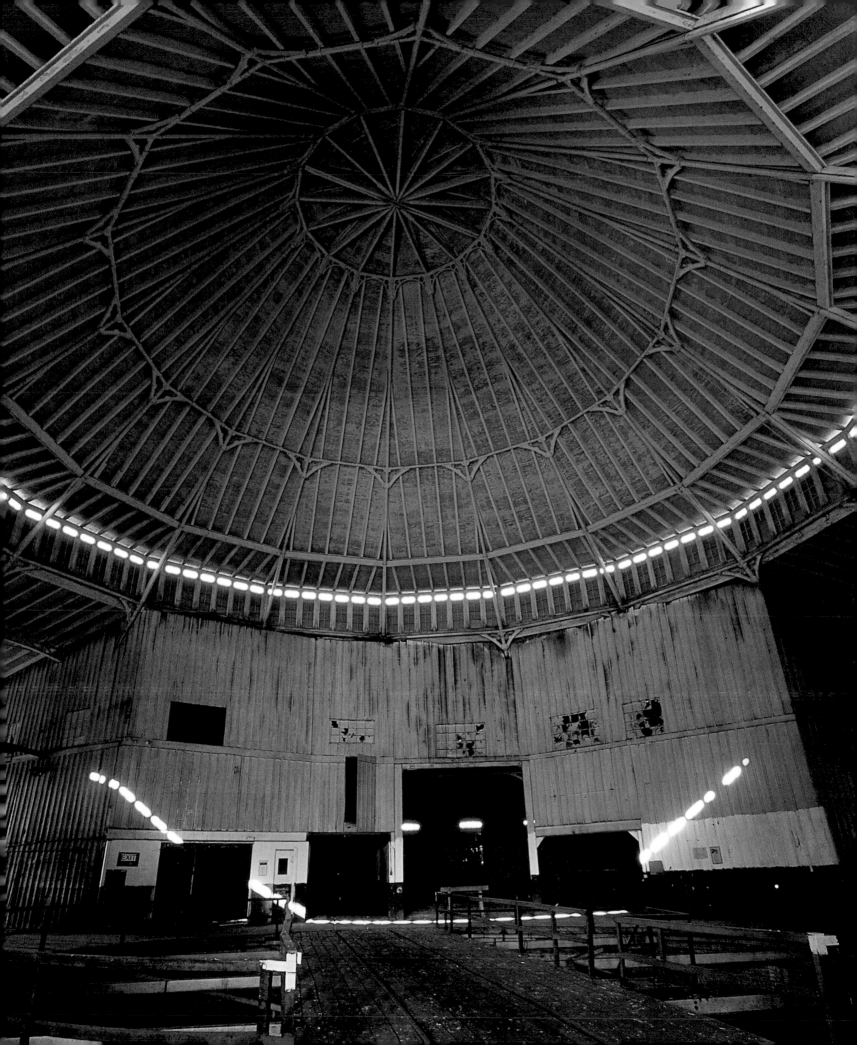

Teeple Barn

What is it that makes an old barn such a pleasure to look at? Maybe the appeal grows out of simple nostalgia: A barn speaks to that part of us that harbors a vague longing for the simple pleasures and rhythms of rural life, even if—maybe particularly if—we've never experienced rural life firsthand and haven't any idea of what farming is all about. Or maybe it has to do with honesty: Most barns look like what they are, attaining a sort of artless nobility through their utter disdain for architectural pretense or fussiness. Or maybe it's all about time and survival: Look long enough at a well-seasoned barn glowing softly in the late afternoon sun, and you may well find yourself thinking, I hope I look that good when I'm that old. Whatever the reason, a building like the Teeple Barn is the visual equivalent of good home cooking: a simple feast for the unhurried, appreciative eye.

Not that it's an ordinary barn. There are thousands of barns in America, but not many of them have 16 sides. If you search hard enough you can find a good many with 8 or 10 or 12 sides and even several round ones, but a 16-sided barn is a genuine rarity. Farmer George Washington built one at Mount Vernon, and a century later farmer Lester Teeple built this one in Illinois.

Latticed with cross braces and rafters and centered on an ingenious multipulleyed device for lifting and distributing hay, the shadowy interior achieves a level of Piranesian grandeur that makes "Teeple Barn" seem too modest a moniker; "Teeple Temple" is more like it. Architect W. W. Abell must have been conscious that he had created something truly noteworthy here: The cupola with which he topped off the building towers over the surrounding Kane County farmland like a big exclamation point.

Top: Ada and Lester Teeple
Above: Lester Teeple poses in a wagon beside his barn, circa 1900.
Opposite: The 8-gabled cupola atop the 16-sided Teeple Barn

ORIGIN
- 1885

CONDITION
- Extensive water damage; structure stabilized, critical compression ring and original cupola reconstructed

PROJECT SCOPE
- Rehabilitation of the barn into a modern regional agricultural education center

148

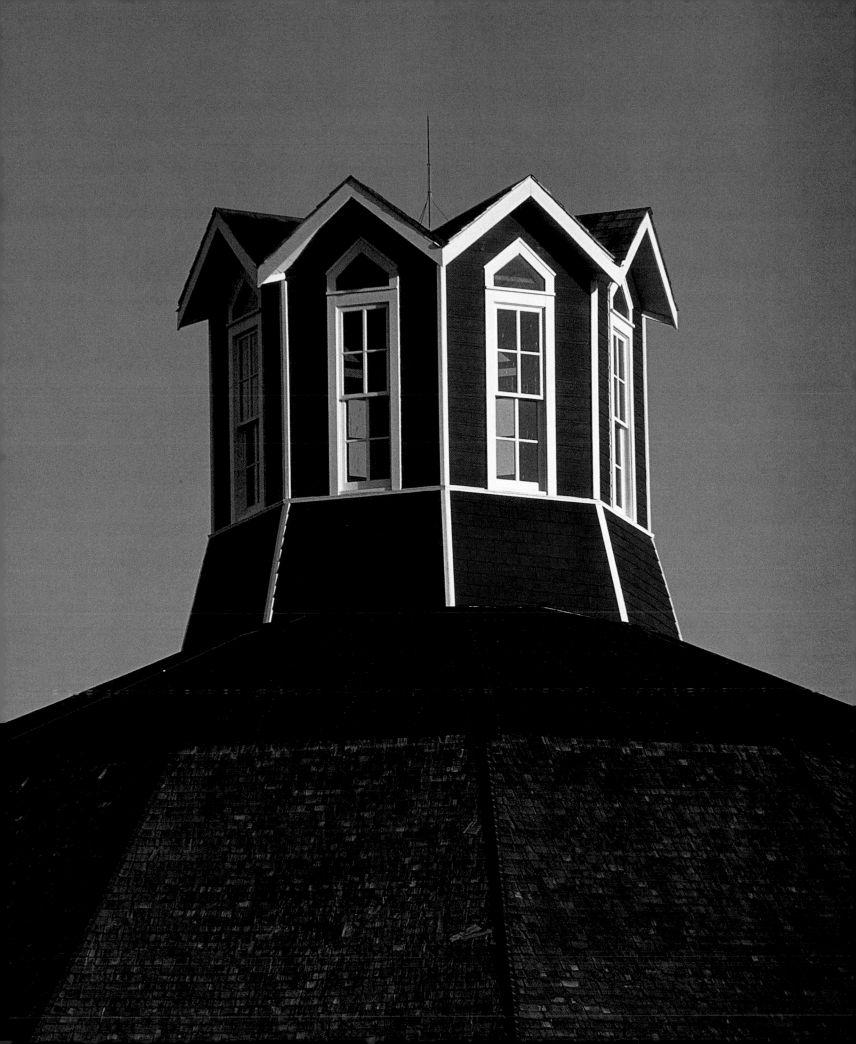

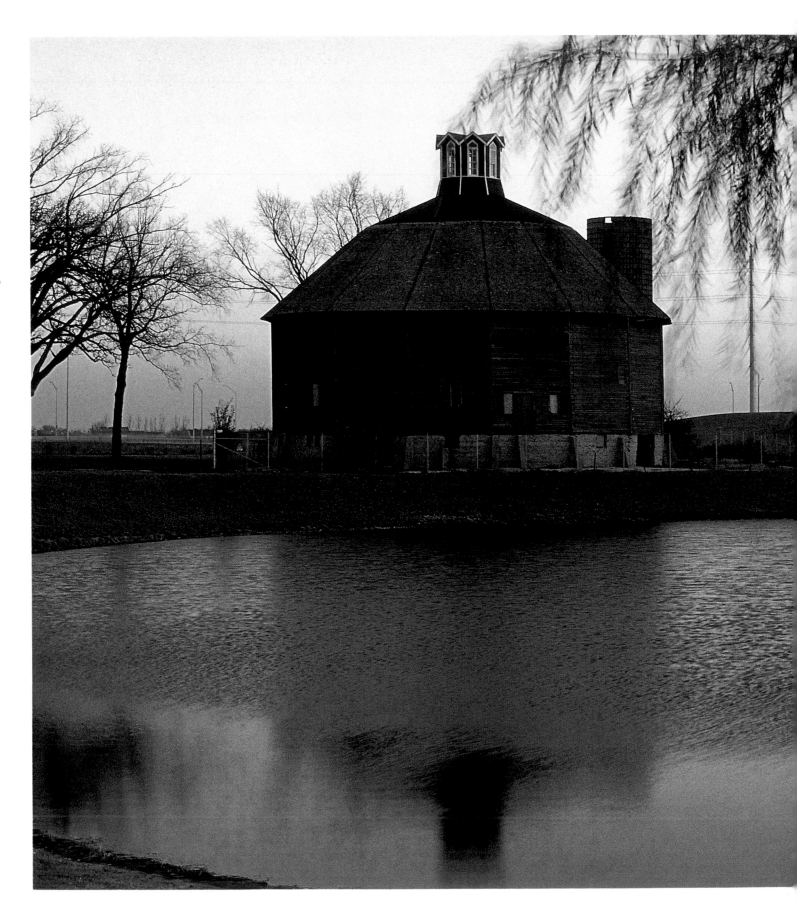

Framed by willow branches and a tranquil pond, the Teeple Barn presents an idyllic image of rural life.

On This Site

Ian Frazier

WHEN I WAS IN MY EARLY 20S I TRAVELED A LOT BY Greyhound bus, mostly in the Midwest. I was living alone in Chicago then and spent much of my time in a gloomy and uncommunicative mood, for no real reason, and I found that long rides on the Greyhound were well-suited to my frame of mind. I don't know why long-distance bus travel should be depressing, but in general, it is. Bus stations, where all that travel piles up and empties out, tend to be depressing, too. Late one night I was sitting in the Greyhound station in downtown Chicago waiting for a bus to Iowa, sunk deep in my Greyhound mood. I was at one of those chairs with a little coin-operated TV attached, but the TV wasn't on. As I stared uncheerfully at the people carrying their belongings in laundry bags, the little kids dressed in pajamas, the guy in the over-large black cowboy hat and the down vest patched with electrical tape, all of a sudden a young black man emerged from the escalator that brought passengers from the downstairs gates. He stepped off the escalator and raised his hands and said, "Thank God, I'm finally here! I finally made it! Oh, man, I have been dreaming of this day!" A halo-like radiance came from his face as he looked around, and wherever his glance landed, his eyes lit up more. There at the top of the escalator with people stepping around him he stood exulting at his arrival and flinging his hands above him as if tossing kisses in the air.

In another moment, still exclaiming, he had gone on his way. Afterward I noticed that the bus station, newly polished on all its surfaces by his joy in it, looked different to me. I now saw it as a longed-for place, a gleaming destination filled with hope and possibility. I felt ashamed of myself—first, because despair is a sin, and I had unfairly projected my own not-genuine version of it on this unoffending place which was, after all, only doing its job; and second, because I suddenly realized that this was not where I should be.

Over time, places begin to look the way people feel when they look at them. The rattiest amusement park, for example, still looks like fun, just as the sunniest hospital waiting room does not. If a mood is cast upon a place often enough, the

Showing the effects of decades of sea air, a stern Art Deco eagle stands guard over the Ellis Island Ferry Terminal.

153

place absorbs it, begins to reflect it, and can even induce it in people who were not feeling it to begin with. For this reason, hanging out in a depressing place being depressed is not as private an act as it might seem; you're not only experiencing your mood, you're eliciting it from what's around you. From an environmental standpoint, indulging in a gloomy mood in a bus station is not a very civic-minded thing to do.

Or so it seems to me now; back then I was still basically a child, and counted on my parents and other grown-ups to construct the world for me, and did not have a civic-minded thought in my head. That an internal mood of mine could have a correspondence with the real world never occurred to me. And yet as I looked at the Chicago Greyhound Station after the exultant young man had gone, I realized that his particular hopefulness was a feeling I would never share. This place would never be the shining city on a hill for me. I also saw that, undeniably, New York City was where I really wanted to be. And so, soon after, I gave up my apartment and hitchhiked there. My own personal longed-for places, it turns out, are ones where bright radii of light come from the buildings like spokes from an axle, and global, oceanic backlighting streams all around: The corniest movie landscape of Manhattan somehow has been imprinted deep within me.

On the last leg of the journey to the city I got a ride with a guy about my age who had recently immigrated from Peru. He was driving a low-slung copper-colored sedan and had olive skin and long black hair. We made a congenial pair; our points of origin differed, but our excitement of destination was just the same. The city's skyline poked above a ridge, and then we came down the long descending loop of elevated highway that ends at the entrance to the Lincoln Tunnel like a swirl going down a drain. In another moment we popped up in the silver-tinted daylight of Manhattan with noise and people and buildings teetering all around us, and the Peruvian left me at the corner of 33rd Street and Seventh Avenue and disappeared forever. I stood on the sidewalk with my one suitcase silently congratulating myself that I had made it, that I was here. I remember feeling almost dizzyingly free.

I HAVE NEVER SEEN the city's horizon from the other direction—from the east—because I have never arrived in New York by sea. Of course for centuries that was how millions of people did arrive; the city's eastern side should be the brighter one, for all the hopefulness with which it has been seen. Immigrants first got used to weeks and weeks of the same ocean they'd been on since they left Europe, and then one day on the horizon to the west someone saw a faint line, and the sails of

Buffalo Trace Greenway

LOCATION • Johnson City, Tennessee

ORIGIN • Late Pleistocene

CONDITION • Threatened animal and paleo-indian trail

PROJECT SCOPE • Create seven- to eight-mile greenway connecting Buffalo Mountain City Park to Tipton-Haynes Historic Site

ships in the distance seemed to be converging on it, and the first gulls flew by. Then the city's steeples and buildings and the masts of ships in the harbor approached the people crowded at the bow railing. New York harbor sites like Castle Clinton and the Statue of Liberty and Ellis Island, ordinary seeming and almost invisible to those who pass by them every day, also have another existence as first-seen images in a landscape of happy endings that has been renewed millions of times. The harbor's history imposes a responsibility on the city from which it will never get away: actually to be the hope-filled place at which so many people thought they had arrived.

In 1976, two years after I moved to New York, the city celebrated the nation's bicentennial with a procession of tall sailing ships in New York Harbor on the Fourth of July. The ships, square-rigged and tall-masted revivals of the age of sail from all over the world, sailed one after the next up the Hudson River past the city's skyline, then turned and came back on the Jersey side. They filled the harbor sky with a stately and splendid multitude of sails and masts that reminded us not only of New York's age-old excellence as a harbor, but also of all the high aspirations that have disembarked here. On Fourth of July night, two million people gathered at the then-new acreage of landfill on the Hudson River downtown (where Battery Park City now stands) for a fireworks display. The fireworks turned out to be almost nothing, a fizzle, and afterward the two million people just stood there in the summer night—unentertained, no further program planned, nothing to buy, all of us packed so tight we could barely move—acre after acre of people unrowdily celebrating the country's two hundred years and the freedom we cared about even if we weren't exactly sure why it mattered or what it was.

Patriotic speeches would only have diminished the spirit among that silent, observant throng. I happened to be wedged among people on an elevated section of the old West Side Highway, and below us the crowd of two million stretched across the level, sandy landfill for perhaps half a mile. As a mass it seemed to breathe and murmur beneath the city's pinkish sky. In the size of the crowd, in its immense, murmuring silence, I felt for a moment the accumulation of two hundred years of history in the country, and the longing for freedom that has been a part of it from the start. Of course I said nothing about this impression at the time, and if the friends I was with that night felt as I did, they gave no sign. I suppose we were afraid of sounding hokey. It's hard not to, when you talk about topics like

freedom and equality and the idea of America; but as I stood looking at the crowd, I understood that all that old-time patriotic rhetoric was based on something completely real.

WORDS FAIL, but meaning inheres in silence, and in places. A place where history occurred, and a plaque with a few straightforward sentences saying what happened there, are eloquent to me. I am sort of a collector of American historic places, and I like them better the less adorned they are. There's no marker of any kind, for example, at the roadside by Foothill Boulevard in the greater Los Angeles town of Pacoima where the L.A. Police were videotaped beating motorist Rodney King. One afternoon my brother-in-law and I looked for the site for over an hour, finding it only after receiving directions from a woman sergeant at the local police station. The place and its surroundings are so much like countless other exurban landscapes—the intersection, the gravel shoulder, the nearby convenience store, the omniscient streetlight overhead—that it could be 10,000 American anywheres.

I stared at it and stared some more without being able to get much purchase on it in my mind. I couldn't reconcile this ten feet of nondescript beige road shoulder with the enormity of what began here. I thought of the beating, and the nationwide and worldwide coverage of the beating, and the trial of the police officers, and the riot that followed their acquittal; of south-central Los Angeles in flames, of the thousands arrested, of the many Korean store owners killed. Maybe this site's apparent nothingness has to do with the fact that it is not so much a distinct place as the generic setting for that terrifying video so widely broadcast. Or maybe this place's message is simpler, and involves the ubiquity and ordinariness of evil.

Maybe the witnessing of evil invests a place with shame, causing it to efface itself and sidle from our gaze. I do know that places where great deeds occurred, by contrast, usually look great. They project the confident geniality of a much decorated hero, an atmosphere pleasant to hang out in for hours at a time. Ebenezer Baptist Church in Atlanta, where Dr. Martin Luther King, Jr., used to preach, is open on weekdays, as part of the Martin Luther King, Jr. National Historic Site. If you're in Atlanta and have a few spare hours, you must go. Especially on weekday afternoons when no one is there, the cool, dark-paneled, high-vaulted church hall has the prettiest silence in the world. The history-making sermons that once resounded here give the silence momentum and dignity. I like to sit in one of the church's wood-backed folding seats near the rear of the hall and let the room's mighty silence cascade around my ears.

"The Battle of Gettysburg" Cyclorama

LOCATION • Gettysburg, Pennsylvania

ORIGIN • 1905

CONDITION • Folding and buckling of fabric; stress due to improper mounting and inadequate exhibit space; damage from improper conservation techniques and moisture.

PROJECT SCOPE • Complete examination, treatment, conservation, and reinstallation of painting for public view

Every year on Martin Luther King, Jr.'s birthday my family and I watch a videotape of his whole "I Have a Dream" speech (delivered, of course, not at Ebenezer Baptist but at the March on Washington, D.C.). As a lover of American places, I get a special charge out of the "let freedom ring" part toward the end of the speech, where he lists the places across the country from which we should let freedom ring. "Let freedom ring from the prodigious hilltops of New Hampshire!" he says, and then repeats the sentence, substituting a new place each time: "…from the mighty mountains of New York"; "…from the heightening Alleghenies of Pennsylvania"; "…from the curvaceous slopes of California," etc., ending with, "from every hill and molehill of Mississippi, from every mountainside, let freedom ring!" The list of places is so specific you can practically see the pebbles on the ground. And at each mention of a place, he's touching it with a metaphorical wand that removes it from a landscape "sweltering with the heat of injustice" and restores it to the great common property, the land of the free.

Nowadays we're told that history is a Rashomon story, a bunch of different and usually conflicting narratives none of which has a claim on total truth. But occasionally good and evil, right and wrong, emerge so unmistakably at a historical moment that ambiguity disappears and conflicting narratives converge. I think that in our history the Civil War was such a moment, and the years of the civil rights movement were another. Actually going to the place where the struggle occurred, I've found, can help us to see through the complications and understand the story's essential simplicity. My great-great-grandfather fought at the Battle of Gettysburg and after the battle marched south with his Ohio infantry regiment and other Union troops in pursuit of the retreating Southern Army. After two days' march, not meeting up with the enemy, they came to a town and camped on the grounds of a college nearby. By cross-referencing between an old book of the regiment's history and a current road map, I located the narrow, winding creek-bottom road they marched on, and the college—St. Mary's College, by Emmitsburg, Maryland—where they camped.

The college's original buildings, red brick versions of the Greek Revival style, still stand. They're on an eminence above the main road, which was dirt back then, and now is paved and busy; an expanse of lawn, now with a parking lot on some of it, stretches between the buildings and the road. The regimental history says, "…an afternoon's rest at the college was a grateful relief." I walked on the freshly mown

lawn in the stately calm of the campus, and suddenly I got the picture: The men of the regiment fought in the battle for days, lost comrades killed and wounded, marched 21 miles, and finally, with immediate danger past, rested here. They knew their cause was just, as indeed it was; lying at their ease on this lawn with the enemy nowhere near, perhaps they had a dawning sense that the course of history had altered, and that they were going to win. I believe that these graceful college buildings and the lawn and even the superimposed parking lot still show the benefit, ineffable but real, of having been the quiet place where brave men rested for the first time after the Battle of Gettysburg.

WE HAVE LESS AND LESS in common nowadays. We spend our lives divided up into subcategories, staring at screens filled with images and information aimed ever more specifically at each onlooker alone. The close-up physical world we inhabit is usually an artificial space that has little to do with any actual earth beneath a person's foot. Sealed in an air-conditioned car speeding on an interstate or in an airplane at 40,000 feet, where, exactly, are we? Often the actual geographic place intrudes only when technology fails: The car breaks down, the plane crashes, and suddenly we notice a certain piece of ground.

The fact that we still have to share places, whether we notice them or not, makes them more valuable and rare. In an age of burgeoning electronic fantasies, places continue to be stubbornly irreducible and real. Happily, much of the country remains a place still held in common, as is the idea of the country itself. And any place here, fenced or paved or public or private, cannot avoid being part of the land of the free; it has to try to live up to the name, however badly it might fail. Lincoln said, in his Gettysburg Address, that the soldiers who had fought and died there had consecrated the ground. Acts of consecration have been done in America over and over. People have looked on the country with hope, and acted with hope, and evidence of the hope invested is still here. You can see it in historic places, or meet it with an unexpected rush of gratitude in an airport terminal when you return from far away. America is an idea and a country and a place, each bound up and evident in the other. The consecrated and numinous and even everyday places we share remind us of the common enterprise of freedom we're pursuing in America.

Ellis Island Ferry Building, Statue of Liberty National Monument

ORIGIN • 1892-1954

CONDITION • Severely deteriorated structure with leaking roof, blocked gutters, broken windows, peeling paint, damaged cladding and heraldic eagles on Art Deco tower

PROJECT SCOPE • Exterior preservation, connecting corridors, and extension of the mechanical, engineering, and plumbing infrastructure to the south side of Ellis Island; link rehabilitated side of Ellis Island and the south side as a catalyst for future rehabilitation of remaining structures

On Ellis Island's unrestored south side, a deserted hospital offers mute testimony to those whose infirmities kept them out of the city that glittered so tantalizingly across the harbor, and a derelict ferry terminal (opposite) welcomes no one.

158

Thick stone walls and gun embrasures recall Castle Clinton's original military function.

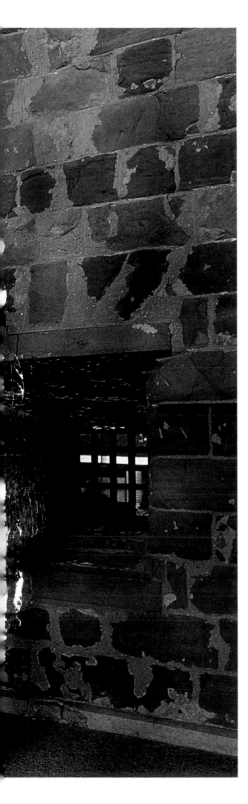

CASTLE CLINTON

Old buildings are almost infinitely adaptable. Just consider the many and varied uses to which the building known as Castle Clinton has been adapted since it was completed in 1811.

In its original incarnation as a fort defending New York Harbor, it is credited with deterring a British attack during the War of 1812. Extensively remodeled and renamed Castle Garden, it served from 1824 to 1855 as the country's largest public assembly hall, hosting performances ranging from the orations of Daniel Webster to the trilling of the "Swedish Nightingale" Jenny Lind. Lafayette began his triumphal national tour by stepping ashore here, and ticker-tape parades honoring Charles Lindbergh, Amelia Earhart, and Nelson Mandela started at the Castle's gates.

Its role as America's "front door" expanded when, as the Castle Garden Emigrant Depot, it welcomed almost eight million newcomers to the New World between 1855 and 1890. After another thorough makeover the building housed the New York Aquarium, one of the city's premier cultural attractions, from 1896 to 1941. Threatened with demolition, it was eventually turned over to the National Park Service and given its present function as starting-point for boat trips to the Statue of Liberty and Ellis Island.

Top: *Jenny Lind sings at Castle Garden, 1850.*

Bottom: *A flotilla of well-wishers welcomes Lafayette to Castle Garden, 1824.*

Few people remember Castle Clinton's one-time role as the nation's primary point of entry for immigrants, but almost everyone knows about Ellis Island. An estimated 40 percent of Americans can trace ancestry to the 12 million immigrants who passed through Ellis Island between 1892 and 1954—a fact that helps explain the huge throngs who flock to the restored Main Building.

ORIGIN

CONDITION

PROJECT SCOPE

• 1811

• Serious threat to exterior from erosion caused by wind-borne abrasives, salt crystallization, freezing water, and damp conditions; original mortar crumbled

• Expand access to New York Harbor; create an educational center with a performance venue and modern ferry terminal, and promote water-based recreation

CLIFF DWELLING SITES

MESA VERDE NATIONAL PARK, COLORADO

On a winter day in 1888, a couple of cowboys looking for stray cattle reined in their horses on the rim of a canyon and gaped open-mouthed at what they saw through the swirling snowflakes: a huge stone castle tucked into an alcove in the canyon wall. Climbing down into the ruins, the men found traces of wall paintings, stone tools, and pottery scattered through rooms which, by current estimates, had been uninhabited for 700 years when the cowboys stumbled upon them.

The complex known as Cliff Palace is now the centerpiece of Mesa Verde National Park, which sprawls across 52,000 acres of canyon and mesa in southwestern Colorado. With more than 500 cliff dwellings and thousands of other archaeological sites, Mesa Verde is a treasure of world significance. It is also a dream place, wrapped in vastness and silence, rich in legend and mystery.

We've given a name to the builders—Anasazi, the "ancient ones"—and we believe they first lived in pit houses and adobe buildings atop the mesa. We aren't sure why they built the cliff dwellings; maybe there were religious reasons, or maybe the cliffs offered better protection from enemy raiding parties. We know that the "golden age" of Anasazi culture was brief. We don't know why they left—were they fleeing war or drought, was the soil worn out, the game killed off?—but by 1300, only a century after the first cliff dwellings were built, Mesa Verde had been abandoned. We know that hundreds of people once made their homes here, raising children and chopping wood and tending crops—but it is hard to imagine these canyons bustling with life. It's so quiet here now. A hawk soars, a chipmunk chatters, the junipers rustle in the wind. The stones of the palace glow pinkish-gold in the sunlight, and the questions hang unanswered in the piñon-scented air.

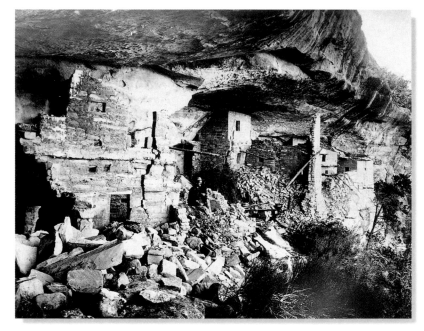

Above: Balcony House in the early 1890s
Opposite: Stone walls and a roofless kiva at Cliff Palace

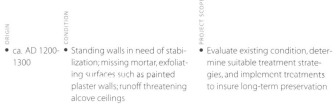

ORIGIN	CONDITION	PROJECT SCOPE
• ca. AD 1200-1300	• Standing walls in need of stabilization; missing mortar, exfoliating surfaces such as painted plaster walls; runoff threatening alcove ceilings	• Evaluate existing condition, determine suitable treatment strategies, and implement treatments to insure long-term preservation

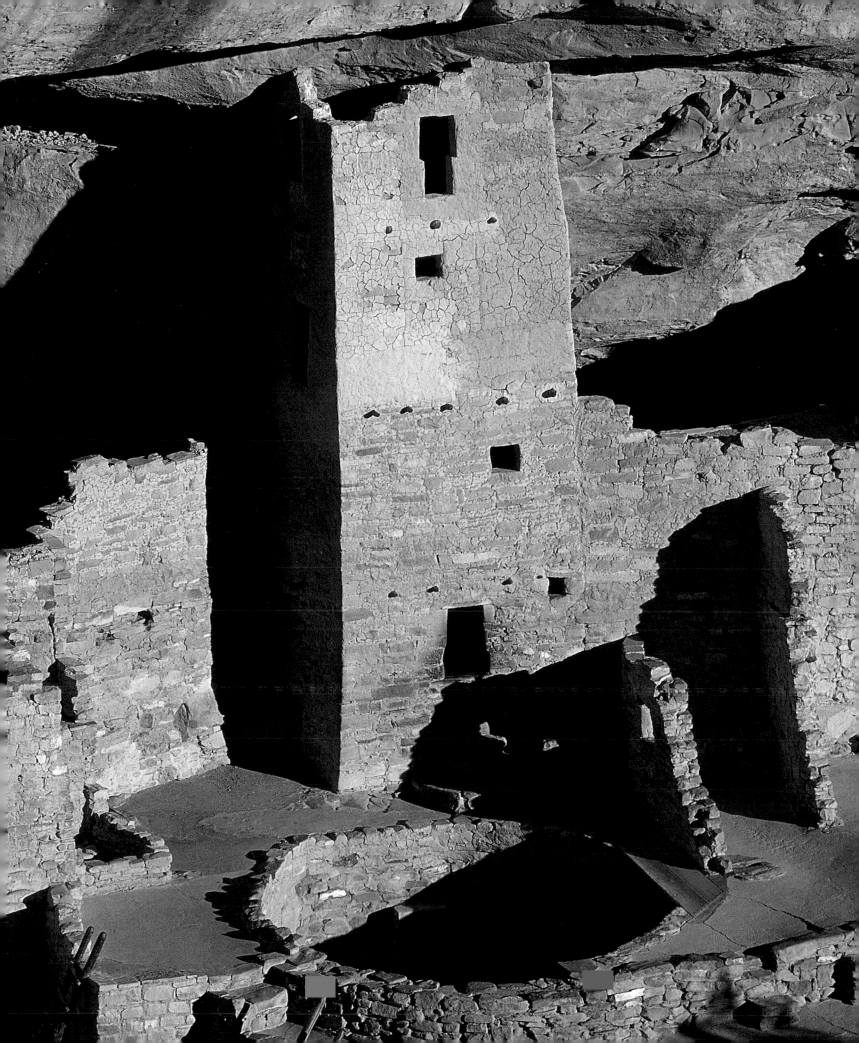

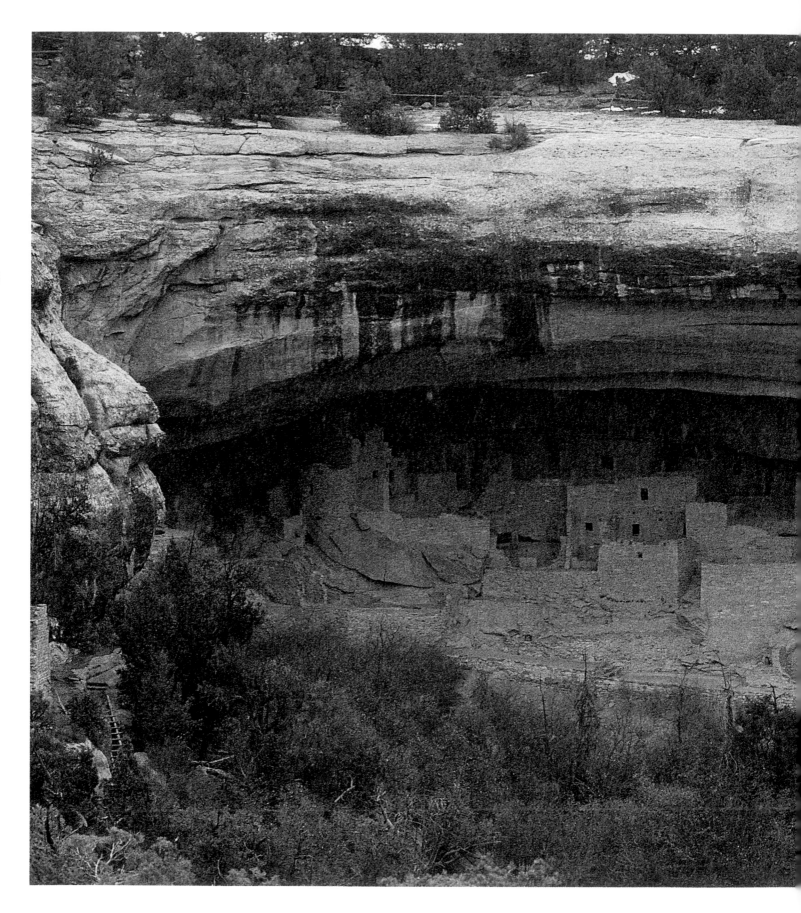

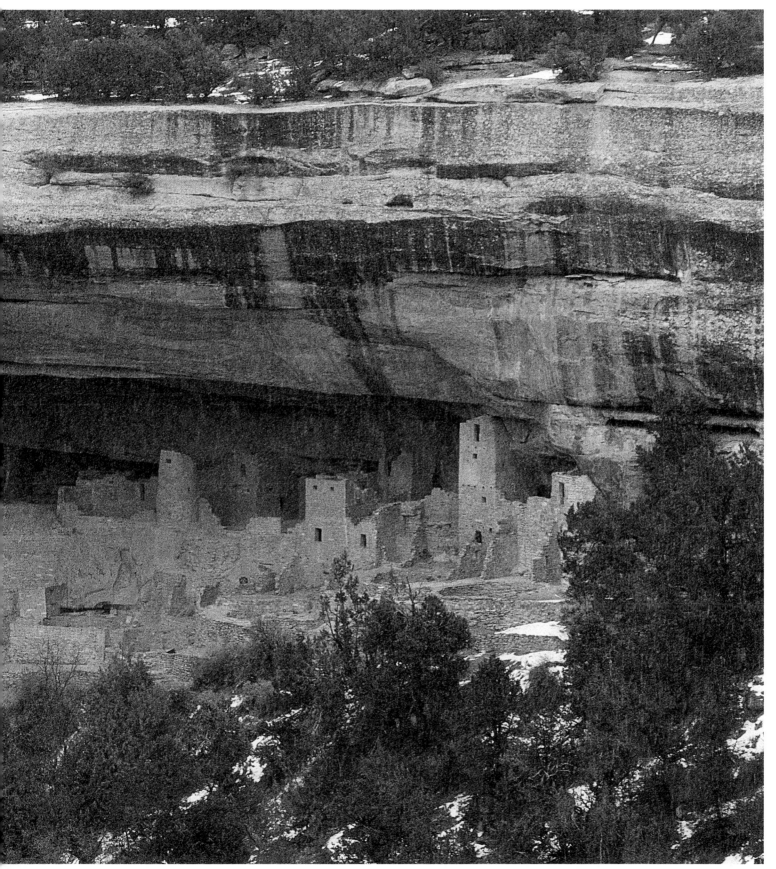

With more than 200 rooms, Cliff Palace is the largest of approximately 600 cliff dwellings at Mesa Verde National Park in southwestern Colorado.

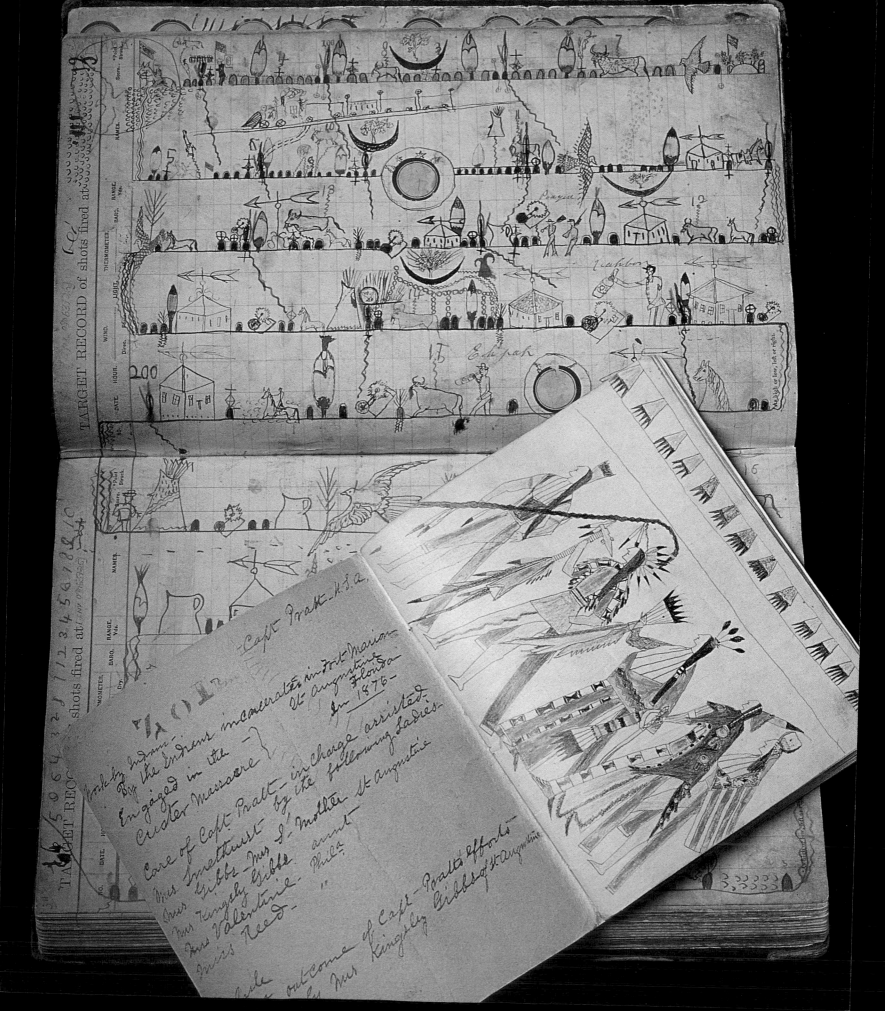

NATIVE AMERICAN ARTWORK

Americans tend to think of the New World as an empty stage before the Europeans arrived. In fact, it was anything but empty—and it wasn't even "new." It was thickly populated by peoples who had been here for centuries. They called themselves by gorgeous names: Hidatsa, Arapaho, Kutenai, Iroquois. They lived their lives, fought their wars, raised their families—did, in short, just what other cultures were doing in other corners of the globe. And then the Europeans arrived, and in a little more than 400 years the world these Native Americans had made was almost completely swept away.

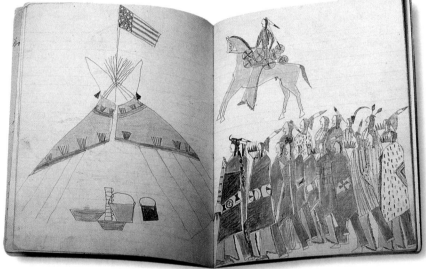

Above: *These colorful and strikingly stylized images were produced in the 1890s by a Kiowa artist named Silver Horn (Haungooah).*

Opposite: *Other examples of Silver Horn's work include an elaborate pictorial calendar in an* Army Target Record Book *and a drawing of a stately procession of warriors.*

Today, reminders of the richness of that vanished world are reverently displayed in museums. Less well known than the spectacular pottery, textiles, beadwork, and jewelry that awe visitors in galleries all over the country are the collections of the National Anthropological Archives in the National Museum of Natural History.

Among the treasures in the Archives is a series of drawings—including those that brighten the pages of the *Army Target Record Book* seen here—by a Kiowa man named Silver Horn (Haungooah). He made these drawings while serving as an enlisted soldier in Troop L of the 7th Cavalry at Fort Sill in the early 1890s—less than 20 years after a unit of the 7th Cavalry commanded by Gen. George Armstrong Custer had met disaster at the Battle of the Little Bighorn.

Many of Silver Horn's drawings were collected by anthropologist James Mooney, who studied the Kiowa at a time (the 1890s) when they were among the last of the Plains tribes maintaining their traditional ways. The Kiowa elders shared information readily with Mooney because they appreciated the importance of his work. Like him they could see, with terrible clarity, the fast-approaching end of their world, and they didn't want it to disappear without a trace.

167

ORIGIN
• 1800-2000

CONDITION
• Works of art on fragile and brittle paper

PROJECT SCOPE
• Provide conservation care to stabilize drawings and make images accessible on the Internet

ANGEL ISLAND IMMIGRATION STATION

Between 1910 and 1940, an estimated 175,000 Chinese and 60,000 Japanese, along with thousands of immigrants from other nations, passed through the station on Angel Island in San Francisco Bay. For many of them, the experience was a soul-searing one. At New York's Ellis Island, most newcomers were allowed into this country after a quick medical screening. At Angel Island, by contrast, the primary objective was to keep most immigrants—particularly the Chinese—out.

The Chinese Exclusion Act of 1882, targeting Asians willing to work for low wages as a threat to American workers, barred Chinese laborers from entry to the United States while allowing freer passage to students, merchants, government officials, and children of U.S. citizens. Chinese immigrants arriving at Angel Island had to endure humiliating medical examinations, intensive interrogations, and long waits while their eligibility for entry was closely scrutinized. They lived in constant fear of deportation. Most were detained for two or three weeks; a few were held for as long as two years. Kept in limbo at the very gateway to the "gold mountain" (*gam saan*) they had crossed the Pacific to reach, many detainees poured out their feelings in poetry, turning the walls and woodwork of the Detention Barracks into a unique and moving record of frustration, hope, and heartbreak. One inscription signed "By One from Xiangshan" reads:

> *There are tens of thousands of poems composed on these walls.*
> *They are all cries of complaint and sadness.*
> *The day I am rid of this prison and attain success,*
> *I must remember that this chapter once existed.*

On Angel Island today, the barracks that was a prison is given over to tourists, the wind, and the fog. But the poems of complaint and sadness remain. And the chapter is remembered by those who lived it and their American-born descendants.

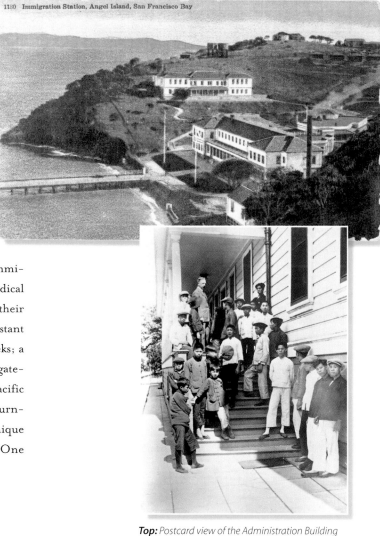

1130 Immigration Station, Angel Island, San Francisco Bay

Top: Postcard view of the Administration Building (foreground) and Hospital.

Above: Detainees on hospital steps, circa 1920s

Opposite: Painstakingly carved inscriptions on the walls of the Detention Barracks record detainees' hopes, frustrations, and despair.

ORIGIN
* 1910-1940

CONDITION
* Structural, code, and accessibility deficiencies; deterioration of carved poetry on interior walls; changes and removal of features in historic landscape

PROJECT SCOPE
* Stabilization and adaptive reuse of buildings; preservation of carved poetry; interpretation and restoration of historic landscape

YBOR CITY

Heavy with the rich aromas of black beans and tobacco, plantains frying and coffee brewing, the sultry breezes that blew through the streets of Ybor City must have been enough to send strollers into olfactory overload. For many residents, the neighborhood's aromas—like its architecture, its social institutions, and the rhythms of everyday life in its streets—were reminders of the homelands they had left behind.

In the last decade of the 19th century, thousands of immigrants, most of them from Cuba, Spain, and Italy, settled here on the east side of Tampa and went to work in Ybor City's major industry: cigarmaking. They labored in small factories, rolling Coronas, Perfectos, and Panatelas that were sold around the world. They raised families in small houses surrounding the factories, worshiped in neighborhood churches, and bought their shoes and chairs and groceries in neighborhood stores.

To keep their cultural identity alive, they founded social clubs that assumed an all-important role in community life. With names that celebrated ethnic roots, clubs such as El Circulo Cubano and L'Unione Italiana provided handsome facilities where members could dance, play cards, and see musical performances and movies. Caruso himself supposedly sang at the Centro Asturiano, where a densely lettered fire curtain told theatergoers where to get their hair marcelled or their typewriters repaired.

For a few decades, Ybor City was a self-contained world. But most residents dreamed of being assimilated into the American mainstream, so as they achieved a measure of financial security, they left for better jobs and homes elsewhere in their adopted land. One by one, the cigar factories closed down. Urban renewal projects demolished scores of houses, turning a neighborhood into a weedy wasteland.

Today, Ybor City is reinventing itself. Outside the old social clubs, tourists rub elbows with the century-old shades of hopeful newcomers who built a haven before going off to be Americans.

Above: "Lector" reading the newspaper to cigarmakers, 1930
Left: Cigar-box labels from Ybor City factories
Opposite: The handsome Unione Italiana was a home away from home for members of Ybor City's Italian community.

ORIGIN
• 1885–1944

CONDITION
• Cigar factories, industrial, commercial, and residential structures, ethnic clubhouses, and worker housing with range of restoration needs

PROJECT SCOPE
• Preserve and redevelop historic buildings associated with Cuban, Spanish, and other ethnic associations and the cigar industry

170

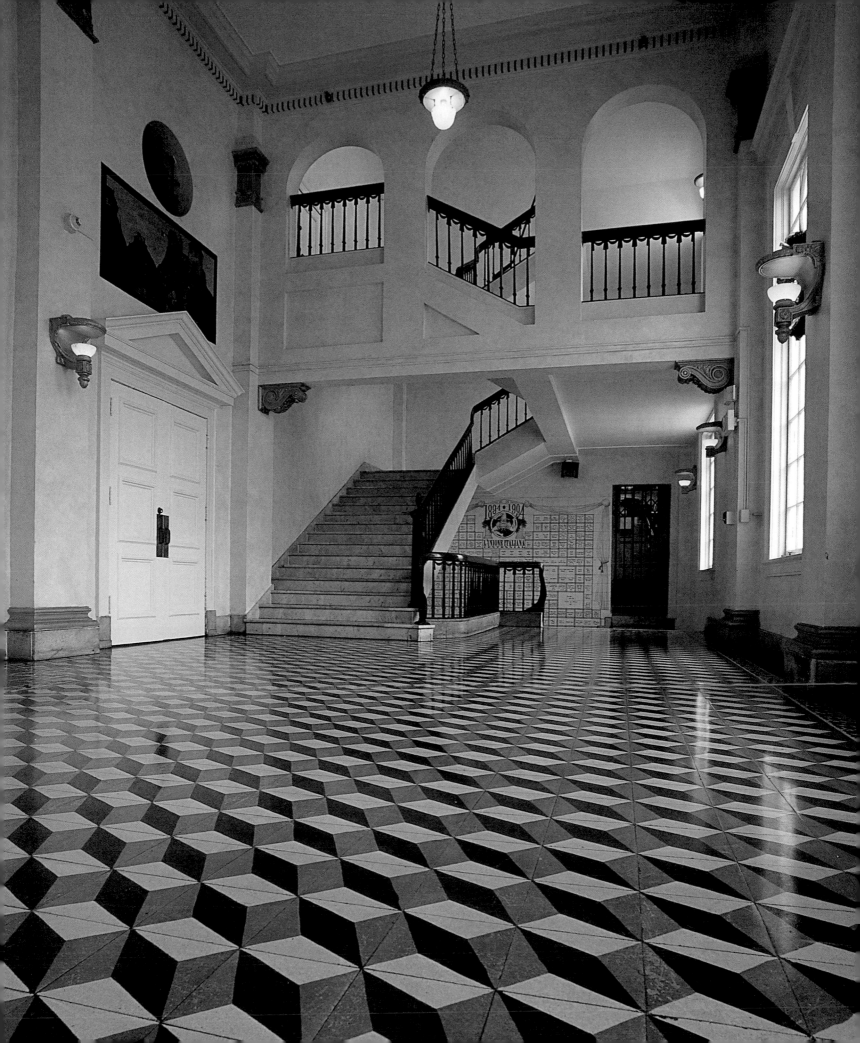

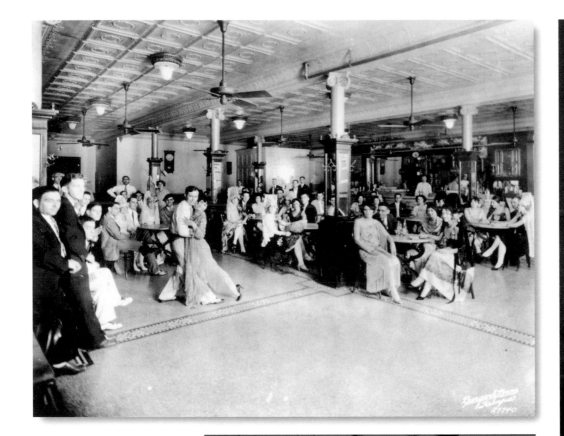

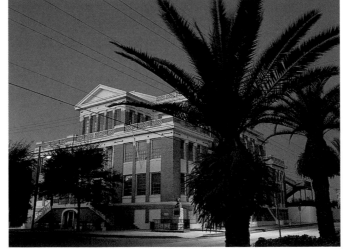

Top: *A festive evening at the Centro Asturiano, 1930s*

Right: *When this clubhouse was built in 1917, El Circulo Cubano had 8,000 members.*

Far right: *The 1,100-seat theater at El Centro Asturiano, built in 1914, is Ybor City's grandest.*

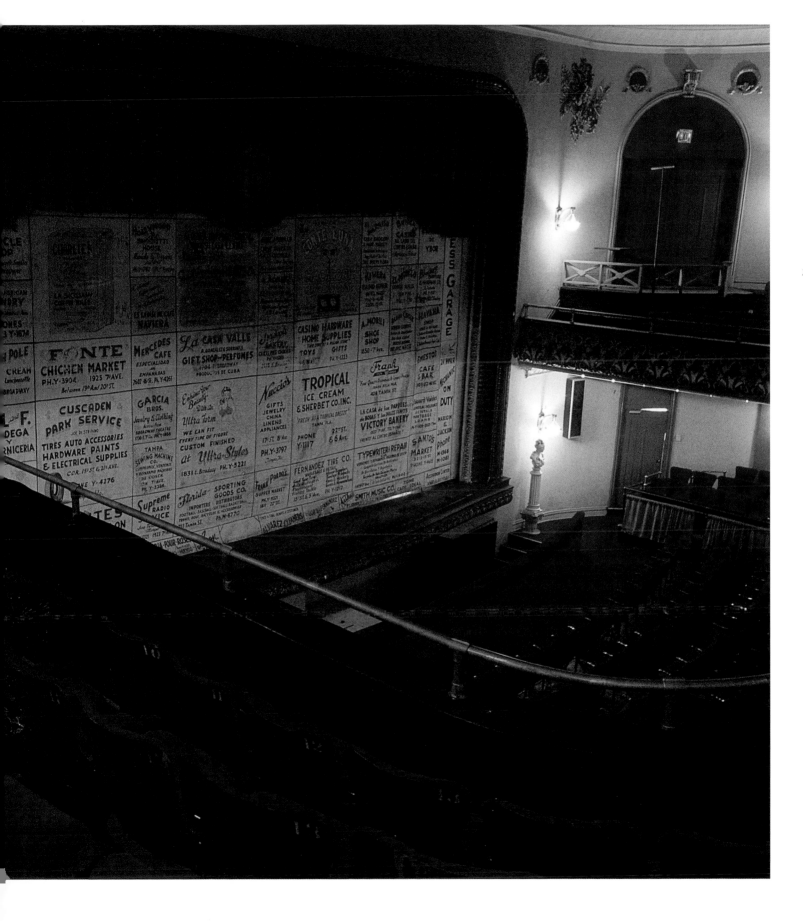

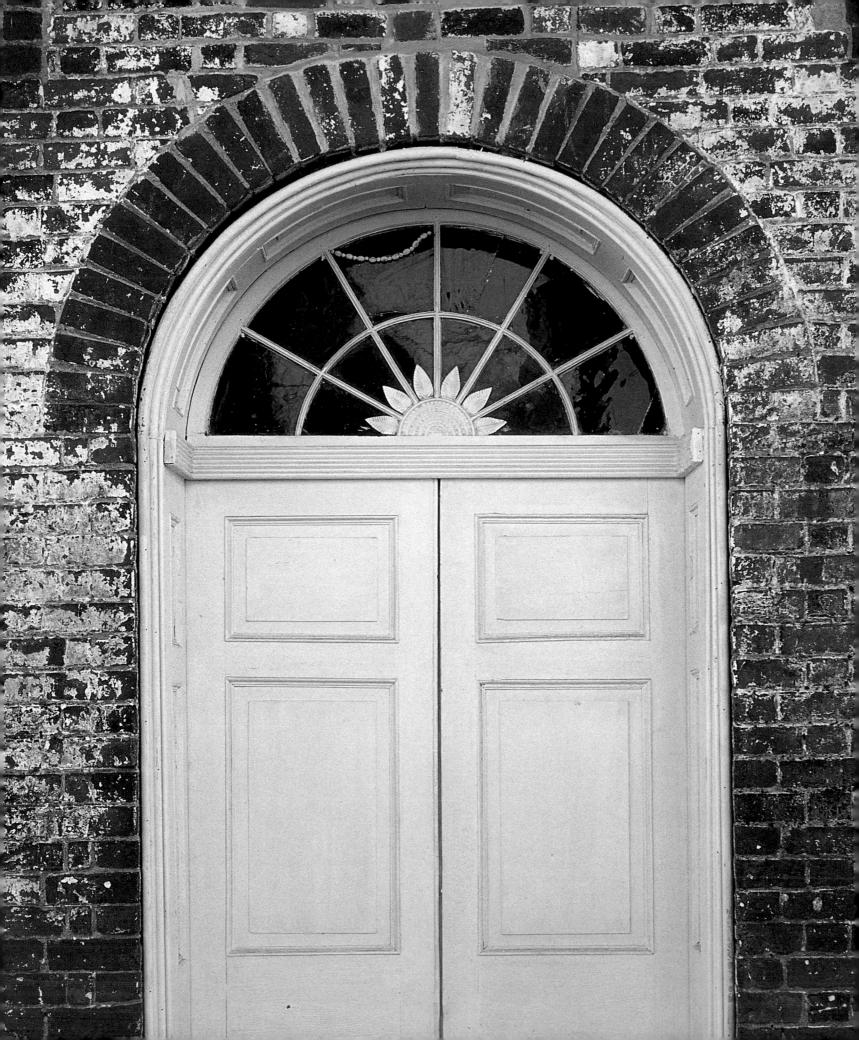

Preserving our Past

Richard Moe

MY DICTIONARY DEFINES "TREASURE" AS "SOMETHING OF 175
great worth or value." That seems an accurate—if woefully under-
stated—definition of the places and things described in this book.

What are we to make of a collection that includes dried
plants, bridges, letters, houses, films, cemeteries, and paintings
on airplane noses? What do these things have in common? I believe that Ray
Suarez's essay provides the perfect answer to that question when it asserts that these
noble, tattered, stirring, ordinary, comical, marvelous things carry "the DNA of
our democracy." In other words, this seemingly random aggregation of miscella-
neous wonders is *us*.

In their amazing diversity, these treasures tell us (whether we like it or not)
who we are as a nation. They constitute an epic cultural narrative whose chapters
include not only world-famous icons like Ellis Island and the Star-Spangled Ban-
ner, but also lesser-known places—*hidden* treasures, if you will—like the Colonial
Theatre in Pittsfield, Massachusetts, the prairie churches of North Dakota, and the
little Jinsha Shrine on the island of Maui. There are some genuine eye-poppers
here (who can look at Mesa Verde, for example, without being stirred by its grandeur
and mystery?), but not all of them are beautiful, at least in the conventional sense.
Some of them can make us smile, others are intensely moving, still others are sim-
ply a puzzle. A few of them even have the power to make us acutely uncomfortable,
which means we probably ought to scrutinize them with particular thoughtfulness.

Perhaps the most important thing they share in common is this: They are
worth saving.

Several years ago, while I was researching a book about the Civil War, I went to
Gettysburg to examine a photo relating to the battle. I was shocked and disappointed
to learn that the photo was no longer in the Gettysburg archives; it had been lost or
stolen. That's when I first realized that America's heritage is disappearing. That lost
photo is merely one entry on a tragic list that includes H. H. Richardson's Marshall
Field Warehouse in Chicago, the Jobbers Canyon Historic District in Omaha,

*A federal-style fanlight lends a note
of chaste elegance to the Thomas Day
House in Milton, North Carolina.*

Louisiana's Uncle Sam Plantation, the Mapes Hotel in Reno, New York's magnificent Pennsylvania Station, and hundreds of diners and mansions, courthouses and mills, barns and theaters—as well as countless documents, films, and artworks—whose loss has left gaping holes in our communities and our lives.

This gradual whittling away of our heritage is a prospect that we should find absolutely unacceptable. Because the complicated story of where we came from, how we got here, and at what cost is bound up in the wood and stone, paper and paint of the treasures described in this book, losing any one of them would be like losing a part of ourselves that we simply can't do without.

This simple fact—that some things are just too important to lose—lies at the heart of Save America's Treasures. Created by the White House Millennium Council in 1998 as a focus of the national celebration of the millennium, and enjoying the sincere and enthusiastic support of its honorary chair First Lady Hillary Rodham Clinton ever since its inception, the program has become a model public-private partnership—and the most ambitious preservation initiative ever undertaken in this country.

As the lead private-sector partner of the White House Millennium Council, the National Trust has been honored to work with Heritage Preservation and the National Park Foundation to designate more than 600 Save America's Treasures Official Projects. This designation serves a dual purpose: It encourages local preservation efforts and helps attract gifts from corporations, foundations, and individuals to support those efforts. Thus far, the program has generated more than $110 million from public and private sources, in amounts that range from substantial federal appropriations to individual gifts of a few dollars. By helping to ensure the preservation of the houses and scrapbooks, stained-glass windows and sailing ships, outdoor sculptures and astronauts' space suits that tell America's story, these funds constitute an investment in our heritage. It's an investment that will continue to pay dividends for generations to come.

Save America's Treasures exemplifies the spirited grassroots activism that has been the primary strength of the American preservation movement ever since Ann Pamela Cunningham rallied the women of the nation to save Mount Vernon in the

Fort Douglas Heritage Commons

LOCATION	Salt Lake City, Utah
ORIGIN	1862
CONDITION	Structurally sound sandstone buildings
PROJECT SCOPE	Complete restoration and renovation; create campus environment with residential and programmatic usage

Montpelier, Home of James Madison

LOCATION • Montpelier Station, Virginia

ORIGIN • 1760

CONDITION • Insensitive additions over time; window and fireplace openings bricked in

PROJECT SCOPE • Restoration and reconstruction of the 1809-1812 main-floor bedroom chamber and basement kitchen

1850s. It's important to note that the collection of treasures listed in this book wasn't assembled by some "expert" in Washington who cast an imperious eye over our vast cultural landscape and said, "This is important, and this, and this." No, it came about because citizens all over the country—families and businesses, elected officials and schoolchildren, card-carrying preservationists and people who would never dream of adopting that label—identified the treasures that make their hometowns unique and committed themselves to the tough work of making sure that these places and things don't disappear.

Over the past several months I've had the pleasure of traveling with the First Lady and members of the Millennium Committee to Save America's Treasures to many of these places. In Chicago, we were awed by the vision of a new kind of architecture so powerfully expressed by Frank Lloyd Wright in his Robie House. In New Mexico, we were welcomed by hundreds of people who crowded around an outdoor stage where dancers performed with the magnificent mesa-top pueblo of Acoma as a backdrop. And in Washington, D.C., we walked thoughtfully through the rooms of the Soldiers' Home, where Lincoln finished the Emancipation Proclamation, and we touched the leaves of the great beech tree he used to climb with his young son.

Everywhere we went, the community's pride in its heritage—and in the treasures that are the tangible expression of that heritage—was inspiring. A strong sense of pride in our shared past has always provided the spark for preservation success. Imparting that pride to a bigger, broader audience of Americans may well prove to be the most valuable legacy of Save America's Treasures.

Travelers embarking on a long journey are often advised to take something familiar with them—a pillow or photograph or knicknack that can provide a comforting link with home. In a sense, we are all travelers today, leaving familiar shores behind and launching ourselves into a new century and a new millennium. As we go, we need to take these treasures with us.

They are the compass that can keep us from drifting off course.

They are our link with the past.

Even more important, they are our gift to the future.

Fallen leaves carpet an outdoor room in the garden of the Mount, Edith Wharton's home in Lenox, Massachusetts.

Official Projects of Save America's Treasures

Sloss Furnaces National Historic Landmark

LOCATION: Birmingham, Alabama

ORIGIN: 1881

CONDITION: Deterioration of steel support members, walkways, and sheet steel due to water damage

PROJECT SCOPE: Restore 1929 Blast Furnace Number One

Richard H. Allen Memorial Auditorium

LOCATION: Sitka, Alaska

ORIGIN: 1910-1911

CONDITION: Structurally sound wood-frame building in need of extensive rehabilitation; some localized structural failure and exterior deterioration; condemned in 1990 and almost razed

PROJECT SCOPE: Installation of new electrical, plumbing, fire suppression, and heating systems; renovation and rehabilitation for auditorium and performing arts center

Official Projects as of June 1, 2000

These projects are found in communities across the country and reflect the remarkable diversity of the people, places, and events that comprise the American tapestry. Many thanks to the individuals and organizations who are dedicated to rescuing these treasures.

Key to Index: **Bold: Project name** *Italic: Sponsoring organization* Roman: Location of project

ALABAMA

"Vulcan" Sculpture and His Park, *Vulcan Park Foundation,* Birmingham, Ala.
Gaineswood Mansion National Historic Landmark, *Friends of Gaineswood, Inc.,* Demopolis, Ala.
Rosa Parks Library and Museum, *Troy State University,* Montgomery, Ala.
Saturn V Rocket, *United States Space and Rocket Center,* Huntsville, Ala.
Save the Armory, 1844 Confederate Arsenal, *Talisi Historical Preservation Society, Inc.,* Tallassee, Ala.
Sixteenth Street Baptist Church, *Sixteenth Street Foundation,* Birmingham, Ala.
Sloss Furnaces, *Sloss Furnaces National Historic Landmark,* Birmingham, Ala.
Tannehill & Brierfield Ironworks, *Alabama Historic Ironworks Commission,* McCalla & Brierfield, Ala.

ALASKA

Fort Egbert National Historic Landmark, *Bureau of Land Management,* Eagle, Alas.
Paddling into the Millennium, *Alaska Native Heritage Center,* Anchorage, Alas.
Recreation Hall, Kennecott Mines, Wrangell-St. Elias National Park and Preserve, *National Park Service,* Cooper Center, Alas.
Richard H. Allen Memorial Auditorium, *Sheldon Jackson Historic Site Preservation Society, Inc.,* Sitka, Alas.
Sitka Pioneers Home, *Division of Alaska Longevity Programs,* Sitka, Alas.
Unalaska Aerology Building, *Alaska Support Office, National Park Service,* Unalaska, Alas.

ARIZONA

Clark Telescope and Dome, *Lowell Observatory,* Flagstaff, Ariz.
Honanki Cliff Dwellings, Coconino National Forest, *Coconino National Forest Sedona Ranger District, U.S. Forest Service,* Sedona, Ariz.
Mission San Jose de Tumacacori, Tumacacori National Historical Park, *National Park Service,* Tumacacori, Ariz.
Saving Southwest Traditions: The Pottery Project, Arizona State Museum, *The University of Arizona,* Tucson, Ariz.
Theodore Roosevelt School, Fort Apache National Register Historic District, *Bureau of Indian Affairs, Fort Apache Agency,* Whiteriver, Ariz.
Vail Ranch House, Empire Ranch Headquarters, Empire-Cienga Resource Conservation Area, *Bureau of Land Management,* Sonoita, Ariz.

ARKANSAS

Camp Ouachita National Historic District, *Central Arkansas Resource Conservation and Development Council,* Perryville, Ark.
Central High School National Historic Landmark, *National Park Service and Little Rock School District,* Little Rock, Ark.
Hotel Pines, *Citizens United to Save the Pines,* Pine Bluff, Ark.
Rialto Community Arts Center, *Rialto Community Arts Center,* Morrilton, Ark.
Star City Historic District, *Star City Historic District,* Star City, Ark.

CALIFORNIA

1894 Carmel Fallon Building, *The Community Center Project,* San Francisco, Calif.
Amargosa Opera House and Hotel, *Amargosa Opera House, Inc.,* Death Valley Junction, Calif.
Angel Island Immigration Station, *Angel Island Immigration Station Foundation,* San Francisco, Calif.
Breed Street Shul, Congregation Talmud Torah, *Jewish Historical Society of Southern California,* Los Angeles, Calif.
Bullocks Wilshire Building, *Southwestern University School of Law,* Los Angeles, Calif.
Calexico Carnegie Library, *City of Calexico,* Calexico, Calif.
Captain Fletcher's Inn, *Navarro-by-the-Sea Center for Riparian and Estuarine Research,* Elk, Calif.
Casa de Dana, *San Luis Obispo County Historical Society,* San Luis Obispo, Calif.
Charles Connick's Stained Glass Windows, *Grace Cathedral,* San Francisco, Calif.
Conservatory of Flowers, *Friends of Recreation and Parks,* San Francisco, Calif.
Cooper-Molera Adobe, *National Trust for Historic Preservation,* Monterey, Calif.
Dr. John Marsh Stone House, *John Marsh Historic Trust,* Brentwood, Calif.
Ennis-Brown House, *Trust for Preservation of Cultural Heritage,* Los Angeles, Calif.
First Church of Christ, Scientist, *Maybeck Foundation,* Berkeley, Calif.
Great Stone Church Monument, *Mission San Juan Capistrano,* San Juan Capistrano, Calif.
Kelley House Museum, *Mendocino Historical Research, Inc.,* Mendocino, Calif.
Knight Foundry Historic Water-Powered Iron Works, *Knight Foundry Corporation,* Sutter Creek, Calif.
Manzanar Internment Camp Perimeter Fence, Manzanar National Historic Site, *National Park Service,* Independence, Calif.

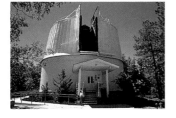

Clark Telescope and Dome

LOCATION: Flagstaff, Arizona
ORIGIN: 1896
CONDITION: Structurally sound Ponderosa Pine dome; potential for catastrophic fire damage
PROJECT SCOPE: Installation of fire-control systems; ongoing maintenance of telescope

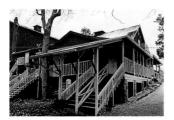

Westport Country Playhouse

LOCATION: Westport, Connecticut
ORIGIN: 1931
CONDITION: Structurally sound 19th-century barn converted to theater in 1931
PROJECT SCOPE: Complete restoration of oldest continuing summer theater in the country to year-round performing arts center

Peralta Hacienda Historical Park, *Friends of Peralta Hacienda Historical Park,* Oakland, Calif.
Rancho Los Cerritos Master Plan, *Rancho Los Cerritos Foundation,* Long Beach, Calif.
The Ebell of Los Angeles, Historic Women's Club and Theatre, *The Ebell of Los Angeles,* Los Angeles, Calif.

COLORADO

Buffalo Bill Memorial Museum and Grave, *Buffalo Bill Memorial Museum and Grave,* Golden, Colo.
Central Park Train, *Boulder County Railway Historical Society, Inc.,* Boulder, Colo.
CF&I Steel Archives Office Complex and Collection, *City of Pueblo,* Pueblo, Colo.
Cliff Dwelling Sites, Mesa Verde National Park, *National Park Service,* Mesa Verde, Colo.
Colorado's Most Endangered Places Program, *Colorado Preservation, Inc.,* Denver, Colo.
Cripple Creek Main Street Program, *City of Cripple Creek,* Cripple Creek, Colo.
Dress by Decade: Costumes of the Boulder Museum of History, *Boulder Museum of History,* Boulder, Colo.
El Corazon de Trinidad National Historic District, *Corazon y Animas de Trinidad Main Street Group,* Trinidad, Colo.
Hispanic Cultural Landscape of the Purgatoire and Apishapa, *Trinidad Historical Society,* Las Animas County, Colo.
Historic African-American Structures, *Colorado Preservation, Inc.,* Dearfield, Colo.
Historic Colorado Mining Sites Database, *Colorado Preservation, Inc.,* Denver, Colo.
Pike's Stockade, *State Historical Society of Colorado,* Sanford, Colo.
Preston Farm, *Historic Fort Collins Development Corporation,* Fort Collins, Colo.
San Juan Mining Districts, *Bureau of Land Management, Gunnison and San Juan Field Offices,* Hinsdale County, Colo.
Snowbound Mine, *Historic Boulder, Inc.,* Boulder County, Colo.
Southwest Colorado Collections, Anasazi Heritage Center, *Bureau of Land Management,* Dolores, Colo.
Telephone Directory Collection Digitization Project, *The Telecommunications History Group, Inc.,* Denver, Colo.
Totec Hotel, *Corazon y Animas de Trinidad Main Street Group,* Trinidad, Colo.

CONNECTICUT

1847 Beckley Iron Furnace and Grounds, *Falls Village-Canaan Historical Society,* East Canaan, Conn.
Cheney Bros. Machine Shop Building, *Manchester Historical Society, Inc.,* Manchester, Conn.
Citizen's Block Building, *Town of Vernon,* Vernon, Conn.
Eli Whitney Boarding House, *Connecticut Trust for Historic Preservation,* Hamden, Conn.
Florence Griswold House, *Florence Griswold Museum,* Old Lyme, Conn.
Franklin and Harriet Johnson Mansion, *Wallingford Historic Preservation Trust,* Wallingford, Conn.
Governor Samuel Huntington Research Project, *The Governor Samuel Huntington Trust, Inc.,* Scotland, Conn.
John Rogers Studio, *New Canaan Historical Society,* New Canaan, Conn.
Joseph Blakeslee House, *Wallingford Historic Preservation Trust,* Wallingford, Conn.
Lockwood-Mathews Mansion, *Lockwood-Mathews Mansion Museum,* Norwalk, Conn.
Mark Twain House, *Mark Twain House,* Hartford, Conn.
Memorial Building, Vernon Town Hall, *Town of Vernon,* Vernon, Conn.
Muddy River Schoolhouse, *Wallingford Historic Preservation Trust,* Wallingford, Conn.
Nehemiah Royce House, *Wallingford Historic Preservation Trust,* Wallingford, Conn.
The D. M. Read's Department Store, *Artspace Projects, Inc. and the Bridgeport Economic Development Corporation,* Bridgeport, Conn.
Sterling Opera House, *City of Derby,* Derby, Conn.
Westport Country Playhouse, *Connecticut Theatre Foundation,* Westport, Conn.

DELAWARE

Andrew Wyeth Paintings, *Wyeth Endowment for American Art, Inc.,* Wilmington, Del.
Gibraltar, *Preservation Delaware, Inc.,* Wilmington, Del.
Smyrna Opera House, *Smyrna-Clayton Heritage Association,* Smyrna, Del.
Winterthur/University of Delaware Program in Art Conservation, *Winterthur/University of Delaware,* Newark, Del.

DISTRICT OF COLUMBIA

Apollo Space Program Artifacts, National Air and Space Museum, *Smithsonian Institution,* Washington, D.C.
Benjamin B. Ferencz Collection, *United States Holocaust Memorial Museum,* Washington, D.C.
Carnegie Library, City Museum of Washington, D.C., *The Historical Society of Washington, D.C.,* Washington, D.C.
Charters of Freedom and Murals, *National Archives and Records Administration,* Washington, D.C.
Congressional Cemetery, *Association for the Preservation of Historic Congressional Cemetery,* Washington, D.C.
Decatur House Museum, *National Trust for Historic Preservation,* Washington, D.C.
Howard Theatre, *Project Change,* Washington, D. C.
James Monroe House, *Arts Club of Washington,* Washington, D.C.
The President Lincoln and Soldiers' Home National Monument, *U.S. Soldiers' and Airmen's Home,* Washington, D.C.
National Gallery of Art Index of American Design, and Permanent Collection of Sculpture, *National Gallery of Art,* Washington, D.C.
Native American Artwork Collection, National Anthropological Archives, *Smithsonian Institution,* Washington, D.C.
Paul Laurence Dunbar Theatre, *Peoples Involvement Corporation,* Washington, D.C.
Pierce Mill, Rock Creek Park, *Friends of Pierce Mill, Inc.,* Washington, D.C.
Sewall-Belmont House and Collections, *National Woman's Party,* Washington, D.C.
Star-Spangled Banner Preservation Project, National Museum of American History, *Smithsonian Institution,* Washington, D.C.
The Clara Barton Missing Soldiers Office and Artifacts, *U.S. General Services Administration, National Capital Region,* Washington, D.C.
The Lillian & Albert Small Museum, *Jewish Historical Society of Greater Washington,* Washington, D.C.
The Old Capitol Pumphouse, *Earth Conservation Corps,* Washington, D.C.
Thurgood Marshall Center for Service and Heritage, *Thurgood Marshall Center Trust, Inc.,* Washington, D.C.

181

Washington Monument, *National Park Service,* Washington, D.C.
Woodrow Wilson House, *National Trust for Historic Preservation,* Washington, D.C.

FLORIDA
Cà d' Zan, the Ringling Winter Residence, *The John and Mable Ringling Museum of Art, the State Art Museum of Florida,* Sarasota, Fla.
Edison and Ford Winter Estates and Arboretum, *City of Fort Myers,* Fort Myers, Fla.
Fort Dade Guardhouse Museum and Education Center, *Egmont Key Alliance/Egmont Key State Park,* Egmont Key, Fla.
Fort Jefferson, Dry Tortugas National Park, *National Park Service,* Monroe County, Fla.
Fort Zachary Taylor, *Florida Department of Environmental Protection,* Key West, Fla.
Frank Lloyd Wright Campus, *Florida Southern College,* Lakeland, Fla.
Historic Log Cabin, *Village of Biscayne Park,* Biscayne Park, Fla.
Historic Old City Hall, *City of Miami Beach,* Miami Beach, Fla.
Pelican Island National Wildlife Refuge, *U.S. Fish and Wildlife Service,* Sebastian, Fla.
St. Michael's Cemetery, *St. Michael's Cemetery Foundation of Pensacola, Inc.,* Pensacola, Fla.
St. Nicholas Cathedral, *St. Nicholas Cathedral,* Tarpon Springs, Fla.
The 1912 Citrus County Courthouse, *Citrus County Board of County Commissioners,* Inverness, Fla.
Ybor City Historic District, *Barrio Latino Commission,* Tampa, Fla.

GEORGIA
1873 Bartow County Courthouse, *Etowah Foundation,* Cartersville, Ga.
Archival History of LaGrange, *City of LaGrange,* LaGrange, Ga.
Battlefield Park Heritage Center, *Coastal Heritage Society and City of Savannah,* Savannah, Ga.
Ebenezer Baptist Church, Martin Luther King, Jr. National Historic Site, *National Park Service,* Atlanta, Ga.
Firehouse Center and Gallery, *Bainbridge-Decatur County Council for the Arts, Inc.,* Bainbridge, Ga.
Glen Mary Plantation, *Preservation America,* Sparta, Ga.
Hay House, *Georgia Trust for Historic Preservation,* Macon, Ga.
Owens-Thomas House Museum, *Telfair Museum of Art,* Savannah, Ga.
President Woodrow Wilson and Supreme Court Justice Joseph R. Lamar Boyhood Homes, *Historic Augusta, Inc.,* Augusta, Ga.
Rhodes Hall, *Georgia Trust for Historic Preservation,* Atlanta, Ga.
Historic Oakland Cemetery Women's and Men's Comfort Stations and Guard House, *Historic Oakland Foundation, Inc.,* Atlanta, Ga.

HAWAII
Maui Jinsha Shrine, *Maui Department of Planning,* Wailuku, Maui, Hawaii
Waikiki War Memorial Natatorium, *Friends of the Natatorium, Ltd.,* Honolulu, Hawaii

IDAHO
Experimental Breeder Reactor I, Idaho National Engineering and Environmental Laboratory, *Department of Energy,* Scoville, Idaho
Idaho State Park System Historic Preservation Plan, *The Idaho Department of Parks and Recreation,* Boise, Idaho
Murray Courthouse Restoration, *Murray Historical Society, Inc.,* Murray, Idaho

ILLINOIS
Anderson Barn Community Center and Farm Park, *Village of Lily Lake,* Lily Lake, Ill.
Aurora Civil War Memorial, *Aurora Civil War Memorial,* Aurora, Ill.
Canal Origins Park, *Canal Corridor Association,* Chicago, Ill.
Chess Record's Studio, *Blues Heaven Foundation, Inc.,* Chicago, Ill.
Chicago Cultural Center's Domes, *City of Chicago Department of Cultural Affairs,* Chicago, Ill.
Coronado Theatre, *Friends of the Coronado,* Rockford, Ill.
Elowa Farm, *Landmarks Preservation Council of Illinois & Lake Forest Foundation for Historic Preservation,* Lake Forest, Ill.
Field Museum Building, *Field Museum,* Chicago, Ill.
The Frank Lloyd Wright Home & Studio, *National Trust for Historic Preservation and Frank Lloyd Wright Preservation Trust,* Oak Park, Ill.
Frederick C. Robie House, *National Trust for Historic Preservation and Frank Lloyd Wright Preservation Trust,* Oak Park, Ill.
Gaylord Building, *National Trust for Historic Preservation,* Lockport, Ill.
Glessner House Museum Coach House and Courtyard, *Glessner House Museum,* Chicago, Ill.
Jane Addams/Hull-House Photograph Collection, *University of Illinois at Chicago,* Chicago, Ill.
Orpheum Theatre, *Orpheum Children's Science Museum,* Champaign, Ill.
Poetry Magazine Archives, University of Chicago Library, *University of Chicago,* Chicago, Ill.
Pullman State Historic Site, *Illinois Historic Preservation Agency,* Chicago, Ill.
Second Presbyterian Church, *Second Presbyterian Church,* Chicago, Ill.
Teeple Barn, *AgTech, Inc.,* Elgin, Ill.
Unity Temple, *Unity Temple Restoration Foundation,* Oak Park, Ill.

INDIANA
Bona Thompson Center, *Irvington Historical Society, Inc.,* Indianapolis, Ind.
Chief Richardville House, *Allen County-Fort Wayne Historical Society,* Fort Wayne, Ind.
Copshaholm, The Oliver Mansion, *Northern Indiana Historical Society,* South Bend, Ind.
Old Republic House, *Historic New Carlisle, Inc.,* New Carlisle, Ind.
West Baden Springs National Historic Landmark, *Historic Landmarks Foundation of Indiana,* West Baden Springs, Ind.

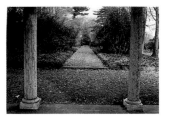

182

Gibraltar

LOCATION: Wilmington, Delaware
ORIGIN: House, 1844; formal gardens, 1915-1923
CONDITION: Mansion, greenhouse, and service building in general disrepair; water damage and structural problems
PROJECT SCOPE: Conservation of garden ornaments and statuary; creation of a visitors' center and establishment of tours, exhibits, workshops, and programming; adaptive reuse of buildings as an inn and restaurant

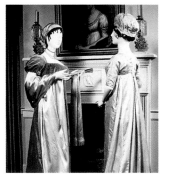

Dolley Madison's Clothing Collection

LOCATION: Greensboro, North Carolina
ORIGIN: circa 1805-1810
CONDITION: Deteriorating, fragile fabrics
PROJECT SCOPE: Conserve and preserve clothing representing the style of the fourth first lady of the United States

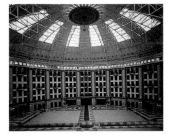

Boys' House, Harriman State Park of Idaho

Idaho State Park System Historic Preservation Plan

LOCATION: Boise, Idaho
ORIGIN: 1902
CONDITION: All building components restored and utilities updated
PROJECT SCOPE: Restored as venue for interpretive programs, classrooms, and public meetings

West Baden Springs National Historic Landmark

LOCATION: West Baden Springs, Indiana
ORIGIN: 1902
CONDITION: Structures collapsing
PROJECT SCOPE: Heritage tourism site until complete restoration for adaptive reuse

IOWA

All Saints Byzantine Church Building, *Project Restore Foundation,* Stuart, Iowa
Barns of Amana, *Amana Colonies Historical Sites Foundation,* Amana, Iowa
Brucemore Greenhouse, *National Trust for Historic Preservation,* Cedar Rapids, Iowa
Dubuque County Jail, *Dubuque County Historical Society,* Dubuque, Iowa
Fort Atkinson State Preserve, *Iowa Department of Natural Resources,* Fort Atkinson, Iowa
Fort Des Moines Black Officers & WAAC Memorial Park, *Fort Des Moines Black Officers Memorial, Inc.,* Des Moines, Iowa
Park Inn Hotel, *City of Mason City,* Mason City, Iowa
Terrace Hill Mansion, *Terrace Hill Foundation,* Des Moines, Iowa

KANSAS

Benedictine College Freshman Hall, *Benedictine College,* Atchison, Kans.
Chase County Courthouse, *Board of Chase County Commissioners,* Cottonwood Falls, Kans.
Fox Theatre, *Historic Fox Theatre of Salina Foundation, Inc.,* Salina, Kans.
Haskell University Museum and Archives Collection, *Haskell Indian Nations University, Bureau of Indian Affairs,* Lawrence, Kans.
Kansas Cosmosphere and Space Center Collections, *Kansas Cosmosphere and Space Center,* Hutchinson, Kans.
Quindaro Ruins, Western University Campus, *Western University Association of the African Methodist Episcopal Church,* Kansas City, Kans.

KENTUCKY

Earick House, *Portland Museum,* Louisville, Ky.
Kentucky Center for African American Heritage, *African American Heritage Foundation,* Louisville, Ky.
Kentucky Theater's Original Wurlitzer Theatre Pipe Organ, *Kentucky's Mighty Wurlitzer-Theater Organ Project, Inc.,* Lexington, Ky.
Latrobe's Pope Villa, *Blue Grass Trust for Historic Preservation,* Lexington, Ky.
Mill Springs Battlefield, *Mill Springs Battlefield Association,* Somerset, Ky.
Old Mud Meeting House, *Harrodsburg Historical Society, Inc.,* Harrodsburg, Ky.
Old State Capitol Paintings, *Kentucky Historical Society,* Frankfort, Ky.
River Heritage Museum, *River Heritage Museum,* Paducah, Ky.
The Kentucky Executive Mansions Project, *Kentucky Humanities Council, Inc.,* Frankfort, Ky.

LOUISIANA

Cypress Lugers, *St. Charles Parish,* St. Charles Parish, La.
Fort Butler, *Fort Butler Foundation,* Donaldsville, La.
Lower St. Charles Avenue Corridor of Central City, *Felicity Street Redevelopment Project, Inc.,* New Orleans, La.
Shadows-on-the-Teche, *National Trust for Historic Preservation,* New Iberia, La.
St. Louis Cemeteries, 1 and 2, *Friends of New Orleans Cemeteries, Inc.,* New Orleans, La.

MAINE

Biddeford & Saco Railroad Co. Trolley Car No. 31, *Seashore Trolley Museum,* Kennebunkport, Me.
Fort Western Main House, *Old Fort Western,* Augusta, Me.
McLellan-Sweat House, *Portland Museum of Art,* Portland, Me.
Portland Observatory, *Portland Observatory Restoration Trust,* Portland, Me.
Save Maine's Colors: Civil War Flag Preservation, *Friends of the Maine State Museum,* Augusta, Me.
Spring Point Ledge Lighthouse, *Spring Point Ledge Light Trust,* South Portland, Me.
The Thomas Ruggles House, *Ruggles House Society,* Columbia Falls, Me.

MARYLAND

Goodwin Building, American Civil War Pole and Rope Stretcher, Surgeon Radzinski's Civil War Uniform Frock Coat, and U.S. Garrison Hospital Flag, *National Museum of Civil War Medicine, Inc.,* Frederick, Md.
Brodbeck Music Hall, *Hood College,* Frederick, Md.
Colonial London Town, *London Town Foundation, Inc./Anne Arundel County,* Edgewater, Md.
Fort McHenry National Monument and Historic Shrine, *National Park Service,* Baltimore, Md.
Francis Scott Key Monument, *Baltimore City Commission for Historical and Architectural Preservation,* Baltimore, Md.
Hammond-Harwood House, *Hammond-Harwood House Association, Inc.,* Annapolis, Md.
Hampton Farm House and Slave Quarters, Hampton National Historic Site, *National Park Service,* Towson, Md.
Historic Coffee House, *Living Classrooms Foundation,* Baltimore, Md.
Maryland State House and Documentation Project, *Maryland State Archives,* Annapolis, Md.
McDowell Hall, *St. John's College,* Annapolis, Md.
Monocacy Aqueduct, C & O Canal Park, *The Chesapeake & Ohio Canal Association,* Glen Echo, Md.
Oakland's 1884 Train Station, *Garrett County Community Action, Inc.,* Oakland, Md.
Paper-Based National Icons, *Maryland Historical Society,* Baltimore, Md.
Peabody Art Collection, *Maryland Commission on Artistic Property of the Maryland State Archives,* Annapolis, Md.
Save Maryland's Treasures, *Maryland Commission for Celebration 2000,* Annapolis, Md.
Sotterley Plantation, *The Sotterley Foundation, Inc.,* Hollywood, Md.
Sykesville Schoolhouse, *Sykesville Development Corporation,* Sykesville, Md.
Teackle Mansion, *Friends of Teackle Mansion,* Princess Anne, Md.
Todd's Inheritance, *Eastside Community Development Corporation,* Baltimore, Md.
U.S. Coast Guard Cutter TANEY, *Baltimore Maritime Museum,* Baltimore, Md.
USS *Constellation*, *USS Constellation,* Baltimore, Md.
Warfield Complex, *Warfield Development Corporation,* Sykesville, Md.

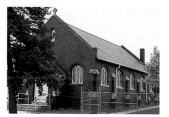

Fort Des Moines Black Officers and Women's Army Auxiliary Corps Memorial Park

LOCATION: Des Moines, Iowa
ORIGIN: 1903
CONDITION: Neglected
PROJECT SCOPE: Rehabilitation of 20,000-square-foot Clayton Hall; creation of museum

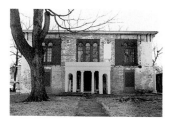

Latrobe's Pope Villa

LOCATION: Lexington, Kentucky
ORIGIN: 1811
CONDITION: Fire damaged; original fabric intact; alterations removed
PROJECT SCOPE: Conservation and restoration to preserve building and create a preservation center

MASSACHUSETTS

"Stonehurst", *Robert Treat Paine Estate,* Waltham, Mass.
Abbotsford Mansion, *National Center of Afro-American Artists,* Boston, Mass.
African Meeting House, Boston African American National Historic Site, *National Park Service and Museum of Afro-American History,* Boston, Mass.
Ayer Mansion, *Bayridge Residence & Cultural Center, Inc.,* Boston, Mass.
Brooks Estate, *Medford-Brooks Estate Land Trust, Inc.,* Medford, Mass.
Chesterwood, Country Home and Studio of Daniel Chester French, *National Trust for Historic Preservation,* Stockbridge, Mass.
Colonial Theatre, *The Colonial Theatre Association, Inc.,* Pittsfield, Mass.
Coolidge Collection of Thomas Jefferson Papers, *Massachusetts Historical Society,* Boston, Mass.
Corson Block Buildings, *The Waterfront Historic Area League, Inc.,* New Bedford, Mass.
Dating Historic Structures Project, *Society for the Preservation of New England Antiquities,* Boston, Mass.
Dimock Community Health Center Campus, *Dimock Community Health Center,* Roxbury, Mass.
Elm Bank, *Massachusetts Horticultural Society,* Wellesley/Dover, Mass.
Fishing Schooner *Adventure*, *The Gloucester Adventure, Inc.,* Gloucester, Mass.
Forbes Library's Calvin Coolidge Collection, *Forbes Library,* Northampton, Mass.
Gore Place, *Gore Place Society,* Waltham, Mass.
Gropius House, *Gropius House,* Lincoln, Mass.
Liberty Tree Park, *Boston 2000, Inc./Boston Freedom Award,* Boston, Mass.
Longfellow National Historic Site House and Collections, *National Park Service,* Cambridge, Mass.
Melvin Memorial, Sleepy Hollow Cemetery, *Melvin Memorial Restoration Committee, Town of Concord,* Concord, Mass.
Nantucket United Methodist Church, *Two Centre Street Restoration Project Inc.,* Nantucket, Mass.
Old Deerfield Town Hall, *Pocumtuck Valley Memorial Association,* Deerfield, Mass.
Orchard House, Home of the Alcotts, *Louisa May Alcott Memorial Association,* Concord, Mass.
The Mount, Home of Edith Wharton, *Edith Wharton Restoration/The Mount,* Lenox, Mass.
The Steeples Project, *Historic Boston Incorporated,* Boston, Mass.
Thomas Crawford's Binney Monument, *Mount Auburn Cemetery,* Cambridge, Mass.
Thoreau Institute, *Walden Woods Project,* Lincoln, Mass.
USS *Constitution* Museum Archives and Collections, *USS Constitution Museum,* Boston, Mass.
Ventfort Hall, *Ventfort Hall Association, Inc.,* Lenox, Mass.
Vilna Shul, *Vilna Center for Jewish Heritage, Inc.,* Boston, Mass.

MICHIGAN

1888 Old Township Hall, *Metamora Historical Society,* Metamora, Mich.
Calumet Theatre, *Calumet Theatre Company,* Calumet, Mich.
Cappon House and Settlers House, Holland Museum, *Holland Historical Trust,* Holland, Mich.
Grand Traverse Commons Redevelopment District, *Grand Traverse Commons Redevelopment Corporation,* Traverse City, Mich.
Michigan Lighthouse Project, *Michigan Historic Preservation Network,* Statewide, Mich.
Oakwood Cemetery, *Wyandotte Oakwood Cemetery Foundation,* Wyandotte, Mich.
Orson Starr House Historic District, *City of Royal Oak Historical Commission,* Royal Oak, Mich.
Quincy Mining Company Blacksmith and Machine Shops, Keweenaw National Historical Park, *National Park Service and A.E. Seaman Mineral Museum,* Calumet, Mich.
Ste. Anne de Detroit Historic Site, *Gabriel Richard Historical Society,* Detroit, Mich.
The Original Old Rugged Cross Church, *The Old Rugged Cross Foundation, Inc.,* Pokagon, Mich.

MINNESOTA

Documentation of the Immigrant Experience, Immigration History Research Center, College of Liberal Arts, *University of Minnesota,* Minneapolis, Minn.
Hermann Monument, *City of New Ulm,* New Ulm, Minn.
Old Council Rooms, Fire Department & Jail House Building, *City of Holland,* Holland, Minn.
Olof Swensson Farm Museum Barn, *Chippewa County Historical Society,* Montevideo, Minn.
Walker Art Center Permanent Collection, *Walker Art Center,* Minneapolis, Minn.
Washburn-Crosby "A" Mill National Historic Landmark, *Minnesota Historical Society,* Minneapolis, Minn.

MISSISSIPPI

Grand Opera House of Mississippi, *Mississippi State University,* Meridian, Miss.
I. T. Montgomery House, *Mississippi Department of Archives and History,* Jackson, Miss.
Scott-Ford Historic Site, *Scott-Ford, Inc.,* Jackson, Miss.
Shaifer House, *Mississippi Department of Archives and History,* Claiborne County, Miss.

MISSOURI

Campbell House, *Campbell House Museum,* St. Louis, Mo.
Fourth Street Theatre, *Randolph County Historical Society,* Moberly, Mo.
Historic Peruque Railroad Depot, *The City of St. Peters,* St. Peters, Mo.
Paseo YMCA Building, *Negro Leagues Baseball Museum,* Kansas City, Mo.
Ste. Genevieve National Historic Landmark District, *City of Ste. Genevieve,* Ste. Genevieve, Mo.
Union Station, Railway Express Building and Power Plant, *Union Station Assistance Corporation,* Kansas City, Mo.

MONTANA

Historic Records Preservation and Online Historical Investigation Project, *Butte-Silver Bow Public Archives,* Butte, Mont.
Oregon Short Line Terminus Historic District, *Yellowstone Historic Center,* West Yellowstone, Mont.
Tenth Street Bridge, *City of Great Falls and Preservation Cascade, Inc.,* Great Falls, Mont.
Travelers' Rest, Lewis and Clark Campsite, *Lolo Community Development Corporation,* Lolo, Mont.

NEBRASKA

Ardis and Robert James Collection, *International Quilt Study Center,* Lincoln, Nebr.
City Auditorium, *City of Superior,* Superior, Nebr.
Historic Kregel Windmill Factory Museum, *Kregel Windmill Museum Company,* Nebraska City, Nebr.
Lincoln Hotel, *Panhandle Landmarks, Inc.,* Scottsbluff, Nebr.
Mari Sandoz High Plains Heritage Center, *Chadron State College,* Chadron, Nebr.
The Florence Mill, *Winter Quarters/Florence Mill, Inc.,* Omaha, Nebr.
Willa Cather House National Historic Landmark, *Nebraska State Historical Society,* Red Cloud, Nebr.

NEVADA

Boulder City/Hoover Dam Museum Archives, *Boulder City Museum and Historical Association,* Boulder City, Nev.
Historic Fourth Ward School Museum and Cultural Center, *Historic Fourth Ward School,* Virginia City, Nev.
Oats Park School/Oats Park Art Center, *Churchill Arts Council,* Fallon, Nev.

NEW HAMPSHIRE

1772 Old Meeting House, *New Durham Historical Society,* New Durham, N.H.
1831 Canterbury Shaker Village Trustees' Office, *Canterbury Shaker Village,* Canterbury, N.H.
Belknap Mill, *Belknap Mill Society,* Laconia, N.H.
Cheshire Mills Complex, *Historic Harrisville, Inc.,* Harrisville, N.H.
Cornish Art Colony Project, *Upper Valley Land Trust,* Hanover, N.H.
Eagle Block, *Economic Corporation of Newport,* Newport, N.H.
Groton Town House, *Committee for the Groton Town House,* Groton, N.H.
Warner House, *Warner House Association,* Portsmouth, N.H.

NEW JERSEY

America's First County Park System: Annual Reports, Historical Documents, Maps, Plans, and Manuscript Collection, *County of Essex Department of Parks, Recreation and Cultural Affairs,* Newark, N.J.
Asbury Park Beach Front, Convention Hall and Casino Complex, *City of Asbury Park,* Asbury Park, N.J.
Camp Evans, Former Marconi Wireless Station, *Information Age Learning Center,* Wall, N.J.
Cape May County Airport Hangar #1, *Naval Air Station Wildwood Foundation,* Cape May, N.J.
Church of the Presidents, St. James Chapel, *Long Branch Historical Museum of the State of New Jersey,* Long Branch, N.J.
Craftsman Farms, *Craftsman Farms Foundation,* Parsippany, N.J.
Crane-Phillips House, *Cranford Historical Society,* Cranford, N.J.
Ellis Island Ferry Building, Statue of Liberty National Monument, *National Park Service,* Jersey City, N.J.
F. Scott Fitzgerald Papers, Princeton University Library, *Princeton University,* Princeton, N.J.
Paulsdale, Birthplace and Family Home of Alice Paul, *Alice Paul Centennial Foundation,* Mt. Laurel, N.J.
Rockingham Historic Site, *Rockingham Association,* Princeton, N.J.
The Old Stone House, *Ramsey High School,* Ramsey, N.J.
Thomas Edison Invention Factory and Collections, Thomas Edison National Historic Site, *National Park Service and Edison Preservation Foundation,* West Orange, N.J.
William Trent House, *Trent House Association and City of Trenton,* Trenton, N.J.

NEW MEXICO

Adobe and Heritage Preservation, *Cornerstones Community Partnerships,* Statewide, N. Mex.
Bandelier National Monument, *National Park Service,* Los Alamos, N. Mex.
Historic Old Town in West Las Vegas, *Citizens' Committee for Historic Preservation,* Las Vegas, N. Mex.
Manhattan Project Site, Los Alamos National Laboratory, *Department of Energy,* Los Alamos, N. Mex.
Montezuma Castle, *United World College of the American West,* Montezuma, N. Mex.
Murray Hotel, *Silver City-Grant County Economic Development Corporation,* Silver City, N. Mex.
Palace of the Governors and Collections, *Palace of the Governors State History Museum,* Santa Fe, N. Mex.
Portrait of Carlos H. Armijo and Beatriz Otero de Armijo, *Branigan Cultural Center,* Las Cruces, N. Mex.
San Esteban del Rey Mission and Convento, *Pueblo of Acoma Tribal Government,* Pueblo of Acoma, N. Mex.
San Miguel Church, *San Miguel Church,* Santa Fe, N. Mex.
San Miguel del Vado Custom House, *End of the Trail Chapter of the Santa Fe Trail Association,* Santa Fe, N. Mex.
Shakespeare Ghost Town Buildings Fire Protection Plan, General Merchandise Building, Grant House, and Old Mail Station Building, *Shakespeare Ghost Town, Inc.,* Lordsburg, N. Mex.
Silver City Waterworks, *Town of Silver City,* Silver City, N. Mex.
"Southwest Pieta" Sculpture by Luis Jimenez, *City of Albuquerque Public Art Program,* Albuquerque, N. Mex.

NEW YORK

1871 Universal Baptist Temple, *Saratoga Springs Preservation Foundation,* Saratoga Springs, N.Y.
20th-Century American Dances, *Dance Notation Bureau, Inc.,* New York, N.Y.

National Color of the First Maine Heavy Cavalry

Save Maine's Colors: Civil War Flag Preservation

LOCATION: Augusta, Maine
ORIGIN: 1862-1865
CONDITION: Flags are stable; require cleaning, humidification, and a flat mount
PROJECT SCOPE: Provide flat exhibition and storage facilities

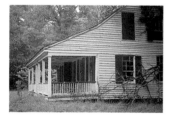

Shaifer House

LOCATION: Claiborne County, Mississippi
ORIGIN: 1860
CONDITION: Structurally sound with damage from erosion and vandalism
PROJECT SCOPE: Complete restoration of house museum and interpretive center

Francis Scott Key Monument, 1911

Save Outdoor Sculpture 2000!

LOCATION: Nationwide
ORIGIN: Varies
CONDITION: 16,000 public sculptures in peril from vandalism, environmental conditions, pollution, and deferred maintenance
PROJECT SCOPE: Encourage appreciation and preservation of contemporary and historic outdoor sculpture

Ste. Genevieve National Historic Landmark District

LOCATION: Ste. Genevieve, Missouri
ORIGIN: 1735-1840
CONDITION: Threat of flooding
PROJECT SCOPE: Development and implementation of design guidelines to protect and preserve integrity of district, one of the oldest surviving French colonial settlements in the continental U.S. and largest ensemble of 18th-century French colonial style buildings within an intact town plan

American Ballet Theatre Choreography Preservation Project, *American Ballet Theatre,* New York, N.Y.
Anti-Slavery Pamphlet Collection, *Cornell University Library,* Cornell University, Ithaca, N.Y.
Auburn Schine Theater, *The Cayuga County Arts Council,* Auburn, N.Y.
Babe Ruth's Scrapbooks, *National Baseball Hall of Fame and Museum, Inc.,* Cooperstown, N.Y.
Brooklyn Historical Society Building, *The Brooklyn Historical Society,* Brooklyn, N.Y.
Brooklyn Museum of Art Façade Restoration, *Brooklyn Museum of Art,* Brooklyn, N.Y.
Camp Santanoni, *Adirondack Architectural Heritage,* Newcomb, N.Y.
Case Research Lab, *Cayuga Museum,* Auburn, N.Y.
Castle Clinton National Monument, *National Park Service and Conservancy for Historic Battery Park,* New York, N.Y.
Conservation Center, Institute for Fine Arts, *New York University,* New York, N.Y.
Cradle of Aviation Museum, *Nassau County Department of Recreation and Parks,* Garden City, N.Y.
Dutch Colonial Manuscripts, New York State Archives, *New York State Archives and Record Administration,* Albany, N.Y.
Dutch Reformed Church, *Hudson River Valley National Heritage Area,* Newburgh, N.Y.
Eldridge Street Synagogue, *Eldridge Street Project,* New York, N.Y.
Fort Ticonderoga, *Fort Ticonderoga Association,* Ticonderoga, N.Y.
Franklin D. Roosevelt's Top Cottage, *Franklin and Eleanor Roosevelt Institute,* Hyde Park, N.Y.
Ganondagan State Historic Site, *Ganondagan State Historic Site,* Victor, N.Y.
Graycliff, Isabelle R. Martin House, *Graycliff Conservancy, Inc.,* Derby, N.Y.
Great Camp Sagamore, *Sagamore Institute of the Adirondacks,* Raquette Lake, N.Y.
Harriet Tubman Residence and Home for the Aged, *Harriet Tubman Home, Inc.,* Auburn, N.Y.
Heritage Campaign, *Albany Institute of History & Art,* Albany, N.Y.
Intrepid Patriotic Visitor Center, *Intrepid Sea-Air-Space Museum,* New York, N.Y.
Landmarks Preservation Fund, *Historic House Trust of New York City,* New York, N.Y.
Louis Armstrong House and Archives, *Queens College, CUNY,* Flushing, N.Y.
Lyndhurst, *National Trust for Historic Preservation,* Tarrytown, N.Y.
M'Clintock House, Women's Rights National Historical Park, *National Park Service,* Waterloo, N.Y.
Manitoga, Home of Russel Wright, Manitoga Trail and Manitoga Hemlock Restoration and Management Plan, *Manitoga, Inc.,* Garrison, N.Y.
Manor Hall, *Philipse Manor Hall State Historic Site,* Yonkers, N.Y.
97 Orchard Street and Lower East Side Tenement Museum, *National Trust for Historic Preservation,* New York, N.Y.
Olana State Historic Site, *Friends of Olana,* Hudson, N.Y.
Our Lady of the Scapular and St. Stephen's Church, *Our Lady of the Scapular and St. Stephen Church,* New York, N.Y.
Peter Augustus Jay House, *Jay Heritage Center,* Rye, N.Y.
Philipse Manor Hall Rococo Room, *Philipse Manor Hall State Historic Site,* Yonkers, N.Y.
RAICES: The History of Afro-American Caribbean Music in New York, *Boys Harbor, Inc.,* East Harlem, N.Y.
Safe Haven Museum and Educational Center, *Safe Haven Inc.,* Oswego, N.Y.
Sag Harbor Whaling and Historical Museum, *Sag Harbor Whaling & Historical Museum,* Sag Harbor, N.Y.
Save America's Treasures Historic Corridor: Buffalo City Hall Sandstone Friezes, President William McKinley Monument, and Soldiers and Sailors Monument, *Buffalo Arts Commission,* Buffalo, N.Y.
Schuyler Mansion and Education Program, *Schuyler Mansion State Historic Site,* Albany, N.Y.
Shea's Performing Arts Center, *Shea's Performing Arts Center,* Buffalo, N.Y.
St. Martin's Episcopal Church, *St. Martin's Episcopal Church,* Harlem, N.Y.
State Theatre, *Historic Ithaca, Inc.,* Ithaca, N.Y.
The American Family Immigration History Center at Ellis Island, *The Statue of Liberty-Ellis Island Foundation, Inc.,* New York, N.Y.
The Hendrick I. Lott House, *Hendrick I. Lott House Preservation Association,* Brooklyn, N.Y.
The Seward House, *Foundation Historical Association,* Auburn, N.Y.
Thomas Cole's Cedar Grove, *The Greene County Historical Society,* Catskill, N.Y.
Thomas Halsey House, *Southampton Historical Museum,* Southampton, N.Y.
Torne Brook Farm, *Passaic River Coalition,* Ramapo, N.Y.
United States Sanitary Commission Records, *The New York Public Library,* New York, N.Y.
Val-Kill Cottage, Eleanor Roosevelt National Historic Site, *National Park Service,* Hyde Park, N.Y.
Walker Evans Archive, *The Metropolitan Museum of Art,* New York, N.Y.
Walt Whitman Birthplace State Historic Site, *Walt Whitman Birthplace Association,* West Hills, N.Y.
Weeksville Society, *Society for the Preservation of Weeksville & Bedford-Stuyvesant History,* Brooklyn, N.Y.
Willard Memorial Chapel, *Community Preservation Committee,* Auburn, N.Y.

NORTH CAROLINA

Bellamy Mansion Slave Quarters, *The Historic Preservation Foundation of North Carolina, Inc.,* Wilmington, N.C.
Biltmore High School, *Western North Carolina Historical Association, Inc.,* Asheville, N.C.
Canary Cottage, Charles Eliot Hall, Galen Stone Hall, Helen Frances Kimball Hall, and Massachusetts Cottage, Charlotte Hawkins Brown Historic Site, *Charlotte Hawkins Brown Historical Foundation, Inc,* Sedalia, N.C.
Coolmore Plantation, *The Historic Preservation Foundation of North Carolina, Inc.,* Tarboro, N.C.
Dolley Madison's Clothing Collection, *Greensboro Historical Museum,* Greensboro, N.C.
Former St. Andrew's Church, Manse and Consolidated Market, *Friends of St. Andrew's, Inc.,* Wilmington, N.C.
Gastonia County Courthouse and Downtown District, *Gastonia Downtown Development Corporation,* Gastonia, N.C.
Glencoe Mill and Mill Village, *The Historic Preservation Foundation of North Carolina, Inc.,* Burlington, N.C.
Loray Mill, *The Historic Preservation Foundation of North Carolina, Inc.,* Gastonia, N.C.
Newbold-White House, *Perquimans County Restoration Association,* Hertford, N.C.
Rogers Theatre Block, *Uptown Shelby Association, Inc.,* Shelby, N.C.
Tillery Resettlement Community, *Concerned Citizens of Tillery,* Tillery, N.C.
Union Tavern and Thomas Day House, *Union Tavern Restoration, Inc.,* Milton, N.C.

**Willa Cather House, National
Historic Landmark**

LOCATION: Red Cloud, Nebraska
ORIGIN: 1875
CONDITION: Deterioration of structural
fabric of building restored to the
period of Willa Cather's occupancy,
1884-1891
PROJECT SCOPE: Comprehensive historic
structures and landscape report to
develop a complete preservation and
conservation plan

Oats Park School/Oats Park Art Center

LOCATION: Fallon, Nevada
ORIGIN: 1915
CONDITION: Building core structurally sta-
bilized and partially renovated; north
and south wings in need of stabiliza-
tion and rehabilitation to address inte-
rior deterioration
PROJECT SCOPE: Return building to an
active community arts facility includ-
ing a 350-seat proscenium theatre
and visual art galleries

NORTH DAKOTA

19th Century Earthen Structures, *State Historical Society of North Dakota,* Bismarck, N. Dak.
Prairie Churches of North Dakota, *Preservation North Dakota,* Statewide, N. Dak.

OHIO

1905 Wright Flyer III, *Carillon Historical Park,* Dayton, Ohio
City National Bank Building, *National First Ladies Library,* Canton, Ohio
Cuyahoga County Soldiers' and Sailors' Monument, *Cuyahoga County Soldiers' and Sailors' Monument Commission,* Cleveland, Ohio
Fine Arts Garden and Adjacent Areas, *The Sculpture Center,* Cleveland, Ohio
Hulett Ore Unloaders, Canal Basin Park, *Ohio Canal Corridor and Cleveland Waterfront Coalition,* Cleveland, Ohio
Jay Cooke Residence, *The Ohio State University,* South Bass Island, Ohio
John P. Parker Historic Site, *John P. Parker Historical Society,* Ripley, Ohio
McKinley National Memorial, *McKinley Museum and National Memorial,* Canton, Ohio
National Home for Disabled Volunteer Soldiers, *VA Medical Center,* Dayton, Ohio
Paul Laurence Dunbar House and Barn, Dayton Aviation Heritage National Historical Park, *National Park Service,* Dayton, Ohio
Stan Hywet Hall and Gardens, *Stan Hywet Hall and Gardens,* Akron, Ohio
The Delany House, *Freedom Way Foundation, Inc.,* Hopedale, Ohio

OKLAHOMA

A.C.H. Hospital, *Central Oklahoma Community Action Agency,* Shawnee, Okla.
Ardmore's Historic Santa Fe Depot, *Ardmore Main Street Authority,* Ardmore, Okla.
Canadian County Jail and Sheriff's Stable, *Preservation El Reno, Inc.,* El Reno, Okla.
Centre for Design Arts, *Oklahoma City Foundation for Architecture,* Oklahoma City, Okla.
El Reno Swimming Pool Municipal Bath House, *Preservation El Reno, Inc.,* El Reno, Okla.
Fort Gibson Historic Site, *Oklahoma Historical Society,* Fort Gibson, Okla.
Korns Building, Columbia Building, and Vogele Building, *Newkirk Community Historical Society,* Newkirk, Okla.
L. L. Stine Home, *Great Plains Preservation and Development Foundation,* Woodward, Okla.
Marland Mansion, *City of Ponca City,* Ponca City, Okla.
Political Commercial Archive, *University of Oklahoma,* Norman, Okla.
Skirvin Hotel, *Preservation Oklahoma, Inc.,* Oklahoma City, Okla.
Tulsa Fire Alarm Building, *American Lung Association of Oklahoma,* Tulsa, Okla.
Tulsa's Hazard Mitigation for Historic Resources Project, *City of Tulsa Project Impact Office,* Tulsa, Okla.
Wheelock Academy, *Choctaw Nation of Oklahoma,* Millerton, Okla.

OREGON

Captain George Flavel House, *Clatsop County Historical Society,* Astoria, Oreg.
Vista House at Crown Point, *Oregon State Parks Trust,* Corbett, Oreg.

PENNSYLVANIA

Benjamin Franklin National Memorial, *The Franklin Institute,* Philadelphia, Pa.
Clivden, *National Trust for Historic Preservation,* Philadelphia, Pa.
D&H Gravity Railroad Open-Air Summer Car, *Waymart Area Historical Society,* Waymart, Pa.
Frank Lloyd Wright's Fallingwater, *Western Pennsylvania Conservancy,* Mill Run, Pa.
Gettysburg National Military Park Collections and "The Battle of Gettysburg" Cyclorama Painting, *National Park Service,* Gettysburg, Pa..
Historic Mill at Anselma, *The Mill at Anselma Preservation and Educational Trust, Inc.,* Chester Springs, Pa
Holland Land Office and First Church of Christ, Scientist Building, *Crawford County Historical Society,* Meadville, Pa.
John Mitchell Monument, *Lackawana Historical Society,* Scranton, Pa.
Lewis and Clark Herbarium, *Academy of Natural Sciences,* Philadelphia, Pa.
McClintock Oil Well #1, *Pennsylvania Historical and Museum Commission,* Titusville, Pa.
Moland House, George Washington's Headquarters 1777, *Warwick Township Historical Society,* Hartsville, Pa.
Paul Robeson House, *West Philadelphia Cultural Alliance,* West Philadelphia, Pa.
Pine Forge Campus' Historic Sites, *Pine Forge Academy,* Pine Forge, Pa.
Rare Book and Archives Collection, *The Dickinson School of Law of The Pennsylvania State University,* Carlisle, Pa.
Thaddeus Stevens Hall, *Gettysburg College,* Gettysburg, Pa.
The Legendary Blue Horizon, *Nia Kuumba,* Philadelphia, Pa.
The Letter Box, Grey Towers National Historic Landmark, *U.S. Forest Service,* Milford, Pa.
The Woodlands Mansion, Carriage House, and Rural Cemetery, *Woodlands Trust for Historic Preservation,* Philadelphia, Pa.
USS *Olympia*, *Independence Seaport Museum,* Philadelphia, Pa.
Valley Forge Winter Encampment, Valley Forge National Historic Park, *National Park Service,* Valley Forge, Pa.
Willcox Ivy Mills and Homestead, *Concord Township Historical Society,* Concordville, Pa.

RHODE ISLAND

Bristol County Courthouse and Statehouse, *Bristol Statehouse Foundation,* Bristol, R.I.
Commercial Pattern Archive, University of Rhode Island Library Special Collections, *University of Rhode Island,* West Kingston, R.I.
Mitre Caps of Providence and British Grenadiers, *Rhode Island Historical Society,* Providence, R.I.
Ochre Court, *Salve Regina University,* Newport, R.I.
Providence Performing Arts Center, *Providence Performing Arts Center,* Providence, R.I.
Schooner Yacht *Coronet*, *International Yacht Restoration School,* Newport, R.I.

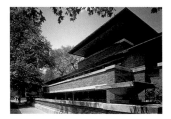

Frederick C. Robie House

LOCATION: Oak Park, Illinois
ORIGIN: 1910
CONDITION: Conserve extant features of the building; minimize impact to original building fabric; restore elements lost, removed, or destroyed
PROJECT SCOPE: Re-create intentions of the architect and client in 1910; continue operations as a house museum

Subway Passengers, New York,
Gelatin silver print 12.2 x 15.0 cm

Walker Evans Archive

LOCATION: New York, New York
ORIGIN: 1903-1975
CONDITION: Stable; conservation completed
PROJECT SCOPE: Preservation of one of the most complete single-artist archives of the 20th century including 30,000 black-and-white negatives, 10,000 color transparencies, papers and collections

Southeast Lighthouse, *Block Island Southeast Lighthouse Foundation,* Block Island, R.I.
The John N.A. Griswold House, *The Newport Art Museum and Art Association,* Newport, R.I.
The Redwood Library, *The Company of the Redwood Library and Athenaeum,* Newport, R.I.
Touro Synagogue National Historic Site, *The Society of Friends of Touro Synagogue, National Historic Site, Inc.,* Newport, R.I.

SOUTH CAROLINA

Ashley River Road Corridor Management Plan, *Ashley River Conservation Coalition,* Charleston, S.C.
Cole-Heyward House, *Bluffton Historical Preservation Society,* Bluffton, S.C.
Drayton Hall, *National Trust for Historic Preservation,* Charleston, S.C.
Middleton Place National Historic Landmark, *Middleton Place Foundation,* Charleston, S.C.
Mt. Zion Rosenwald School Project, *Mt. Zion United Methodist Church,* Florence, S.C.
Nation Ford Civil War Battery, *Nation Ford Land Trust,* Fort Mill, S.C.
Old Charleston City Jail, *School of the Building Arts,* Charleston, S.C.

SOUTH DAKOTA

1921 Middle School Structure, *Brookings County Commission,* Brookings, S. Dak.
D.C. Booth Historic National Fish Hatchery, *U.S. Fish and Wildlife Service,* Spearfish, S. Dak.

TENNESSEE

Bemis Auditorium, *Bemis Historical Society,* Bemis, TN
Buffalo Trace Greenway, *Tipton-Haynes Historical Association,* Johnson City, Tenn.
Elkmont Historic District, Great Smoky Mountains National Park, *National Park Service,* Elkmont, Tenn.
First Hermitage, *The Hermitage, Home of President Andrew Jackson,* Hermitage, Tenn.
Historic Elmwood Cemetery, *Historic Elmwood Cemetery,* Memphis, Tenn.
McGinnis Hotel, *Biblical Resource Center & Museum,* Collierville, Tenn.
Tennessee Main Street Design Manual, *Tennessee Main Street Association,* Franklin, Tenn.
The Great Smoky Arts & Crafts Community Museum and Cultural Arts Center, *The Great Smoky Arts & Crafts Community,* Gatlinburg, Tenn.

TEXAS

1877 *Elissa*, *Galveston Historical Foundation, Inc.,* Galveston, Tex.
Aviation Nose Art from World War II, *American Airpower Heritage Museum,* Midland, Tex.
Charles W. Moore House and Moore/Andersson Studio Compound, *The Charles W. Moore Foundation,* Austin, Tex.
Engine No. 1, 1857 Steam Locomotive, *El Paso Community Foundation,* El Paso, Tex.
Faison Home, *City of La Grange,* La Grange, Tex.
Frank Reaugh Photograph and Painting Collection, J. B. Erwin Watercolor Paintings, and Ruth Pershing Uhler Paintings, *Panhandle-Plains Historical Museum,* Canyon, Tex.
Historic Texas Courthouses, *Preservation Texas, Inc.,* Statewide, Tex.
Keystone Dam Archaeological Site and Archaic Wetlands, *Keystone Heritage Park, Inc.,* El Paso, Tex.
Menard County Courthouse, *Menard County,* Menard, Tex.
Missouri, Kansas & Texas Railroad Train Depot, *City of La Grange,* La Grange, Tex.
Peter Wolf Administration Building, Fair Park National Historic Landmark, *The Women's Museum,* Dallas, Tex.
Plaza Theatre, *Plaza Theatre Corporation,* El Paso, Tex.
Rio Vista Farm Historic District, *City of Socorro,* Socorro, Tex.
Socorro Mission, *Roman Catholic Diocese of El Paso,* El Paso, Tex.
U.S. Hispanic Literary Heritage Project, *University of Houston,* Houston, Tex.

UTAH

Fort Douglas Heritage Commons, *University of Utah,* Salt Lake City, Utah
Governor's Mansion and Carriage House, *Utah Governor's Mansion Foundation,* Salt Lake City, Utah
Topaz Museum and Site, *Topaz Museum,* Delta, Utah

VERMONT

Benedict Arnold's Revolutionary War Gunboat *Spitfire*, *Lake Champlain Maritime Museum,* Vergennes, Vt.
Hand Painted Theater Curtains of Vermont, *Vermont Museum & Gallery Alliance,* Statewide, Vt.
Jones Brothers Company of Vermont Building and Collection, *Vermont Granite Museum of Barre,* Barre, Vt.
St. Johnsbury Athenaeum Landmark, *St. Johnsbury Athenaeum,* St. Johnsbury, Vt.

VIRGINIA

Alexandria Academy, *Historic Alexandria Foundation,* Alexandria, Va.
Beacon Theatre, *Hopewell Preservation, Inc.,* Hopewell, Va.
Belle Grove Plantation, *National Trust for Historic Preservation,* Middletown, Va.
Circuit Court House, *City of Fredericksburg,* Fredericksburg, Va.
Culpeper's Main Street Program, *Culpeper Renaissance, Inc.,* Culpeper, Va.
Custis Family Papers, *Virginia Historical Society,* Richmond, Va.
Dodona Manor, Home of General George C. and Katherine Marshall, *The George C. Marshall International Center at Dodona Manor,* Leesburg, Va.
Eakleton Hotel, *Historic Staunton Foundation,* Staunton, Va.
George Washington's Military Tents, Colonial National Historical Park, *National Park Service,* Yorktown, Va.

The Redwood Library

LOCATION: Newport, Rhode Island

ORIGIN: Colonial charter in 1747; original library, 1750

CONDITION: Major interior structural problems, slate roofing damaged, water and insect damage

PROJECT SCOPE: Complete exterior and interior restoration of the first public neoclassical structure in United States; country's oldest community library building and oldest lending library

Hanover Tavern, *Hanover Tavern Foundation,* Hanover, Va.
Historic Black School and Grist Mill, *National Independence Day Parade, Inc.,* Jeffersonton, Va.
Jackson Ward National Historic Landmark District, *City of Richmond, Historic Jackson Ward Association and Richmond Redevelopment and Housing Authority,* Richmond, Va.
Kenmore Mansion, *George Washington's Fredericksburg Foundation, Inc.,* Fredericksburg, Va.
Loudon Bell, *St. Peter's Episcopal Church,* Purcellville, Va.
Menokin, *Menokin Foundation,* Warsaw, Va.
Millwood Recreation Center, *Help With Housing, Inc.,* Berryville, Va.
Montpelier, Home of James Madison, *National Trust for Historic Preservation,* Montpelier Station, Va.
Monumental Church, *Historic Richmond Foundation,* Richmond, Va.
Oatlands, *National Trust for Historic Preservation,* Leesburg, Va.
Page Place Museum, *Fluvanna County Historical Society,* Palmyra, Va.
Rose Hill Farm, *Glen Burnie Historic House, Gardens & Julian Glass, Jr. Collection,* Winchester, Va.
Stratford Hall Plantation, *Robert E. Lee Memorial Association,* Stratford, Va.
The Pope Leighey House, *National Trust for Historic Preservation,* Alexandria, Va.
Thomas Jefferson's Poplar Forest, *Corporation for Jefferson's Poplar Forest,* Forest, Va.
Thomas Slave Chapel, *African American Heritage Preservation Foundation, Inc.,* Huddleston, Va.
Woodlawn Plantation and "George Washington" Portrait by Rembrandt Peale c. 1799, *National Trust for Historic Preservation and The Woodlawn Foundation,* Mount Vernon, Va.

WASHINGTON

A Timeline Between Two Great Western States Odyssey, *The Maritime Discovery Center and The Alaska Native Heritage Center,* Seattle, Wash.
Admiral Theatre, *Admiral Theatre,* Bremerton, Wash.
Green Mountain Lookout, Mt. Baker-Snoqualmie National Forest, *U.S. Forest Service,* Darrington, Wash.
Jefferson County Courthouse, *Main Street Program of Port Townsend,* Port Townsend, Wash.
Mukai Farm and Garden, *Island Landmarks,* Vashon Island, Wash.
Nathaniel Orr Pioneer Home Site, *Steilacoom Historical Museum Association,* Steilacoom, Wash.
Northwest Art Collection, *Tacoma Art Museum,* Tacoma, Wash.
Yakima Valley Museum Costume Collection, *Yakima Valley Museum,* Yakima, Wash.

WEST VIRGINIA

B&O Roundhouse, *Berkeley County Roundhouse Authority,* Martinsburg, W. Va.
Grave Creek Mound Historic Site Archaeological Collection, Delf Norona Museum, *West Virginia Division of Culture and History,* Moundsville, W. Va.
John List House, *Victorian Wheeling Landmarks Foundation,* Wheeling, W. Va.
The Kimball War Memorial Building, *McDowell County Museum Commission,* Kimball, W. Va.
Weston State Hospital, *Office of the Governor,* Charleston, W. Va.
Wetzel County Courthouse, *Wetzel County Commission,* New Martinsville, W. Va.

WISCONSIN

Captain Fredrick Pabst Mansion Pavilion, *Captain Frederick Pabst Mansion, Inc.,* Milwaukee, Wis.
First Unitarian Meeting House, *First Unitarian Society of Madison,* Madison, Wis.
Taliesin, Home of Frank Lloyd Wright, *Taliesin Preservation, Inc.,* Spring Green, Wis.
Ten Chimneys Estate, *Ten Chimneys Foundation, Inc.,* Genesee Depot, Wis.

WYOMING

Evanston Railroad Complex, *Roundhouse Restoration, Inc.,* Evanston, Wyo.
Mormon Row Historic District, Grand Teton National Park, *National Park Service,* Moose, Wyo.
Murie Ranch Historic District, Grand Teton National Park, *National Park Service and The Murie Center,* Moose, Wyo.
Sheridan Inn, *Sheridan Heritage Center, Inc.,* Sheridan, Wyo.

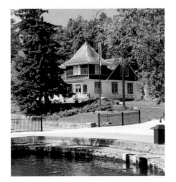

D.C. Booth Historic National Fish Hatchery

LOCATION: Spearfish, South Dakota

ORIGIN: Hatchery Building, 1899; Booth House, 1905

CONDITION: Deterioration of Hatchery Building, Booth House, stone garages, pond and flood channel retaining walls, and Yellowstone Boat

PROJECT SCOPE: Restore structural integrity and upgrade systems of the only site devoted to the preservation of the National Fisheries Program

NATIONAL

Founding Fathers' Papers, *National Trust for the Humanities,* Conn., Mass., N.J., Va.
Mason and Dixon's Line Monument Preservation, *Pennsylvania Society of Land Surveyors,* Del., Md., Pa., W. Va.
Save America's Clocks, *Save America's Clocks,* Nationwide
Save Outdoor Sculpture 2000!, *Heritage Preservation,* Nationwide
Treasures of American Film Archives and Saving the Silents, *The American Silent Fiction Film Project, National Film Preservation Foundation,* Nationwide

INTERNATIONAL

Benjamin Franklin House, *The Friends of Benjamin Franklin House,* Philadelphia, Pa., London, U.K.
Chateau de Blerancourt, Historical Pavilion at the Museum of French-American Cooperation, *American Friends of Blerancourt, Inc.,* NY, NY, Blerancourt, France
Commercial Pacific Cable Station and 1941 Naval Facilities, Battle of Midway National Landmark, Midway Atoll National Wildlife Refuge, *U.S. Fish and Wildlife Service,* Midway Islands
Traditional Community Houses, *Office of Historic and Cultural Preservation,* Yap, Federated States of Micronesia

Millennium Committee to Save America's Treasures

In appreciation for their guidance, expertise, and boundless generosity

190

Honorary Chair
First Lady Hillary Rodham Clinton

Cochair
Ms. Susan Eisenhower

Cochair
Mr. Richard Moe

Members
Ms. Shahara Ahmad-Llewellyn
Ms. Kathleen B. Allaire
Mr. David Altschul
Ms. Clara R. Apodaca
Mrs. Claudine Bacher
Ms. Zoe Baird
Professor Hilary Ballon
Mr. Bernard D. Bergreen
Mr. Randy Best
Mrs. Carol Oughton Biondi
Mr. Eli Broad
Ms. Carolyn Brody
Mr. Michael Bronner
Mr. John H. Bryan Jr.
Ms. Nancy N. Campbell
Dr. Emma Chappell
Mr. James W. Cicconi
Mr. Emanuel Cleaver
Mrs. Janet Langhart Cohen
Ms. Betsy Cohn
Mr. John Cooke
Ms. Sally Irvine Crow
Mr. Leslie Dach
Ms. Beth R. DeWoody
Ms. Chaz Ebert
Ms. Inge-Lise Eckmann
Mr. Keith E. Ferrazzi
Mr. David I. Fisher
Ms. Nancy M. Folger
Ms. Rona E. Ginott

Ms. Francine E. Goldstein
Dr. Vartan Gregorian
Ms. Agnes Gund
Dr. Lois Harding
Mrs. Randolph Hearst
Mr. Don Henley
Ms. Julie Holdren
Dr. James Horton
Dr. Ray R. Irani
Ms. Maxine Isaacs
Mr. Richard H. Jenrette
Mrs. Sheila Johnson
Mr. Bruce D. Judd
Mrs. Hannah Kamin
Dr. Michael Kammen
Dr. Alice S. Kandell
Ms. Catherine S. Kangas
Mr. Jeffrey Katzenberg
Ms. Aerin Lauder
Mrs. Lyn Lear
Mr. Norman Lear
Dr. Deborah Marrow
Ms. Iris Martin
Mr. Roger L. Mayer
Ms. Judith A. McHale
Ms. Donna C. McLarty
Dr. Heidi Miller
Ms. Loretta Leversee Morgenstern
Mr. Raymond D. Nasher
Dr. Libby H. O'Connell
Ms. Sharon L. Patrick
Hon. Molly Raiser
Mr. Matthew Ringel
Mr. David S. Rose
Mr. William C. Rudin
Ms. Buffy Sainte-Marie
Mr. Arthur W. Schultz
Ms. Smita N. Shah

Hon. Ann Elizabeth Sheffer
Mr. Walter H. Shorenstein
Ms. Cathryn H. Buford Slater
Ms. Susan L. Solomont
Ms. Roselyne Chroman Swig
Mrs. Louise Taper
Ms. Sandra E. Taylor
Mr. Daniel K. Thorne
Mrs. Susie Tompkins Buell
Ms. Ruth Usem
Ms. Sandra G. Wagenfeld
Dr. Lucy R. Waletzky
Ms. Susan M. Walter
Mr. B. Kenneth West
Mr. W. Richard West
Mr. Harold M. Williams
Ms. Marsha Williams
Ms. Yeni Wong

Save America's Treasures Supporters

In gratitude for their generous assistance, and the help of many others, in ensuring a brighter future for our past.

Polo Ralph Lauren

General Electric Company
Richard and Rhoda Goldman Fund

AT&T
Federal Emergency Management Agency*
The J. Paul Getty Trust
Lyn and Norman Lear
National Endowment for the Arts*
The Pew Charitable Trusts
Pritzker Foundation
The Madeleine H. Russell Fund and the
 Columbia Foundation
The City and County of San Francisco
Target Stores
United States Mint and the Numismatic
 Coin Collecting Community
Sandra G. Wagenfeld and Fran Goldstein

The Fidelity Foundation
Goldman, Sachs & Co.
William Randolph Hearst Foundation
Ms. Elizabeth E. Meyer
Mobil Oil
Tauk World Discovery/Traveler's
 Conservation Foundation
Robin and Marsha Williams

AT&T Learning Network
Carol and Frank Biondi
Susie Tompkins Buell Donor Advised Fund
 of the Marin Community Foundation
Commonwealth of Virginia
Fannie Mae Foundation
Mrs. Randolph Hearst
Occidental Petroleum Corporation
Marianne and Richard H. Peterson
Carol Swig Sedlack, Marjorie Swig,
 Susan Swig Watkins, and Roselyne
 Chroman Swig through The Swig
 Foundation
Mark Taper Foundation
Dr. Lucy R. Waletzky
Warner Bros. Records Inc.
Yeni Wong
World Monuments Fund and
 American Express Company

The Morris and Gwendolyn Cafritz
 Foundation
Gates Family Foundation
Agnes Gund and Daniel Shapiro
Procter & Gamble

Anonymous
Claudine and Fred Bacher through the
 Susan Bacher Fund
Chambers Family Fund
Discovery Communications, Inc.
Ronni and David Ginott
Dr. Alice S. Kandell
Ellen Klutznick and Philip Schlein
 Philanthropic Fund
The Ambassador Bill and Jean Lane
 Fund at the Peninsula Community
 Foundation
Thomas H. Lee and Ann Tenenbaum
Carolyn and Peter Lynch
Scalamandré, Inc.
Daniel K. Thorne Foundation, Inc.
U.S. Department of Education*
Yamaha Corporation, Band & Orchestral
 Division

Anonymous (4)
Bank of America
Barnes & Noble College Bookstores
Anne Bartley
Allen and Joan Bildner and the Bildner
 Family Foundation, in memory of
 Joseph Bildner
Marianna and David Fisher and The
 Capital Group Companies, Inc.
The Coneway Family Foundation
Ms. Sally Irvine Crow
Fender Musical Instruments
 Corporation
Nancy M. Folger
Cynthia Friedman
Mr. and Mrs. Thomas Gosnell
Dr. Barbara W. Grossman and Steven
 Grossman
Graham and Ann Gund
Donna M. Harris-Lewis on behalf of the
 Reggie Lewis Foundation, Inc.

Hartmann Studios
Mr. John S. Hendricks
The Stewart Huston Charitable Trust
Intel
James A. Johnson and Maxine Isaacs
Mitchell and Rebecca Mandich
A.E. & Martha Michelbacher Fund of the
 Marin Community Foundation
Nikon Precision Inc.
Pacific National, a division of
 FleetBoston Financial
Sharon L. Patrick
Public Service Company of New Mexico
Recording Industry Association of
 America, Inc.
Vicki and Roger Sant
Susanna Young Schoetz
The Selmer Music Company
The Betty R. Sheffer Foundation
Alan D. & Susan Lewis Solomont Family
 Foundation
United Musical Instruments U.S.A., Inc.

Anonymous
Kathleen B. Allaire
Joan Evans Anderman
The ASCAP Foundation
Steve and Joan Belkin
Mr. Arnold S. Gridley and
 Cable Car Charters
Cathay Pacific Airways Limited
Honey and Peter Chapin
Deloitte and Touche
Faraway Productions
Fannie Mae-National Housing Impact
 Division
Mr. and Mrs. Thomas F. McLarty III
Mrs. Barbara R. Peck
Rayburn Musical Instrument Co.
David Jr. and Diana Rockefeller
Sam Ash Music Company
Simpson Gumpertz & Heger Inc.
Starwood Hotels and Resorts
 Worldwide, Inc.
Winston Band Instruments Co.

*Federal Funds

PUBLISHED BY THE NATIONAL GEOGRAPHIC SOCIETY

John M. Fahey, Jr. *President and Chief Executive Officer*
Gilbert M. Grosvenor *Chairman of the Board*
Nina D. Hoffman *Senior Vice President*

PREPARED BY THE BOOK DIVISION

William R. Gray *Vice President and Director*
Charles Kogod *Assistant Director*
Barbara A. Payne *Editorial Director*

STAFF FOR THIS BOOK

Lisa Lytton *Project Editor*
Rebecca Lescaze *Text Editor*
Bill Marr *Art Director*
Ira Block *Photographer*
Dwight Young *Text and Caption Writer*
Corinne Szabo *Illustrations Researcher and Caption Writer*
Janet Dustin *Illustrations Assistant*
Kristian House *Researcher*
R. Gary Colbert *Production Director*

MANUFACTURING AND QUALITY CONTROL

George V. White *Director*
John T. Dunn *Associate Director*
Vincent P. Ryan *Manager*
Phillip L. Schlosser *Financial Analyst*

Illustration Credits

3, courtesy National Museum of American History, ©1999 Smithsonian Institute; **4 (top),** Milo Stewart, Jr., Baseball Hall of Fame Library, Cooperstown, NY; **4 (bottom),** Library of Congress; **5 (top to bottom),** Society for the Preservation of New England Antiquities; Ira Block; Ybor City Museum Society; **9,** Tod Swiecichowski, Switch Architectural Photography; **12,** Jefferson Papers, Library of Congress; Adams Papers, Massachusetts Historical Society; **13 (left),** National Portrait Gallery, Smithsonian Institution; Gift of the Regents of the Smithsonian Institution, the Thomas Jefferson Memorial Foundation, and the Enid and Crosby Kemper Foundation, owned jointly with Monticello; **13 (right),** National Portrait Gallery, Washington, DC; **15 (top),** Library of Congress; **16-17,** courtesy National Museum of American History, Smithsonian Institute; **35 (both),** National Woman's Party; **38 (top),** Art Resource; **38 (bottom),** American Philosophical Society, Philadelphia, PA; **41,** Library of Congress; **42,** © CORBIS; **43 (top),** © Hulton-Deutsch Collection/CORBIS; **46 (top),** Library of Congress; **46 (bottom)** courtesy Pauline Copes Johnson/Harriet Tubman Home, Inc.; **49,** National Archives; **50,** American Airpower Heritage Museum, Midland, TX; **52 (top),** Library of Congress; **55,** Franklin D. Roosevelt Library; **58,** courtesy of Elizabeth Wing Byram, copy photo by John Corbett; **66 (top),** courtesy of the Berkshire County Historical Society at Arrowhead; **66 (bottom left),** courtesy of the Berkshire Athenaeum, Pittsfield, MS; **66 (bottom right),** courtesy of the Berkshire County Historical Society at Arrowhead, photos by Nicholas Whitman; **69 (top),** Library of Congress; **70 (top),** Library of Congress; **70 (bottom),** Asbury Park Historical Society; **74 (top to bottom),** UCLA Film and Television Archive; University of Alaska, Fairbanks; National Museum of Natural History, Smithsonian Institution; George Eastman House; **75,** Minnesota Historical Society; **74-75 (all),** Preserved through Treasures of American Film Archives organized by the National Film Preservation Foundation; **76 (left),** The John and Mable Ringling Museum of Art, photo by Terry Schank; **76-77 (all),** courtesy of The John and Mable Ringling Museum of Art; **80 (top),** Collection of George Marcopulos; **82 (bottom right),** as published in *Coronet Memories: Log of the Schooner-Yacht Coronet on her Off-Shore Cruises from 1893 to 1899* (F. Tennyson Neely, Publisher, 1899); **83,** courtesy of the Society for the Preservation of New England Antiquities (#4418.NS); **85,** © Charles Graham (*The Great Jazz Day*), used by permission; **86-87,** Louis Armstrong House and Archives at Queens College/CUNY; **88 (top),** Edith Wharton Restoration at The Mount; **88 (bottom),** courtesy of The Lenox Library Association; **91 (bottom),** Oregon State Parks Trust, photo by Cross & Dimmitt, Portland, OR; **92 (top),** ©1999 The Frank Lloyd Wright Foundation, Scottsdale, AZ; **104,** Society for the Preservation of New England Antiquities; **107 (top),** ©Flip Schulke/CORBIS; **107 (bottom),** courtesy of Ebenezer Baptist Church, Martin Luther King, Jr. National Historic Site; **108,** Jackson Hole Historical Society and Museum; **111,** courtesy of Alexander & Baldwin Sugar Museum; **112,** National Anthropological Archives, National Museum of Natural History, Smithsonian Institution; **115,** courtesy of Elwyn B. Robinson Department of Special Collections, Chester Fritz Library, University of North Dakota; **116 (top),** courtesy Jewish Historical Society of Southern California; **118,** Friends of New Orleans Cemeteries, Inc.; **130,** Historic Pullman Foundation Archives; **134,** U.S. Department of the Interior, National Park Service, Edison National Historic Site; **137,** collection of the Maine Historical Society; **139,** The Thomas Day House/Union Tavern Restoration, Inc.; **141,** courtesy of Bob Blakeslee; **143 (both),** Minnesota Historical Society; **145,** Library of Congress; **146 (top),** Berkeley County Historical Society; **148,** courtesy of Vera Teeple; **157,** Gettysburg National Military Park; **158,** courtesy of the National Park Service; Statue of Liberty National Monument; **160,** National Park Service; **161 (top),** National Park Service, Manhattan Sites; **161 (bottom),** Museum of the City of New York; **162,** National Park Service; **168 (top),** Good Buy Sweet Prints; **168 (bottom),** National Archives; **170 (top),** University of South Florida/Tampa; **170 (bottom 3),** Ybor City Museum Society, photo by Steve Poisall; **172 (top),** University of South Florida/Tampa; **177,** Library of Virginia; **182 (bottom),** courtesy Mac Jamieson © Southern Living 1988; **186 (top),** courtesy Ron Solomon ©1999; **188 (bottom),** © The Metropolitan Museum of Art; **11, 23, 31, 63, 101, 127, 155, 176, 180-181, 182 top, 183-185, 186 bottom, 187, 188 top, 189,** photos used with the permission of individual sites through Save America's Treasures

ACKNOWLEDGMENTS

The National Trust for Historic Preservation would like to thank Save America's Treasures Honorary Chair First Lady Hillary Rodham Clinton; Ellen McCulloch-Lovell and the staff of the White House Millenium Council; T.C. Benson, Bobbie Greene, and Ariane McCarthy from Save America's Treasures; Millennium Committee to Save America's Treasures member Leslie Dach; with special thanks to Sara Karrer, Assistant Director, Save America's Treasures, for editorial coordination; and Lisa Lytton for her expertise and vision to make this terrific publication a reality.

NATIONAL TRUST *for* HISTORIC PRESERVATION™

The National Trust for Historic Preservation, chartered by Congress in 1949, is a private, nonprofit membership organization dedicated to protecting the irreplaceable. It fights to save historic buildings and the neighborhoods and landscapes they anchor. Through education and advocacy, the National Trust is revitalizing communities across the country and challenges citizens to create sensible plans for the future. It has six regional offices, twenty historic sites, and works with thousands of local community groups nationwide.

For more information about the National Trust and its programs, services and historic sites, please call 1-800-944-NTHP (6847), or write to the following address:

National Trust for Historic Preservation
1785 Massachusetts Avenue, N.W.
Washington, D.C. 20036-2189

Visit the National Trust's Web site at: www.nationaltrust.org